Queer Style

'If clothes make the man (and the woman), how much more do they make the queer man or woman. This insightful book looks at the way fashion has coded same-sex desire, from eighteenth-century macaronis and gentlemen fops to modern leather-men and muscle queens, from mannish Sapphic women to lipstick lesbians. As those with homoerotic orientations constructed their sexualities and identities, the authors reveal, so they dressed themselves for the parts they played.'

Robert Aldrich, University of Sydney, Australia

'From Rosa Bonheur and Radclyffe Hall through Bowie and Warhol to Boy George and Leigh Bowery: just a few of the style icons present in this wide-ranging, illuminating and highly readable account of over two centuries of queer performance and posing.'

Nick Rees-Roberts, author of *French Queer Cinema*, University of Bristol, UK

'This book provides a refreshingly engaging and extraordinarily superior standard of scholarship that inquires analytically into complex LGBTQI issues and challenges and complements the works of Butler, Foucault, Halberstam, Shapiro and others in the field. Their work will contribute to original scholarship on LGBTQI in a number of related ways. This text further gives voice to the many LGBTQI communities of actors and displays a scholarly trajectory that is not only well-grounded but combines the best traditions of theoretical and methodological triangulation.'

Wesley Crichlow, University of Ontario Institute of Technology, Canada

Subcultural Style Series

ISSN: 1955-0629

Series editor: Steve Redhead, Charles Sturt University

The *Subcultural Style* series comprises short, accessible books that each focus on a specific subcultural group and its fashion. Each book in the series seeks to define a specific subculture and its quest to exist on the fringes of mainstream culture, which is most visibly expressed within a subculture's chosen fashions and styles. The books are written primarily for students of fashion and dress but will also be of interest to those studying cultural studies, sociology and popular culture. Each title will draw upon a range of international examples and will be well illustrated. Titles in the series include *Punk Style, Queer Style, Body Style* and *Fetish Style.*

Queer Style

Adam Geczy and Vicki Karaminas

BLOOMSBURY

·LONDON · NEW DELHI · NEW YORK · SYDNEY

Bloomsbury Academic
An imprint of Bloomsbury Publishing Plc

50 Bedford Square	1385 Broadway
London	New York
WC1B 3DP	NY 10018
UK	USA

www.bloomsbury.com

Bloomsbury is a registered trade mark of Bloomsbury Publishing Plc

First published 2013

British Library Cataloguing-in-Publication Data
A catalogue record for this book is available from the British Library.

ISBN: HB: 978-1-8478-8195-3
PB: 978-1-8478-8196-0

Library of Congress Cataloging-in-Publication Data
A catalog record for this book is available from the Library of Congress.

Typeset by Apex CoVantage, LLC, Madison, WI, USA
Printed and bound in Great Britain

To Carolyn, Justine and Rita

Contents

List of Illustrations

Acknowledgements

We would first like to thank our editor, Anna Wright, for her unremitting patience and positivity. Thank you to Sydney College of the Arts, University of Sydney; professor Desley Luscombe, dean of the faculty of design, architecture and building; and professor Lawrence Wallen, head of design at the University of Technology Sydney for their unwavering support. We would also like to acknowledge Deborah Szapiro for her research support.

Introduction

The writer must not be indignant if the invert who reads this book gives his heroines a masculine countenance. For only by the indulgence of this slightly aberrant peculiarity can the invert give to what he is reading its full import.

—Marcel Proust[1]

The dubious insight for which Heinrich von Kleist's short philosophical narrative *Über das Marionettentheater* (1810) is best remembered is that dancing puppets are more beautiful than dancing people. This is expounded in the style of a Platonic dialogue, where in the winter of 1801 the anonymous narrator meets a mysterious Herr C who informs him that he finds the movements of puppets more elegant than those of humans because they are devoid of affectation (*Ziererei*); their limbs betray a lightness that we cannot match. Unlike puppets, whose movements are pure, humans conflate their actions with doubt. These stirrings of consciousness, impulse and will distract us from the task at hand. This is the inevitable symptom of having eaten from the tree of knowledge. Expelled from paradise, we amble the earth to see 'if maybe there is a back door somewhere that is open'.[2] We must resolve this split somehow, but it is uncertain whether this is ever possible. Kleist implies that our instinctual desires also cause the delay, the gap, which drives us to create. He doesn't use the word as such but the more tempered term *Ziererei*—affectation, coyness or false hesitation. Within the aesthetic circuit of the dance, desire is, on one hand, reduced to distractions of consciousness, while on the other, cast into the mould of affectation—artifice, false creation. Once we realize how we falsely create the world, we are lured to recreate it, falsely afresh.

Why is this classic text from the German Romantic period being invoked in a book about queer subculture, fashion and dress? It is because of three key terms: *the fall, affectation* and *false creation.* We are in no way submitting Kleist to a 'queer reading'; rather we wish to begin this book by isolating the philosophical and moral implications of what it means to be queer, unusual, off the mark, bent, unconventional. From the premise of the fall from grace, all human beings are queer, inasmuch as they crave a completeness that they believe was deprived them. The Christian-Platonic paradigm in its simplest form is that we seek to rupture the realm of falsehood to find a unified truth. Queer, as we define it, however, is that state of being and its visible incarnations that have embraced affectation and false creation as ends in themselves, in

effect abjuring the distinction between thing and appearance, and embracing artifice, pretence and exaggeration over 'conformity' to an imaginary truth. The most famous embodiment of this principle in recent memory can be found in Oscar Wilde, who vaunted the virtues of excess and lying. His line in *An Ideal Husband* comes forcefully to mind: 'To be natural...is such a difficult pose to keep up.' Or in 'The Decay of Lying', 'Truth is entirely and absolutely a matter of style.' It is not for nothing, then, that the aestheticist movement with which he is associated—also referred to as the decadents—was complicit in more than one way with aesthetics of camp. The melancholy consequences of the fall sounded by Kleist are effectively left at the door for another path altogether that rejects homologies, be it in manners, mores or sexual preferences. The mindset of this potentially transgressive condition finds its visual signifiers in queer style.

Queer, which can still be used for its former meaning of strange, peculiar or odd, has now permanently shifted into the realm of social and bodily types that do not conform to a model that is 'straight', namely heterosexual, conventional and middle class. We might add the word *mostly* to heterosexual and middle class because being queer does not necessarily entail being gay or lesbian, although it generally does. As we will see, the most common conflation with gay and lesbian subculture is with bohemianism, a source of both consternation and delight. It is to the advantage of the idea, but not quite to the advantage of theoretical simplicity, that there is no consensus as to the terms *gay, queer* or *homosexual.*

But for the sake of this book, queer is the most apt place to start as it suggests divergence from a rooted norm. It is also a constructive, advisedly used alternative to homosexual, which, although a word in common currency, has the taint of the scientific diagnoses of the nineteenth century. What is also misleading is the *homo* which, although linked to the idea of same-sex, is still too limiting, least of all because queer identity is about diversity and difference. Steven Seidman sees queer as encompassing, or enshrining, the debates around gay or lesbian autonomy and around ethnicity and the crisis that has emerged from a lack of a single message or atomizing theory.[3] It is coterminous with theories of the Other (feminism, postcolonialist) and is also fundamentally shaped by the trauma of HIV/AIDS, the traumatic threshold, the gay Holocaust if you will.[4] If anything, being queer understands itself according to what it is not: the Christian, Western, heterosexual middle-class construct.

Gay and lesbian politics is largely a history for gaining recognition against this standard.[5] Queer, as it grew out of the early 1990s, was, in the words of Murray Healy, 'a manifestation of a cynical attitude toward organized politics (another symptom of the postmodern loss of faith in truth, history and teleology) which had resulted in a wave of apathy hitting even the most politicized sites, such as student union and gay societies'.[6] He sees queer as having had its demise, 'evaporated' upon its entry into the passage of language and discourse.[7] While there is suitable evidence in popular culture for this, we number among those who still defend its currency. We contest the idea that it is vapid or dead on the grounds that *queer* can be used in a more

subversive sense as a stand-in term for an indefinable or irreducible quantity, like pi in mathematics. For queer is the notion that sets out to dodge, undermine, parody and ultimately eradicate the hetero–homo binary, which is an imposed binary. We argue that through style and dress, one can begin to uncover queer less as a category or system and more as a dynamic of slippage, a site of renegotiation, undermining, overstatement and reinstatement. The celebratory tones of queer acts are often also tinged with notes of melancholy. If the term is always insufficient, it is this insufficiency that ensures its ongoing life and that it keeps desiring. To put this another way, notes Rob Cover, who uses the motif introduced by Judith Butler of how we perform our gender:

> The performativity of lesbian/gay subjectivity is by no means necessarily determinant of *all* or *any* lesbian/gay articulations. While the stereotype is a discursive element cited in performativity, it does not foreclose on performances that are outside of the body-movement/desire dynamic—otherwise no such stereotype would be identifiable to be dismissed.[8]

This statement is also useful for our methodology, since we traverse stereotypes, showing how they came into being—voluntarily or involuntarily—whilst also leaving space for inconsistencies and indeterminacies.

What makes the study of fashion, dress and style so important to queer identity is the role of clothing in constructing material identity and its shaping of personal and social space. Patrizia Calefato is eloquent on this notion, suggesting,

> Fashion has turned the body into a discourse, a sign, a *thing*. A body permeated by discourse, of which clothes and objects are an intrinsic part, is a body exposed to transformations, to grotesque openings toward the world; a body that will feel and taste all that the world feels and tastes, if it simply lets itself open up.[9]

The study of fashion and dress with respect to queer allows for these 'tastes'. For queer is something far more lived, experienced, enjoyed and suffered than it is theoretical. It abjures its nineteenth-century incarnation as a scientific diagnosis. Rather, to quote Moe Meyer, 'The definition of queer is one based on an alternative model of the constitution of subjectivity and of social identity. The emergence of the queer label as an oppositional critique of gay and lesbian middle-class assimilationism is, perhaps, its strongest and most valid aspect.'[10]

On face value, from the view of the strictures of social convention, it is entirely understandable that a word for strange should be used for people outside of the heteronormative mould. Yet the term *queer* conceals a great many historically constructed presumptions to do with normalcy and with socio-economic models that date back to as recently as the eighteenth century. These presumptions become more sinister when we consider another vernacular usage of queer, which is to spoil or ruin

something. What is being ruined is, by all accounts, an ideal of sexual difference that, albeit nebulously indefinable, is at the same time irrepressibly present. In the words of Judith Butler, 'We could nevertheless explain intersexuality by claiming that the ideal is still there, but the bodies in question—contingent, historically formed—do not conform to the ideal, and it is their nonconformity that is the essential relation to the ideal at hand.'[11] The ideal normative state of sexual difference relies on 'intersexuality', or queer, to assert itself. As Butler states a little later, 'Sexual difference thus functions not merely as a ground but as a defining condition that must be instituted and safeguarded against attempts to undermine it (intersexuality, transsexuality, lesbian and gay partnership, to name but a few).'[12] Butler argues that sexual difference is a standard of measure that can only exist, can only be understood and be visible as such, through the constant struggle to contain itself against a perverse 'outside'.

Richly enshrined within the word *queer* is a cornucopia of ideas that will be explored in this book—the deportment, the dress and accoutrements that amount to its style—that are either a cause of celebration because they are novel, because they are unusual, or incite hostility because they threaten a neatly constructed status quo. As anyone who identifies with queer will agree, the poles of carnival and transgression are close bedfellows. As Eve Kosofsky Sedgwick eloquently puts it, 'Queer is a continuing movement, motive—recurrent, eddying, *troublant*...Keenly, it is relational, and strange.'[13] By extension, queer style is the unstable, bizarre other to heterosexual normativity. Whereas the latter is aligned to legible codes such as the suit for the male and the dress for the female, queer style is resistant to them. It does, however, have a set of consistent attributes such as non functionality and exaggeration. In a visual, metaphoric and sometimes more material sense, queer style has a tendency toward violence. It signifies a state of rupture and courts the anxiety that comes from unaccountability.

Although we can retrospectively find examples of queer style in aberrations in fashion and dress in every era, it is only with modernity that it becomes a distinguishable trait. For it is only in the middle of the nineteenth century that notions of conformity in dress become welded to broader notions of social order. This occurs at precisely the same time as the theorization of homosexuality. Hitherto considered under the oblique term *inversion,* homosexuality entered into everyday discourse with Richard von Krafft-Ebing's *Psychopathia Sexualis* of 1886, from which followed an ongoing effort on the part of sociologists and psychologists to define homosexuality, with the eventual aim to cure it. With homosexuality given its own category, a series of presumptions and definitions flowed from what constituted correct deportment and socially appropriate dress. Homosexuality, then, is a by-product of the rise of the middle class. Middle-class behaviour distinguished itself from that of the working class with its fastidiousness and pride in upholding the details of moral rectitude, while it also rejected the arbitrariness and extremities associated with the aristocracy. The social and economic philosophies of Karl Marx and Max Weber characterize the middle-class values of conformity, sobriety

and industry as pre-eminently Protestant. The abstemious and thrifty bourgeois was driven to amass private wealth for security and comfort. Behaviour that deviated from this was inevitably seen as hostile to these aims and dealt with accordingly. The fear and loathing of homosexuals that arises from such attitudes is therefore a social as well as economic affair. For the homosexual is someone who interferes in the smooth functioning of a capitalist society; he (right to the present day the term is more associated with men than with women, something to be discussed shortly) was also a sign of something fundamentally aberrant within society, something that was not working and needed correction. Homosexuals were a symptom of some seam of dysfunctionality in the capitalist system. It is also with this in mind that we can begin to theorize queer style as linked but not entirely wedded to being homosexual: to the present day, a person who is not a homosexual can, however, exhibit queer traits in dress and manner. He or she is queer inasmuch as the dress and manners do not represent a clean fit into everyday mores. Queers are at turns avoided and feared because they embody signs that these mores may not be as sound or as watertight as they are purported to be.

Homosexuality's coming to visibility and 'coming to being' as it were in the nineteenth century has to be understood together with the birth of the human sciences, debates about evolution and theories about behavioural models, which ranged from the psychoanalysis to sociology. These are disciplines that grew from the modern, post-Kantian concepts of anthropology—that is, no longer seeing 'man' as a reflected image who is an instrument of a larger Godly design but rather as an entity that designs his own conditions of life. This is reflected in the social philosophies of Henri de Saint-Simon and August Comte (credited with coining the term *sociology*), for example, which posed models of social evolution and organization. Society was thus organized not in terms of nobles, clergy and others but more intricately according to sex, ability, body type, race and vocation. With society disaggregated into categories, homosexuals and to a lesser extent lesbians would naturally stand out as particular, deviant types. And given that science after Francis Bacon is based on empirical study, the modes of appearances of homosexuals and lesbians were an important factor in devising codes of differentiation, in order for a 'healthy' society to be imagined and realized.

Queer theory is itself a new area of inquiry, much like that of fashion studies itself. It is a significant coupling in this book since both disciplines (if they are permitted to bear that name) are seemingly constituents of a frivolous Other: queer to reproductive, straight heterosexuality, fashion to serious fine art. Queer theory has a number of key coordinates: Freudian psychoanalysis, feminist theory and the historical revisionism of Michel Foucault.

Foucault's seminal *History of Sexuality,* in particular the first volume, *The Will to Knowledge* (1976), opened the way for rethinking sexuality as more than a biological function and as a way in which we conceive ourselves and others; it is integral to our psychic and social ordering. As Foucault argues, 'The notion of "sex" made it

possible to group conducts, sensations, pleasures, and it enabled the use of this ficti-
tious entity as a causal principle'.[14] After quoting this passage, the philosopher Slavoj
Žižek, strongly influenced by Foucault's contemporary Jacques Lacan, rejoins:

> From a Lacanian perspective, however, Foucault overlooks here the inherently 'antago-
> nistic' status of sex, the 'antagonistic' relation between sex and sexuality *qua* plurality of
> discursive practices: these practices endeavor again and again to integrate, to dominate,
> to neutralize, 'sex' *qua* traumatic core which eludes their grasp.[15]

In other words, *sex* is a word for an unquantifiable energy that is a compulsion to
compensate for the lack within our being; it the point at which biological will and
psychic desire are no longer separable. *Sexuality* is the multitude of ideas, presump-
tions, constructs and associations that exists to give sense to sex; since no adequate
sense can be attributed to it, sexuality is always reasserting itself in various ways.

Once again it would be all too tempting to assert that sex is fundamentally queer
and that sexuality is the name for the attempt to give it order. What concerns us more
here is the contention that queer style is the outward expression of the imponderable
disorder of sex, a necessary crack in the symbolic order of sexuality. We are inter-
ested in the outward, material registers of a psychosexual state of being, a state that
has multiple and sometimes contradictory attributes. For being queer is not a stable
or reasonable state in the way that heterosexuality thinks it is. There is no fundamen-
tal locus in the symbolic order for queer in the way that straight can be brought down
to denominators of coitus linked to productive sex (even if unproductive) and to the
image of the nuclear family with gender paradigms of the father as authority figure
and the mother as nurturer. Since unproductive sex is, from a metaphysical point of
view, inessential, being queer is also irreducible to a definable set of components. It
is largely defined as what it is not straight. But what does this mean?

The nineteenth-century idea of inversion is still by far the most tenacious model
for characterizing homosexuality—the mannish female lesbian and the effeminate
male—but as much as it applies to many homosexuals, it is far off the mark. We
might begin with the famous speech by Aristophanes in Plato's *Symposium* in which
he expounds the theory that humans first existed as combined entities before being
split in two. This does not mean that they were hermaphrodites, for these original
beings were but one of a genus of three, the other two being double men and double
women. Riven in two, they spent their life searching for their lost soulmate. There
are several things to be learned from Aristophanes. The first is that the homosexual
combinations make no presumption of any other gender but their own; they do not
need to become their other or play a role. The second is that, as Aristophanes empha-
sizes, the attraction of couples transcends sexual pleasure; it is an instinct that goes
far deeper. In effect, Aristophanes mounts an argument for three different species
of human in which attraction is not genital but spiritual. Implicitly expanding on
Aristophanes's argument, Gilles Deleuze in a footnote in *Proust and Signs* describes

human attraction not as threefold but eightfold; the man in man looks for the woman in woman, the woman in man seeks the man in woman, the man in woman finds the woman in woman and so on.[16] Here Deleuze conceives humans as a gender dyad combination further defined by the dyadic combination of his or her mate.

But both theories, helpful as they are for exploding the myth that only straight is great, are nevertheless insufficient, for they do not account for the degrees of psychic desire or the role played by outward manifestation. We can change our sexual orientation and the nature of our desire in the course of our life, and we can also gain extreme pleasure from acting out certain parts without engaging in genital sex. Crucial here is the shifting nature of object choice on one hand and the role of aesthetics on the other. When one turns to hermaphrodites, transsexuals and drag kings and queens, these two conditions are combined to unquantifiable degrees. With transgender individuals, the sex-gender distinction becomes unstuck. For in their particular case, gender as a mentality and linguistic construct is incompatible with that of sex seen in terms of biological function and manifestation. On a base level, the aesthetic plays a part here in the discordant harmony, if we may put it that way, between what is thought and what is seen (for example, I feel woman but parts of me look male). The aesthetic is also important in the autoerotic fulfilment, in which the subject takes pleasure in his or her particular appearance (s/he lacks nothing for s/he has both breasts and a penis). This leads us back to our introductory gambit that situates affectation, unnaturalness, as key to human behaviour. Queer style is therefore to be considered not only as a set of signifiers of dress and accoutrements, but it also is worn as part of the body. Whereas the straight construct sees a dichotomy between the naked body and the clothing that covers it, queer style considers a far more seamless relation between the two.

For Judith Butler, gender is always an active phenomenon: what we say or think we are is a result of something we do.[17] We perform our gender to ourselves and to the respective communities we inhabit. This is a profoundly useful concept as it incorporates the artificial with the natural and the lived and fails to distinguish between clothing and gesture. Various strategies have been developed by gay, lesbian and transgendered people to manage their identities in a world that values and prioritizes heterosexual ideals and norms. These strategies include not only attitude and behaviour but most importantly for the study of this publication also dress. The act of dressing, to choose what to wear, when and for whom, is a social process through which actors execute different performances in front of different audiences.[18] Growing up queer and experiencing difference means a constant questioning of identity politics and results in the need to define and belong to a group. Experimenting with fashion is a way of both displaying and accepting difference—or a way of passing and becoming invisible under the guise of heterosexuality. Dress is therefore a visible and conscious marker of a constructed or performed gender.

Following from Foucault, Butler suggests that we are moulded by and respond to the multitude of conditions within society. These conditions themselves are not fixed

and generally take the form of prohibition. But, as Butler argues, the responses that arise from prohibition are not always to be seen reactively—that is, replicating the same structure of power from a different position. Rather,

> the sexuality that emerges within the matrix of power relations is not a simple replication or copy of the maw itself, a uniform repetition of a masculinist economy of identity. The productions swerve from their original purposes and inadvertently mobilize possibilities of 'subjects' that do not merely exceed the bounds of cultural intelligibility, but effectively expand the boundaries of cultural intelligibility, but effectively expand the boundaries of what is, in fact, culturally intelligible.[19]

This is a useful way of understanding queer identity and queer style. It is a sociosexual force pushing the limits of cultural acceptability and knowledge. This is why, when a subculture first appears, it is treated as bizarre and frightful, a threat to the moral order of the social fabric.

A good deal of work has been done on subcultures such as mods, punks and goths, especially since Dick Hebdige's landmark *Subculture: The Meaning of Style* (1979) situated subculture as a viable social and aesthetic category. But not that much has been made of fashion and style as they relate to queer identity. This is all the more astonishing considering that they are indissoluble from the countercultural movements of the sexual revolution of the late 1960s, which rattled normative sexuality on all levels, bending gender orientation and questioning monogamy. After this, queer culture had three clear phases. The first is the Stonewall riots, which began on 28 June 1969; the second can be marked with the first diagnosed case of AIDS, on 5 June 1981. The third, which is less precisely dated but falls around 2001, is the noticeable, but still insufficient, acceptance of homosexuals into the fabric of society. In 2001, seven European countries plus Argentina, South Africa, Canada and some states in the United States allowed same-sex couples to marry. Other countries have different provisions including civil unions. Although internationally uneven, the institution of gay marriage—a sort of conventionalizing of gay identity—has also brought to more public notice gay subcultures such as leathermen, feeders and drag kings. Edmund White writes about how the costumes of the 1960s became supplanted in the 1970s by what he calls a 'new brutalism': boots, beards, denim and mustaches.[20] Today these forms of style have a certain historical subtext and are recognized as belonging to a genre. The transition of the post-war period from acting to belonging is not to be underestimated. The postmodern historicization of forms of dress may diminish their political pungency, but in the case of queer style it does something more important. It enlists it to a social category which, if called deviant, is no longer a bland threat but an aesthetic descriptor.

Up until the third phase, the evolution of gay, queer culture is largely oriented toward men. Much has been written on the changing historical conceptions of male homosexuality, from the stereotypically effeminate 'pansy' to the overtly masculine 'macho man' of the 1970s, and the role that clothing and mannerisms played in

indicating gender roles and sexual orientation. Yet, in the field of fashion studies, little attention (if any) has been paid to the dynamics and symbolism of lesbian dress in constructing identities and subcultural style. From the strictly encoded femme/ butch dress codes of the 1950s through to the 'lipstick lesbians' and the highly stylized 'drag king' performances of the 1990s, lesbian fashion continues to parody and subvert the associated oppositions between masculinity and femininity. Indisputably, in a little over a decade or more, lesbians have accorded the term *lesbian*—which they prefer to *gay* because they consider that to be male—a more widespread definition, albeit thanks to the public coming out of conventional, lipstick lesbian couples such as Ellen DeGeneres and Portia de Rossi.

But conventionality need not be a problem. One of the main challenges of this book is to displace a reductive binary between convention and radicality. Queer is not so simple as a countervailing structure. While this may appear to apply when we set up oppositions between bourgeois heterosexuality and queer counterculture, we at first reiterate a reductive binary that is enlisted for the sake of conservative society in its efforts to make sense of itself and to eradicate complications that arise from excess and difference. Second, we situate queer as both outside and within the so-called common order. Thinkers such as Foucault, Lacan and subsequently Butler and Žižek have amply demonstrated that the symbolic order not only requires, but solicits the forces that threaten its oblivion. Indeed, the patina of stability and correctness of the symbolic order is built on a deeper set of unresolvable contradictions that, paradoxically, need to remain unresolved for the symbolic order to function properly. On the other side of the coin, radical counterculture cannot function without consensus that it is oppositional and, by degrees, objectionable. For countercultures are built on a complex merging of the political and aesthetic: while they are expressions of pain and resentment at the lack of recognition, it is also true that they take pleasure in their opposition and most immediately in the way they perform that opposition in outward appearances. The energized and cultish nature of radical subculture should, however, not decry establishment gays and lipstick lesbians as phallic—that is, enlisting into the social order that rejects them. Such an attitude reverts to an invidious binarism that, ultimately, resituates queer as abnormal. A salient theme within this book is the extent to which *normal, straight* and *symbolic order* are highly constructed terms that, like the system of capitalism itself, feed on opposition in order to widen their embrace.[21]

What is also true is that the image of homosexuality in popular memory is not only male but predominately American. This has next to nothing to do with men in the halls of power—precious few indeed come out, and we will be waiting a lot longer for a queer US president—and everything to do with the media. For instance, almost all of the anglophone world will know the French comedy *La Cage aux Folles* through its Hollywood adaptation *The Birdcage* (1996) and its straight lead actor, Robin Williams. It is also remarkable that films that purport to address the sexual balance still have a comparative blind spot to lesbian experience, and the actors—from Daniel Day-Lewis in *My Beautiful Laundrette* (1985) to Philip Seymour Hoffman in

Truman (2005) to Sean Penn in *Milk* (2008)—are not gay. Not that they necessarily need to be, since they are acting, but it is also worth taking note of a comment made by Rupert Everett, who did come out, that he would recommend against being an openly gay actor.

This book will not only address lesbian experiences as well as global practices in queer lifestyles, but it will also examine queer identities such as the male transsexual or transvestite ladyboys of Thailand; masculine Thai lesbians known as tomboys; *Dees* (feminine-identified Thai women who have relations with other women); women-identified males known as the *Kathoeys*; male-to-female transgendered *fa'afafine* of Samoa; and the Albanian sworn virgins who 'elect' to become men. The reason for such inclusions is because queer is a Euro-American construction, and by examining non-Western culture, even though there have been Western influences via colonization and globalization, these cultures open up yet more spaces for rethinking sexuality. The non-European cultures we examine are useful to frame and understand the manner of fluidity within the notion of queerness and the tenuousness with which definitions and categories of gender and sex, and their connection to fashionable signifiers, function within the prevailing social order.

The first chapter deals with the concept of classic—that is, what queer is not—and style, first as it began as a philosophical tenet in art and then its subsequent appurtenance to fashion and dress. Although briefer than the subsequent one, this chapter is necessary for setting up the dialectics that underscore this book. The language of style as it emerged out of the seventeenth and eighteenth centuries became increasingly complex when increasingly freighted with social assumptions. In burgeoning concepts of history and anthropology, the most accessible way of understanding cultures and epochs was through their embodiment in style. While glossing some of these principles, what is of deeper interest to us are the assumptions that surround concepts of the beautiful and the classic and what is by extension a corruption of this; what is a perversion or an exhaustion of a once robust style. Drawing on the work of Joanne Entwistle and Valerie Steele, we look briefly at the historical construction of gender through dress, establishing its many arbitrary coordinates and also, by default, what constitutes queer.

The two chapters that follow are on sapphists and lesbian sartorial style, and on gay style. At first glance, such a division seems at odds with some of our arguments about the fluidity of gender thus far, but it is in the interests of clarity and for the case that a lesbian experience is very different from a male gay one, not least, as we have already articulated, because she is typically his queer Other.

The final two chapters are devoted to non-Western manifestations. Chapter 4 looks at sadomasochism (SM) and bondage (BD) and the accoutrements, dress codes and role-playing that are associated with these particular queer styles. The chapter following, on drag kings and queens, examines drag as a performance that mimics and parodies dominant stereotypes of masculinity and femininity and that relies on sartorial cues and gestures to mark a space of identity.

An important caveat needs to be made with respect to the historical scope of this book. As opposed to same-sex encounters and relationships, for reasons that we have touched on and that we will continue to explore, queer as a social category is relatively new. It is for this reason we choose not to dwell on queer style from an a posteriori viewpoint, preferring to concentrate on roughly the nineteenth century onwards. It is only then that queer is crystallized as something as such, caught between the poles of disgust caused by the lack of acceptance and recognition, and defiance, the resistance of those who cherish their rights to conduct themselves in ways that do not comply with prescriptions of normalcy. It is also only in the modern and postmodern eras that forms of dress, mannerisms and accessories take their own independent life as attributes of queer identity.

Literature on queer space and urban history has readdressed the myth that there was no early queer social culture by deliberately challenging isolation, invisibility and internalization, as well as by highlighting the significance of a gay, lesbian and transgendered social culture in establishing a recognizable queer identity. The achievement of such texts has been groundbreaking and must be viewed in the context of restoring other voices that have been denied representation in historical records. However, the priority in this politicized agenda has meant that they rarely relate queer experiences to the broader social, economic and political contexts in which fashion resides.

The Meaning of Style between Classic and Queer

It's part of my bad side.

—Balthus[1]

In the introduction we discussed Judith Butler's contention that sexual difference is a condition of comprehensibility that is constantly safeguarding itself against the myriad variations that undermine it. Gender is not essence; it is resistance. It was Foucault's singular contribution to show that reason and non reason (madness) are self-generating and therefore reciprocal forces of control linking the individual with the state. The definitions of what was admissible and inadmissible in human conduct reflected forms of power relative to social organization and control. His 'age of reason', which begins roughly in the seventeenth century—this has been criticized for being too loose, yet it avoids the overly generic word *modernism*—is predicated on a series of oppositions, each of which is dialectical and mutually exclusive. For example, the elevation of straightness means the construction of gayness. What is of interest to Foucault is the way in which social formations and states of being reach a level of visibility—a comprehensible category of identification. If we turn to homosexuality, we can say that sexual acts between women and women, and men and men, have occurred since the proverbial dawn of time. However, to be a homosexual, lesbian, queer is a recent phenomenon whose social identity is built more on a way of life—mores, mannerisms and clothes—than on an isolated genital act. To begin to define queer style, it is therefore important to trace the meaning of the term *classic* as it portends, first, to the notion of style that emerged together with the inception of art history in the latter half of the eighteenth century and, second, to normative modes of dress. Thus before we turn to queer, we need to look at the way the notion of convention—and the forceful notion of timeless convention as enshrined in the loaded term *classic*—was shaped in beauty and dress. It is a history peppered with ironies.

Winckelmann and the Suppressed Homoerotism in Modernist Style

Big claims can be made about Winckelmann. A central figure of Western humanism, within a little more than a decade (1755–67) he reshaped ideas of art, history, culture

and thought. He is also singularly responsible for theorizing the concept of the Greek ideal, which subsequently became a benchmark for thinking about quality on grounds that brought the quality of life into consequence with aesthetics. In other words, a good style was the consequence of a good and robust culture. His *Geschichte der Kunst des Altertums* (History of Ancient Art, 1764) formulated a coherent argument for the historical development of Greek culture, tracing it according to the tripartite evolution of progeniture–climax–decline. This was similar to the Vitruvian conception of style, except that Winckelmann built into his theory a broader sense of philosophical purpose. Before Winckelmann the study of art had been a study of style that had remained virtually unchanged since the writings of Cicero and Quintilian. Winckelmann essentially integrated the study of style into the contours of history and, thereby, human activity. In a truly humanist vein, he gave style moral impetus.

Here is not the space to go too deeply into the byways of Winckelmann's thinking with respect to art; rather, our purpose is to adumbrate the kind of stylistic premium he introduced that has been the benchmark for Western taste until at least the middle of the twentieth century. Winckelmann's famous statement of antique art's 'noble simplicity and calm grandeur' became a slogan that distinguished the art of the ancients from that of his time, and with that, the rudiments for classic art's timelessness as against the greater transience of the art of his own time. Winckelmann's advocacy for the Greco-Roman style is now the benchmark for the modern idea of a classic— namely, something with enough stylistic strength or weight to endure in itself or as an armature for other styles, insofar as it supplies a default structure or maintains an echo of itself regardless of superficial variants. This has enormous ramifications when we come to the idea of queer, which is theoretically the other of classic style. Although Winckelmann never used the term *classic* as such, the highly powerful assumption associated with it—as truthful, lasting, reliable, adaptable and somehow clean—is attributable to his writing. Any notion of classic queer style is better understood as a historical iteration that has become a genre (say, leather queen).

Winckelmann went to great lengths to define the constituents of ideal beauty, which, being based on Greek art, was centred on the human form. He arrived at a concept of beauty that was denuded of social and cultural baggage and cleansed of anecdotal or incidental association. In the words of the best modern interpreter of Winckelmann, Alex Potts, 'In the ideal nude, then, you have an image that seems to represent a common humanity lying beneath the clothing of social identity.'[2] Winckelmann argued forcefully that the Greek ideal was the sine qua non of bodily beauty that transcended cultural boundaries. Here we can be forgiven from thinking that Winckelmann sowed the seeds for the image of the violent male Greco-Roman hero vaunted by National Socialism. In Potts's words again, Winckelmann situated

the Greek ideal of beauty as transcending the particularizing effects of environmental context. It was commonly believed that the different physical types associated with non-European races could be explained by environmental factors, or, to use a term current at the time, climate. Winckelmann himself embraced these theories, and subscribed to the

notion that people's conceptions and ideals depended upon their empirical experience of the particular milieu they inhabited. There was much in Winckelmann's intellectual baggage that would make it logical to see details of physical beauty as culturally specific, dependent upon a society's immediate experience of its own ethnic type. Against this, however, he sought to argue that the white European Greek ideal possessed an abstract perfection of form that transcended the relativism of any actual norm of physical beauty.[3]

Winckelmann's theoretical pursuit evolved into a significant philosophical achievement emulated and analysed by countless scholars in his wake. The panhistoric conception of the Greco-Roman style was profound, ramifying to the very essence of how Western discourse evaluated beauty and style. For it opened up much surer rhetorical speculation as to what was inferior, undesirable, degenerate or in decline. Winckelmann's influence was all but lapidated with Hegel's *Lectures on Aesthetics* (1818–29). With numerous appreciative acknowledgements in Winckelmann's direction, Hegel accepted the Greek ideal and took up the topology of rise-climax-decline and placed it within a much broader historical frame and accorded with deep historical purpose. Indeed, the Greek ideal has an unusual place in Hegel's aesthetic philosophy, which conceives of the Spirit (*Geist*) as inhabiting style. Style is a carapace that evolves in sophistication commensurate with the dynamic evolution of the Spirit, with the imminent goal of overcoming art and evolving into a deeper stage of self-realization (religion then philosophy). But for Hegel, the middle phase of art's evolution, the classic, was a special interlude in which the spirit dwelt comfortably within the ideal body of the Greek sculpture. It is as if the wiles of classic Greek beauty are strong enough to still, to immobilize, if only relatively briefly on the historical scale, the dynamic power of the spirit.[4]

To return to Winckelmann, what we see throughout his writings is a version of beauty that is focused on the male form and is unmistakably homoerotic. Winckelmann lavishes particular attention on a handful of sculptures, among which is the Hercules of Belvedere. Here are several excerpts from his encomium:

> What a conception we gather from those thighs, whose solidity clearly shows that the hero has never flinched, and never been forced to bend!
>
> The might of the shoulder indicates to me how strong the arms must have been that strangled the lion upon Mount Cithæron which bound and carried off Cerebrus. His thighs and the remaining knee give me an idea of the legs, which were never weary, and which pursued and caught the brazen-footed stag.[5]

Even though he states that the 'image of the hero leaves no room for a thought of violence or licentious love', the disavowal gives the game away.[6] What we have is a curious theoretical incident that sets the terms of reference for classic beauty in a homoerotic sensibility. An example of this in more recent memory is the film *Brothers of Arcadia* (2012) by creative director Nicola Formicetti for Thierry Mugler. Directed by Branislav Jankic with the music of Franz Schubert, the film is a homoerotic tribute

to the classic Greek masculine form. In the opening sequence, in black and white, three young men with sculptured physiques rise erect like architectural pillars from a Greek temple, somewhat reminiscent of Leni Riefenstahl's film *Olympia* (1938). The three men, dressed in black Mugler underpants, frolic and wrestle playfully along the water's shore as the camera feasts on details of their bodies.

This has nothing so much to do with the historical distinctions of power and friendship between Greek and Roman men and men of modern times,[7] and more to do with exposing a fundamental seam of repression within the modernist claim for conceptual purity, utopianism and formal clarity. These normative values—analogous to heteronormativity—belie deeper strata of meeting and activity. To put it a different way, to maintain the illusion of its universality, normalcy requires queerness. These lines of reasoning pose a threat to orthodox and so-called phallocentric art history—the histories of Wölfflin, Gombrich and Greenberg, for example—since it not only disturbs a habitual presumption of gender, but it also abundantly demonstrates how art history relies on descriptive rhetoric and (sublimated) sexual desire.

Since the culture of bodybuilding that evolved out of the late 1970s, it is now conventional to 'wear' a body. How many times and how often is there commentary before a Mardi Gras parade or a dance party that gay men flood the gyms to get into shape in anticipation of disrobing for the festival? In effect, they are partaking of a collective ritual of Hellenism. The equivalent celebration of the developed male physique in more straight milieux are institutionalized, hence sanitized, in contests or else in informal rituals in gym locker rooms, the repressed homosexuality of which was most outrageously satirized in *Little Britain USA*.[8]

Winckelmann's homosexuality in both his writings and his life is widely documented, although in the nineteenth century, when his reputation was sedimented, it was repressed. Goethe, for instance, glossed over it by exhorting readers to a kind of Dionysian excess, that he 'lived as a man and went forth from this world as a man in his fullness'.[9] Winckelmann's homosexuality was always a subtext but never discussed at great lengths. Homosexuality, it will be remembered, was not a term in currency in Winckelmann's lifetime. He and his aesthetic-sexual preferences were seen by sympathetic observers, and those who wanted the issue overridden, as simply following in the footsteps of the ancients. In his close examination of these matters, Kevin Parker explains that, in full conformity with the ancient Greek sensibility, Winckelmann was in thrall of youthful manhood, beauty which he found inarticulable and dangerous. It was Winckelmann's concern to master his worldly desires with respect to the youthful male ideal and thereby to institute a timeless and untouchable beauty that paid full respect to the ideals of male beauty and love voiced in Plato's *Phaedrus*—true love gained through restraint and renunciation. As Parker concludes,

The Enlightenment brought with it the fall of an ethics of the body modeled on Christian asceticism. The rift that ensued, in the place between Descartes' establishment of the self-referential subject, who chose simply to forget the body, and the rise in the

nineteenth century of clinical medicine, the new forum for the mortification of the body, allowed for the mutual emergence of the discourses of modern history and aesthetics. The problem of the boy, which is also most emphatically the problem of the seduced subject, returned to lay claim to the Western body. Aesthetics, but also art history, was there to meet this return of the repressed, effectively vanquishing it as reason's symmetrical other.[10]

This is a very strong assertion; however, it does suggest that within the modern sensibility, in which the sensuous and sensual are nervously aligned, virtue rests in stylistic simplicity and clarity. The late nineteenth-century aversion to homosexuality as an ailment and a corruption occurs only decades before proclamations by architects such as Adolf Loos and his disciple Le Corbusier, who used biological metaphors to denigrate ornament. Modernist style presumes that there is an essential core that must be protected against the violations of wanton, extraneous additions. Again, the pared-down modernist armature is socially productive if not democratic, while the over-adorned form—a chair, an architectural façade—reflects an obscurity inimical to the unimpeded progress of culture and industry. It is therefore of no surprise that homosexuality and lesbianism are so often associated with flamboyance. Queer celebrates flamboyance in and for itself, whereas the bourgeois ethos considers it intrusive, ostentatious—and treacherous.

In the final episode of series eight of Larry David's (of *Seinfeld* fame) *Curb Your Enthusiasm,* Larry finds himself at odds with his current girlfriend when he buys her seven-year-old son, Greg, a sewing machine for his birthday. On their first meeting, the boy says he had been watching *Project Runway* on television because he *loves* fashion. In the exchanges between the dissociative mother and Larry, the boy is euphemistically pronounced 'flamboyant'. With perceptive irony, flamboyance and a male love of fashion are supposed predispositions to being gay. Social conditioning and truth are jumbled in a room of mirrors. But what counts is that flamboyance is deemed feminine.

The stylistic judgment of flamboyance as retrograde has a long history that is also linkable to Winckelmann. In his view, the Baroque, specifically Bernini, was inferior to the Renaissance since it was too subjective. In contrast to the serene nobility of objective beauty, subjectivism is here defined as illusionism and having a fascination with effect over substance. In short, Bernini falls short of fulfilling his charge as an artist because of his insufficient respect of the demarcation between art and nature. The parallels we are drawing are not dissonant with our argument that queer is more affiliated artificiality. For the focus here is on a proto-performative dimension;[11] Bernini's art is highly temporal in that it expresses ephemerality which, for the classicist in Winckelmann, vitiates the air of permanence of classical austerity. In Winckelmann's writings, Baroque art is deprecated for its excessive exaggeration and a spiritedness that he regards 'insolent'.[12] Bernini was, incidentally, a lover of the gorgeous flow of fabric over the body; he disavowed the classical articulated relation between drapery and the body. Arbitrariness, excess, flamboyance were henceforth integers to stylistic ruin. To invert Winckelmann's famous formula, they are neither

nobly simple nor calmly grand; they are grandness overwrought—and in this regard, we are precariously close to Susan Sontag's notion of camp. Whereas the classical, albeit abstract, was for Winckelmann the primordial axis of civilization, the baroque as a wayward step that denied the transcendent and enduring qualities that art could enshrine. Much later, it would be Nietzsche who would also warn against feminizations of style in his onslaught against Wagner, whose aesthetic depravities he deemed symptomatic of vulgar mass culture.[13] On the other hand, pared-back classicism was, after Winckelmann, made of sterner stuff and consigned to rectitude and convention.

Let us conclude this section with a more frontal assault on the sexual contradictions in Winckelmann's writing and its long-term effect on art history:

> In large part, the inherently closeted status of art history can be attributed to the way in which Johann Winckelmann laid the earliest foundations for the discipline. Winckelmann was the foremost theoretician of a neoclassicism in which he cleverly transposed his 'subjective personal erotics and politics in objectivizing formalist and historicist analysis'. It was the sublimation of Winckelmann's own homodesires in creating a history of art methodology that has encouraged or, more specifically, mandated, suppression of homoerotic desires in art history as we know and practice it. It was, however, through Winckelmann's channeled investment of his queer desires into the legitimizing spaces of antiquity, myth, and the centrality of the male body for expressive communication that a safe haven for veiled expression of unspoken sexual desires between men was provided, especially as they had been nourished within the homosocial environment of the artist's studio.[14]

What we can say is that the modern concept of style and its mandates and imperatives are built on assumptions that involve some very large and enduring repressions. The renegotiations of normative codes that define the protest era and postmodernism in general must therefore not be seen as voluntarist or arbitrary, as guided only by political will. Rather, the emergence of queer style, we assert, is the making-conspicuous of what is always already there. But if it is always there, it is never normal. The queerness of queer style has multiple functions: it retains the remnants of its suppression, it announces itself as form of resistance and, finally and most importantly, it maintains queerness as a reluctance, mild to militant, to be at one with normalcy. Even if being gay is 'normal', it can never be so since normalcy always conspires with codes that imply hostility to difference.

A Selective History of Non-queer, Standard, Straight and Classic Dressing

As Joanne Entwistle observes, 'Clothing is none of the most immediate and effective examples of the way in which bodies are gendered, made "feminine" or "masculine."'[15] In premodern times, distinctions of gender in dress are linked to

the origins of civilization itself: war. Civilization begins with social enclaves built, architecturally or in name, to protect them from outside tribes desirous to encroach on their territory for greater power and better survival. The distinctions in dress were therefore military, but in times of peace, these distinctions were less evident. In ancient times right into the Renaissance, the tunic, a vestimentary default, was worn by men and women alike. Deviations from the norm were with symbolic registration (the imperial purple), adornments (headdress) and quality (silk). But these are all attributes of costume and not, strictly speaking, fashion. This is now a well-rehearsed area of fashion studies that associates the development of fashion with class and society. Since they are both forms of social ordering, the distribution of class is coterminous with sexual difference. There were evident differences in dress from the Renaissance onward, but it was the French Revolution and the nineteenth-century middle class that made the decisive step to placing imperatives on forms of dress. In her examination of the concept of body and self in the Revolutionary period, Dorinda Outram states:

> Eighteenth century clothes were designed for artifice, display and disguise; Revolutionary styles for authenticity, simplicity, and transparency for the gaze of others. No longer seducing the eye of the beholder with artifice, they emphasized the actual gender of the wearer. Dress practices, like the use of make-up, jewellery, artificial hair and facial patches, which had been common to both sexes before 1789, began to be rigidly differentiated by gender and their use confined to women. The new 'minimalist' clothes of the Revolution, and the forbidding to men of disguise, display and artifice in dress and body adornment, meant that Revolutionary fashions echoed the new political culture's emphasis on sharpening differentiation between the sexes and insisting that members of each sex appear for what they 'really' were.[16]

The Revolution polarized the notions of masculinity and effeminacy that had gradually crystallized over the eighteenth century. It made ideological an increasingly held belief in the effeminacy of the aristocracy. In the words of Kosofsky Sedgwick, the abstract image of the aristocracy 'came to be seen as ethereal, decorative, and otiose in relation to the vigorous and productive values of the middle class'.[17]

The vigorous changes in fashion, art and society that the Revolution precipitated revealed just how porous convention could be. Changeable they may be, but the century that followed is characterized by deep ideological restrictions. Valerie Steele points out that the sobering up of male dress—the great male renunciation—occurred well before the Revolutionary years, as it was associated with sporting apparel appropriate to the country gentleman. While not discounting the effect of the Revolution, it was also the rise in centralized government and a civil service that entailed a certain uniformity that held a mirror to civic duty.[18] It was the appearance of functionalism and efficiency that mattered.[19] But what we will also see in Chapter 3 is that the great epitome of this ideal becomes personified in the dandy George 'Beau' Brummell, who abjured family life and was not expressly sexual, which also

suggests disinclined to the female sex. The origins of the suit are not queer, but men's dress is not as firmly anchored as many would think. The ideal of the slender body is also of recent, twentieth-century origin. Since the Middle Ages, right through to the Victorian era, skinny bodies were associated with impoverishment and ill health. This changed with mass-production and the wider availability of food in cities and with the connection between physical activity, efficiency and upward mobility.

Dress frames the body. It expresses who we are and who we are not as a means of expressing identity and a way of interacting and belonging to a particular culture. The adoption of what is considered masculine or feminine clothing is a means of communicating membership of a particular group or the affirmation or rejection of an 'assigned' rather than 'chosen' gender. In this way, clothes are given value as a means of making a statement about individuality and a person's place in society. Clothes also play an important part in proclaiming a person's sexual and gender identity. If clothing is a form of non verbal and visual codes which communicate certain characteristics or facts about the wearer, then the dress choices of alternative genders within a culture demonstrate a desire to be seen as someone else.

Gender differentiation is an important aspect of fashion and dress, especially in Western culture (as opposed to, say, pre-Meiji Japanese), but it is only in modern times that it becomes 'fixed'. The frameworks of productivity and success that formed in the nineteenth century called for sophisticated forms of organization. The forces that caused the polarization of male and female dress are as much calculated as they were subconscious. With women having long hair and skirts, and men with short hair and trousers, not only could gender roles be differentiated, but race as well. These polarities stood in dramatic contrast to the tunics, caftans and gowns of Asiatic and Middle Eastern—Oriental—cultures. Indeed in modern times, gender demarcations of dress found an appreciative audience in such countries as Japan and Turkey. When Japan opened its doors to the West in the Meiji period, it made sure also to differentiate men, who were to wear Western-style clothing, from women, who were to wear the newfangled adaptation of the ancient *kosode,* the kimono. In short, men no longer wore gowns. Given that even other cultures had begun to internalize these conventions, one can only imagine the horror when suffragettes began to wear bloomers which connoted not only manly trousers but also harem pants. The female reorientation of self in the form of dress and action was a threat to the social fabric: its values, its functioning and its well-being. This perceived threat is all the more ironic since women wished for a more active contribution to society. It finally took two world wars for this to come indelibly into effect.

When subcultures become more intricately divided and when they are not simply lumped into the bohemia basket, we observe a common thread of rupture. This is usually worn or transcribed on the body in some way. Calefato has productively assigned the term *grotesque* to these aberrant manifestations and behaviours, which range from the flamboyant to the sexually strange, from surrealist subversion to the man-machine hybrids of techno and cyberpunk. So conceived, the grotesque is a form of masking in which the mask can take hold so that barriers between inside

and outside begin to lose their meaning. 'The metastability of grotesque stylistic features lies in their inexhaustible potential for use in different semantic contexts.'[20] In style and dress, grotesque assumes a fictive but stable core—the classic and the natural—that it disturbs. It is the sinister remainder that circulates around the empty real of normalcy.

The casual American sportswear label Abercrombie and Fitch (also A&F, or just Abercrombie) is a brand strongly associated with the lifestyles of the leisured, young, upper classes. Fashion photographer Bruce Weber—known for his Calvin Klein and Ralph Lauren advertisements—is behind the company's magazine, *A&F Quarterly,* which was launched in 1997 to 'glamorize the hedonistic collegiate life-style on which the company built its irreverent brand image'. The brand's natural and classic image has its clearest articulation in the *Abercrombie Look Book: Guidelines for Brand Representatives of Abercrombie and Fitch* (revised August 1996), affec-tionately known as the *Look Book,* a step-by-step guide to achieving the A&F style.

The *Look Book* begins thus:

> Exhibiting the 'A&F Look' is a tremendously important part of the overall experience at the Abercrombie and Fitch Stores... Our people in the store are an inspiration to the cus-tomer. The customer sees the natural Abercrombie style and wants to be like the Brand Representative... Our brand is natural, classic and current with an emphasis on style.[21]

The A&F look is important as part of the overall experience of the brand. The 'preppy, collegiate style' is about selling to the consumer, American, middle-class values of success and 'wholesomeness' framed on the construction of 'naturalness' as 'classic'.

Consider the following stylistic guidelines from the *Look Book*:

- For men and women, a neatly combed, attractive, natural, classic hairstyle is ac-ceptable. Dreadlocks and any type of 'fade' cut is unacceptable.
- Jewellery must be simple and classic, gold chains are not acceptable for men. Dressy watches are also unacceptable... No pieced jewelry is acceptable (e.g., nose ring, pierced lips, etc.).

The frequent use of *accepted* and *unacceptable* in the *Look Book* has to do with the reordering and the recontextualization of objects to communicate fresh meanings. This bricolage of objects constitutes a sign—in this case, white, American, middle-class values that have also found their way amongst queer subcultural communities. As Dwight McBride comments, 'Whether I was at home in Chicago or travelling in New York City, Los Angeles, Houston, or Atlanta in any mainstream gay venue there was sure to be a hefty showing of Abercrombie wear among the men frequenting these establishments.'[22] What is it about the Abercrombie style that gay men identify with, and what kinds of meanings about sexuality, class and masculinity are attached to this style? In the last twenty years, queer studies have highlighted the intersections

between gender, class, race and sexuality and how they impact the body and style. The politics of appearance is about the process of becoming, a statement that is politically and aesthetically charged. Calefato describes how a 'look' functions as an image and as an expression of one's outlook of the world. She argues that a look articulates 'a way of being in the world and creating a social universe',[23] and that the 'wordliness' of a clothed body conveys 'rational values, by virtue of a sort of category of Otherness'.[24] To put this another way, style is about identity; it is a way of being in the world. Style is a strategy of resistance, of talking back and drawing attention to one's self. It is a state of refusal and revolt. The cultivation of dreadlocks or a lip piercing is a gesture of defiance against the natural order. It is a construction of a style that is a gesture of defiance.

Queer style, as subset of grotesque forms of release, is a perturbation of social moral order. It renounces faith in the way in which society is organized. Queer style cannot be limited to threats to sexuality and propriety, as it spreads also to economics; it is a symbolic jolt to the myth of efficient systems. Yet we know that capitalism is multivalent and requires forces that resist it. The gender polarities of dress that we inherit from the nineteenth century also mean that we inhabit a deeply aestheticized world, where we are constantly revealing some beliefs, traits and urges and concealing others through signs conveyed in mannerisms and dress.

In her essay 'Queer Visibility and Commodity Culture', Rosemary Hennessy writes:

> One effect of the aestheticization of daily life in industrial capitalism is that the social relations on which cultural production depends are even further mystified. The aestheticization of everyday life encourages the pursuit of new tastes and sensations as pleasures in themselves while concealing or backgrounding the labour that has gone into making them possible. In keeping with the aesthetic emphasis on cultural forms, 'style' becomes an increasingly crucial marker of social value and identity. While the term has a more restricted sociological meaning in reference to specific status groups, 'lifestyle' as a way of making sense of social relations crystallized in the 1980s in the United states as new forms of middle-class professionalism became the focal point for heightened involvement in consumption and the promotion of cosmopolitanism.[25]

Lifestyle is a concept that is constantly positioning class and gender. It is the most profitable strategy of global capitalism to confirm and confirm again gender stereotypes, because, being clichés, they are the easiest to define, digest and market. But this also allows queer style to flourish. For as Foucault explains, the increasing effort to diagnose homosexuality and to reduce it to set of taxonomic attributes, to reduce it to a matrix, only revealed how this was impossible because it opened up more exceptions and complications. So too, the more mass-market fashion instates or recreates stereotypes, the more room is made for cracks and slippages. But what we will also see is that the marketing of lifestyle in the 1980s exposed a deeper condition of gay and lesbian life. For it too was recognized as a lifestyle; a way of life and being.[26]

Lesbian Style: From Mannish Women to Lipstick Dykes

Of course, there's a strict gay dress code no matter where you cruise. At the height of my college cruising, I was attending Take Back the Night meetings dressed in Mr Greenjeans overall, Birkenstocks, and a bowl haircut that made me look like I'd just been released from a bad foster home. There is nothing more pitiful to look at than a closeted femme.

—Susie Bright (Susie Sexpert)[1]

If I'm still just like a virgin, Ricky, then why don't you come over here and do something about it? I haven't kissed a girl in a few years…on TV.

—Madonna to Ricky Gervais at the 2012 Golden Globe Awards

A stereotype exists of lesbians having poor fashion sense, which is rooted in cultural prejudices about the mannish woman as unnatural and ugly. Although lesbian style is not exclusively about masculine attire, the idea that lesbians tend to dress like men has persisted through representations of them in popular culture. There has never been one sole type of lesbian style—whether local or international, underground or visible, femme or butch. Lesbian style reflects a mix of cultural forms and multi-ethnic styles.

The historical and social formation of lesbian subjectivities and their association with a sartorial style has been, since the early twentieth century, framed around butch-femme identities. It is difficult to determine how long lesbians have practiced butch and femme roles. Before the latter half of the twentieth century in Western culture, gay, lesbian and queer societies were mostly underground or secret. Butch and femme roles, and the importance of elements of styling, mannerism and clothing, date back at least to the beginning of the twentieth century, although the exact origins of the butch-femme identity are unknown. Before the twentieth century, women passed as men by dressing and acting like men for either sexual or economic reasons or simply for adventure. It comes as no surprise, then, that after years of feminist scholarship and political interventions, from the Stonewall riots to the feminist movements of the 1970s and the establishment of queer theory and post-feminism of the 1990s, lesbian style has now become more fluid as gender and sexual binaries have become increasingly blurred.

In her essay 'The Femme Question', Joan Nestle comments that both butches and femmes have a history of ingenuity in the creation of a personal style and that it is 'easy to confuse innovative or resisting style with a mere replica of the prevailing custom'.[2] As Nestle notes, both butches and femmes created very distinct styles that, although they seem to replicate heterosexual gender roles and styles, were in fact 'rewriting' them in order to signify their own desires and sexualities. A butch woman who dressed in men's clothing was still a woman, but the creation of a particular style was used to 'signal to other women what she was capable of doing—taking erotic responsibility'.[3] A femme woman, although dressed in clothing that signals conventional femininity in order to 'attract men', was in fact subverting this convention and attracting women. However, the emergence in the 1990s of a 'new, sexy and glamorous style', coined 'lipstick lesbianism' by the media, reflected deeper questions about identity, gender and politics. This chapter traces lesbian sartorial style of the twentieth century by drawing on popular culture and established lesbian scholarship to uncover the impact that dress and appearance has had in constructing lesbian identities.

Mannish Lesbians and Salon Dandies

Colette, in her essay on lesbianism in Paris, 'The Pure and the Impure', divided lesbians into two types: the mannish and the perverse. The latter was more common and the idea more tenacious in the public imagination; the former was more exotic and decadent. In her novel *Chéri,* she combines the two, but in a man. In a Proustian inversion that some would say is a craven act of masking for the sake of conservative prudery, Collette gives a highly precious and feminized lover to an aging courtesan; her lover has all the attributes of both sexual coquette and invert. But such binaries can only take us so far. As Elisa Glick explains, their over-persistence 'minimize[s] the continuities *within* lesbian identities and *between* lesbian and gay male subjectivities'.[4] For Glick, the model of the lesbian dandy presents one solution to this predicament but only if one does not accept that the female dandy is just a feminized version of the male. To make too fixed assumptions about lesbians in our present era is not to 'see' them all and certainly to underestimate the limits of women's sexuality as a whole. As Albertine once told Proust's narrator, Marcel, after he inquired about what she had been doing with her female friend, there are things you will and can never know or see.[5] In this context, visibility and elusiveness is a complex matter that also has to do with the lesbian reorientation or renunciation of the traditional Freudian fetish. In many ways, lesbian dress is a kind of visualization of the limits and limitations of a masculine style.

The representation of the mannish lesbian portrayed in Radclyffe Hall's novel *The Well of Loneliness,* argues Esther Newton, 'was and remains an important symbol of rebellion against male hegemony, and…of one significant pattern in lesbian

sexuality and gender identification'.[6] The protagonist of the novel, Stephen Gordon, is a woman who from birth finds herself 'different', somehow masculine in appearance and personality yet female in body. Hall has been criticized for creating a character based on the stereotype of the 'sexual invert' as defined by sexologists such as Krafft-Ebing and Havelock Ellis, but Newton argues that Hall's character is in fact not a passive victim of nature:

> By endowing a biological female with a masculine self, Hall both questions the inevitability of traditional gender categories and assents to it. The mannish lesbian should not exist if gender is neutral. Yet Hall makes her the hero—not the villain or clown—of her novel.[7]

In her essay 'Forbidden Love', Elizabeth Wilson views Stephen as embodying a masculinity that is infused with a sense of danger and power, one that is attributed to a 'doomed' personality. Wilson observes, 'The lesbian resembles the archetypal Romantic movement hero, the doomed rebel, often an artist, often sexually ambiguous.'[8] Mimicking her protagonist, Radclyffe Hall's appearance reflected the model of the 'sexual invert' offered by sexologists. The *Birmingham Post* described her in April 1927 as

> a well-known figure at all the interesting parties and public occasions and [she] is easily recognizable by her distinctive appearance, tall, slim, and very well groomed. Miss Hall affects a mannish mode of dress, and has what many people consider the best shingle in London. Her hair is of gold, and cropped as closely as a man's, a natural ripple in it being the only break in its sleek perfection.[9]

Needless to say, the *Well of Loneliness,* which instigated a trial and was banned for obscenity in the same year of its release, is of enduring relevance because it confronts the stigma of lesbianism—as most lesbians have experienced it.

In the late nineteenth and early twentieth century, there was greater visibility and cultural presence of lesbian identities in major urban cities such as London and Paris. Yet these women were primarily middle class and their lives were financially independent, meaning that they did not necessarily have to depend on marriage as a means of daily survival. Such women enjoyed the privileges and economic power that class offered and were drawn into literary and artistic circles.

These women included the Duchess de Clermont-Tonnere (Elizabeth de Gramont), the artist Gluck (Hannah Gluckstein) and Una Troubridge. They were in many ways the epitome of lesbian style of the period. The cigarette, the monocle, the cropped short haircut, the tuxedo and the fedora hat are the most recognizable accessories and sartorial displays of the mannish lesbian culture of London and Paris of this time.

Perhaps the most significant and well-rounded precursor to the mannish lesbian was what in France was called the *lionne.* The lionne, or lioness, was a subcategory

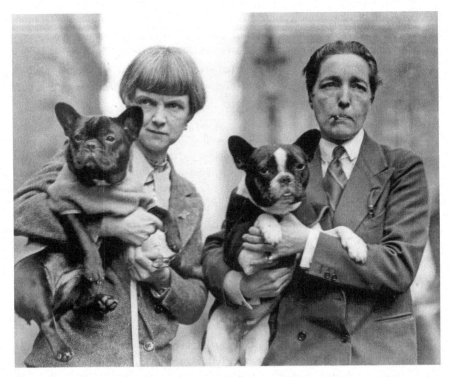

Fig. 2.1 Radclyffe Hall and Una Troubridge; photo taken by an English photographer. Courtesy: Private Collection, Bridgeman Art Library.

of the *femme à la mode,* distinguished, as the name denotes, by an aggressive temperament and a just as fervent taste for novelty. She appears around the time of the July Monarchy, and is now viewed as a reaction, or antidote, to the waifish, Romantic woman immortalized by the novel by Alexandre Dumas *fils* in *La dame aux camélias* (1848) and popularized by Verdi in the opera *La Traviata.* As opposed to pining on a chaise longue, pale-skinned and languorous, eating only the titbits that the restrictions of her corset would allow, the lionne favoured exercise and sports such as pigeon shooting and swimming. She ate, drank and smoked profligately. In all these respects, she was dipping into the pool of male activity, which, for a woman of the time, was thought to be dangerous and eccentric to the point of objectionable. The lionne participated in what Miranda Gill calls 'surrogate masculinity'; she was characterized as sexually voracious and excessive. Males who exhibited eccentric behaviour that strayed from the image of what they ought to be were known as *femmelettes*; their female counterparts were *homasse*—mannish.[10] However, the lionne was a paradoxical figure because her assertiveness was also attractive. And it is also important to point out that her mannish whiles were depoliticized. She distanced herself from the *femme libre* and the *femme nouvelle* of Saint-Simonian free-thinking

and from the portraits of rebelliousness in the writings of George Sand (one of the most famous historical cross-dressers), for the lionne would rather leave politics to men.[11] The political indifference of the lionnes, and other associated subgroups such as the *lorette,* were nonetheless female counterparts to male dandyism. (Although it can just as easily be said that the flouting of political responsibility in male dandyism was itself a highly political stance.)

Another term bandied about in late nineteenth- and early twentieth-century France was the *garçonne,* a noun and an adjective that translates best as tomboy. When volume four of Marcel Proust's *A la recherche du temps perdu, Sodome et Gomorrhe* and Victor Marguerite's *La Garçonne* appeared at virtually the same time in 1922, the term assumed widespread resonance in France. Marguerite's novel ignited a scandal and resulted in the loss of his Legion d'Honneur. Proust's book not only contained the famous tract on inverts (the longest sentence—over 500 words—that he ever wrote) but also accounts of the narrator's serial frustrations

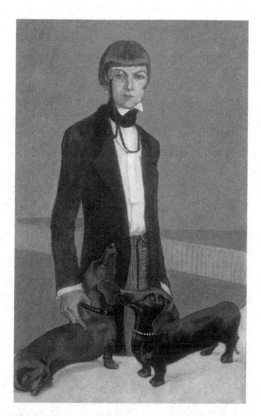

Fig. 2.2 *Lady Una Troubridge* by Romaine Brooks, oil on canvas. Courtesy: Smithsonian American Art Museum.

with the suspected lesbian trysts between his lover Albertine and her friend Andrée. The feminizing of what are more commonly male names was not lost on the audience and has been the subject of critical debate ever since.[12] Outside of France, the garçonne phenomenon found its equivalent in the flapper, whose bowl hairstyle and vigorous movements were at odds with notions of female grace and serenity. Less about sexual preference, the flapper's boyishness was a buoyant assertion of liberation from traditional constraints of gender. And as Quentin Crisp suggests, 'The word "boyish" was used to describe girls of that era. This epithet they accepted graciously. They knew that they looked and dressed nothing like boys. They also realized that it was meant to be a compliment.'[13] This type of boyish or masculine look came to be known by a variety of names, including 'hard boiled flapper, boyette, boy-girl or modern girl' and can be traced by fashion historians to about 1918. These had a particular charm to the male gaze (and gay male gaze) of the early decades of the twentieth century, as Elisabeth Landeson explains in her book *Proust's Lesbianism*:

> What makes women such as Albertine and Odette eternally inaccessible and thus eternally desirable is specifically their status as desiring subjects whose desire is always elsewhere. This is the very definition of the *être de fuite,* the paradigm of the Proustian object of desire. It is also what lies behind the appeal of Marlene Dietrich in her tuxedo.[14]

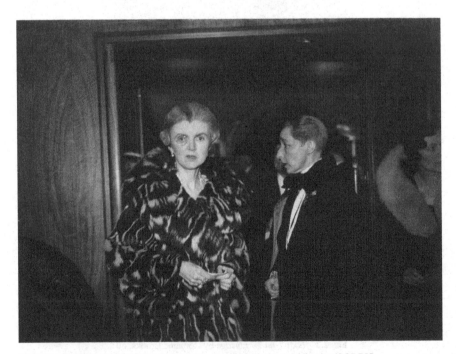

Fig. 2.3 Radclyffe Hall and Una Troubridge. © Hulton-Deutsch Collection/CORBIS.

But unlike her younger, perkier counterparts, Radclyffe Hall was no longer a young woman, and in her maturer gravitas she decisively tipped the sartorial balance. But she was also in certain respects very much of her time, subscribing to the nineteenth-century 'diagnosis' of inversion as a man trapped in a woman's body. Disowning her given names, Marguerite Antonia, she preferred to be called John, the name of her father. 'The high-fashion clothing of women like Radclyffe Hall', notes Marjorie Garber, 'the Marquise de Belboeuf (Collette's lover), Romaine Brooks, and Una Troubridge was in part an extension of the costume of the male dandy.'[15] Upper-class women dressed in tuxedos and cravats in public and often wore a monocle and smoked a cigarette or a cigar. Women belonging to the lower classes only wore mannish clothes in the evening, concealed under a coat while on their way to a lesbian venue. In the words of Garber, the lesbian style of the 1920s was dominated by 'men's formal dress, top hats and tails—popularized onstage by entertainers like Marlene Dietrich and Judy Garland, became high fashion statements, menswear for women re-sexualised as straight (as well as gay) style'.[16]

Although scholars contextualize lesbian style at the time as masculine, or mannish, Laura Doan takes the position that masculine dress in the 1920s was not necessarily an indication of the wearer's sexuality and challenges the image of the tuxedoed, hair cropped, cigarette-smoking woman as a lesbian. In her essay 'Passing Fashions: Reading Female Masculinities in the 1920s', Doan discusses the fashion trend towards a 'masculine style', particularly in London and Paris. She warns against pinning down the cultural significance of monocles, short hair (the Eton crop) and cigarettes to any sole indicator. Cross-dressing women of all sexual persuasions, she argues, were merely being fashion-conscious, and their new stylistic accessories were symbols of the freedom and decadence that women embraced after the Second World War, when women wore trousers for the first time. As Doan explains,

> The phenomenon of masculine fashion for women with its concomitant openness and fluidity, allowed some women, primarily the middle and upper classes, to exploit the ambiguity that tolerated, even encouraged, the crossing over of fixed labels and assigned categories, such as a female boy, women of fashion in the masculine mode, lesbian boy, mannish lesbian and female cross-dresser.[17]

According to Doan, lesbians seem to follow the fashion and stylistic trends of the time and did not single out any particular accessory or garment as a sign of sexual identity. Doan writes, 'Radclyffe Hall rarely wore trousers in public, and women such as Vita Sackville-West would normally only wear them [trousers] in the privacy of their own home. Only Gluck continued to wear trousers publically.'[18] The doubling of meaning associated with masculine dress at the time, as both outré modern chic and lesbian, enabled women such as Una Troubridge and Radclyffe Hall simultaneously to appear as lesbians and fashionable. Glick makes the subtle observation that Hall's novel

both participates in the decadent impulse to depict the queer (both male and female) as a spectacle of artifice and perversion *and* aims to refashion masculine lesbian identity as the very apotheosis of bourgeois ideology—as, in other words, antidecadence. We can see this double move at work in Hall's rendering of the figure of the mannish lesbian as a rewriting of the leisured, dandified aesthete.[19]

Hall's novel and she herself are not only to be understood as epitomizing certain paradigms but also standing on the threshold of them. After all, by 1928, the masculine mode of style was gradually on the wane and was being replaced by a more feminine look. Doan cautions the reader that 'masculine style' should not be taken as synonymous with lesbian subjectivity; however, a new cultural and social presence of self-fashioning lesbians was emerging in the early twentieth century. Women with same-sex desires began forming vibrant lesbian communities in major urban metropolises such as Paris, Berlin and New York, specifically in Harlem and Greenwich Village.

From the late nineteenth century until the 1940s, Paris was a centre of sexual freedom and same-sex cultures. American and European lesbian expatriates joined with French lesbian writers and artists to create their own special bohemia congenial to their sexuality, mores and creative talents. No different from the arch-heterosexual Henry Miller, people of unconventional beliefs and desires saw Paris as a welcome reprieve from the more straight-laced values of England and America. Paris's cultural milieu accepted homosexual practices to some degree, provided that they were relegated to the elite and aristocratic salons or to secluded working-class bars. A notable meeting place for lesbians and all kinds of bohemians from the late nineteenth century onward was the cabaret 'Le Chat Noir' ('Black Cat') in Montmartre. It is now best remembered in popular memory for the photographs that George Brassaï took there. These photographs have all the classic qualities of empathy and directness, conveying their subject matter with incontrovertible frankness.

In Brassaï's memoirs are descriptions of Paris as the 'Sodom and Gomorrah' (again from Proust), where the lesbian bar The Monocle, on the Boulevard Edgar-Quinet, was 'the capital of Gomorrah', one of 'the first temples of Sapphic love':

> From the owner, known as Lulu de Montparnasse, to the barmaid from the waitress to the hat-check girl, all the women were dressed as men, and so totally masculine in appearance that at first glance one thought that they were men. A tornado of virility had gusted through the place and blown away all the finery, all the tricks of feminine coquetry, changing women into boys, gangsters and policemen. Gone the trinkets, ruffles! Pleasant colours, frills!...they wore the most sombre uniforms; black tuxedos...and of course their hair—women's crowning glory—abundant, waved, sweet smelling, cured—had also been sacrificed on Sappho's altar. The customers of Le Monocle wore their hair in the style of a Roman emperor or Joan of Arc.[20]

The wealthy American playwright, poet and novelist Natalie Clifford Barney established a salon from 1890s to the 1960s that attracted a coterie of lesbian writers

and artists such as Collette, Romaine Brooks, Renée Vivien, Gertrude Stein, Alice B. Toklas and Radclyffe Hall. Flamboyant and self-confident, Barney was openly lesbian, declaring: 'Albinos are not reproached for having pink eyes and whitish hair, why should they [society] hold it against me for being a lesbian? It's a question of nature: my queerness isn't a vice, isn't deliberate and harms no one.'[21] Gertrude Stein's salon at 27 rue de Fleurus, frequented by the likes of George Braque, Matisse and Picasso and writers such as André Salmon and Max Jacob, also flourished at this time, cultivating a circle of significant relationships with the lights of the avant-garde while also supporting subversive sexuality and cultural practices. Although their status as expatriate artists and writers allowed these women to participate in subversive behaviour and dress, dominant French society drew limits on permissiveness, still considering homosexuality 'deviant' and preferring people to keep such behaviour to themselves.

Berlin was also home to a vibrant lesbian community in the 1920s until the Nazis came to power in 1933. Boasting a number of lesbian bars, balls and clubs, it was home to prominent lesbian publications such as *Die Freundin* (The Girlfriend) between 1924 and 1933 and *Garçonne* specifically for male transvestites and lesbians. According to Leila Rupp, both periodicals featured 'photographs and illustrations of a variety of lesbians: some crossdressed, some in butch-fem couples, some entirely feminine'.[22] Clubs varied between large establishments, so popular that they were tourist attractions, and small neighbourhood cafes, where only local women went to find other women.

By the 1920s, Greenwich Village and Harlem had also established reputations as being hubs of lesbian activities. Like Paris and Berlin, these two districts were bohemian enclaves that attracted subversive crowds. Known as the Harlem Renaissance period from about 1920 to 1935, African American lesbians were meeting one another other, socializing in cabarets and private parties know as rent parties, and creating a vernacular to do with lesbian love and sex. The most popular lesbian (and gay) venue was the Clam House, a long, narrow room on 133rd Street's Jungle Alley. Popular lesbian celebrities such as Libby Holman and her lover, Louisa Carpenter du Pont Jenny, who often dressed in matching bowler hats, were regulars amongst the crowd. The Clam House presented live stage acts and drag queen performers and the mannish impresario Gladys Bentley, who dressed in a tuxedo and top hat and sang popular songs of the day. Other lesbian and mixed gay bars included Ubangi, which featured a female impersonator who went by the name of Gloria Swanson, Yeahman and the Garden of Joy.

Eric Garber's study of lesbian (and gay) subculture in Harlem during the jazz age indicates that African Americans were relatively tolerant of lesbian (and gay) culture. Rent parties were, according to Garber, the best place for lesbians (and gay men) to socialize because of their privacy and safety. Throwing large, extravagant parties and charging admission was a popular and common way for Harlem residents to raise funds to pay their weekly rent. Lesbians could also be found at the literary gatherings of Alexander Gumby, a postal clerk who acquired a white patron and

rented a large studio on Fifth Avenue between 131st and 132nd Streets. Known as Gumby's Bookstore because of the great number of books that lined the wall of the studio, the salon attracted artistic and creative luminaries including author Samuel Steward, who remembered 'enjoying a delightful evening of "reefer", bathtub gin, a game of truth, and homosexual exploits'.[23]

Heiress A'Leila Walker, credited for being a patron of the artistic renaissance and known for her love of lesbians and gay men, was another to gain repute for her extravagant parties. Walker, who lived between her palatial estate, Villa Lewaro, on the Hudson River and her Manhattan apartment on 136th Street, was a tall, swarthy woman whose looks were considered striking for her time. Always seen carrying a riding crop and wearing a jewelled turban, Walker's salon attracted elegant lesbians such as Mayme White and vaudeville performer Edna Thomas, with whom she had been romantically involved. Her salon brought together an eclectic mix of multiracial intellectuals, artists, writers and musicians. Novelist Marjorie Worthington recalls:

> We went several times that winter to Madam Allelia [sic] Walker's Thursday 'at-homes' on a beautiful street in Harlem known as 'Sugar Hill'...[Madame Walker's] lavishly furnished house was a gathering place not only for artists and authors and theatrical stars of her own race, but for celebrities all over the world. Drinks and food were served, and there was always music, generously performed and enthusiastically received.[24]

Like Paris and Berlin, Harlem's lesbian venues reflected a zone where sartorial display and extravagance was a key indicator of the diversity of sexual identities and the politics of subcultural style.

Lesbian Bar Culture of the 1940s and 1950s

Femme and butch styles were particularly prominent in the working-class lesbian bar culture of the 1940s, 1950s and early 1960s, where butch-femme relationships were the norm. In the 1940s in the United States, most butch women had to wear conventionally feminine dress in order to keep their jobs, reserving their heavily starched shirts, large cufflinks, ties and oxford shoes for weekends to go to bars or parties.

The 1950s saw the rise of a new generation of butches who refused to live double lives and wore butch attire full-time, or as close to full-time as possible. Their wardrobes consisted of casual wear for weekends such as sports jackets, chino pants and Western shirts. Cowboy boots were popular, as were penny loafers, which were worn with argyle socks. From the late 1950s, sweaters, cardigans and V-necks became trendy amongst butches. Tuxedo shirts and ties were popular for evening wear, as were low-cut men's dress boots. Their visibility usually limited the butches to a few jobs, such as factory work and taxi driving, which had no dress codes for women. Fuelled by the anti-gay rhetoric of the McCarthy era, violent attacks on lesbians

increased, while at the same time the strong and defiant bar culture became more dis-posed to respond with force. Although femmes also fought back, it became primarily the role of butches to defend against attacks and hold the bars as lesbian space. While in the 1940s the prevailing butch image was severe but gentle, it became increas-ingly tough and aggressive, as violent confrontation became an aspect of life. In 'Butch-Femme Relationships: Sexual Courage in the 1950s', one of the first essays in defence of butch-femme roles, Nestle argues that such role playing made lesbian communities visible and paved the way for sexual liberation in the 1960s and 1970s.

The most publicly visible sign of lesbianism in the 1950s was the appearance of the butch or stud lesbian, with her stylized short hair, men's tailored suit or blue jeans, boots loafers or sneakers. She held doors for her femme women, paid the bill when on a date and lit her own cigarettes. Meanwhile, femmes appeared glamorous and wore make-up, tight dresses and skirts (rarely pants), pantyhose and high-heeled shoes. The importance of dressing up continued throughout the 1950s; however, the style changed as it reflected dress styles and trends in mainstream culture. These changes also reflected developments in the lesbian community. As Elizabeth Ken-nedy and Madeline Davis confirm, 'White tough bar lesbians, Black tough lesbians, and the primarily white upwardly mobile lesbians projected different images.'[25]

In their study of the pre-1960s working-class lesbian community in Buffalo, New York, Kennedy and Davis note that white, American, tough bar butches cultivated working-class masculine looks and modelled themselves on popular musicians of the emerging rock and roll scene, such as Elvis Presley, Ritchie Valens and Buddy Holly, whose slicked-back hair, pouted lips and smouldering eyes all became paragons of this particular style. Young butches greased their hair in the popular DA, or Duck's Arse, and wore black leather jackets, white T-shirts and blue jeans, a look that was popularized by James Dean and Marlon Brando; 'It was a style that was at once tough and erotically enticing; simultaneously careless and intense.'[26]

African American butches adopted more formal wear than white studs, especially for evening attire. They wore starched white shirts with formal collars and dark dress pants. They preferred men's Florsheim dress shoes, which they wore with dark nylon socks. Their hair was processed, combed back on the sides and cut square at the top. Mannerisms for both black and white butches continued to play an important part of lesbian style: 'Mannerism...The way they was [*sic*] dressed...they [*sic*] way they talk [*sic*], the way they acted...was a tough, rough and ready style'.[27]

Lesbian bars in the 1940s and 1950s were very important meeting places for lesbians, went hand in hand with the development of lesbian sexuality and paved the way to liberation. Lesbian bars such as Sydney's Rainard's and Tommy's Place in San Francisco were essential meeting places in the construction of a lesbian com-munity and acted as safe spaces in an often hostile and homophobic world. In Phila-delphia, Barone's and Rusty's were popular amongst butch and femme lesbians. In Rusty's, lesbians called each other brothers and protected each other from police and straight male harassment. A 1954 raid on Tommy's Place demonstrated that 'lesbians

remained vulnerable to the whims of politics and police' and helped to create a 'siege mentality' in the bars that galvanized lesbian and gay communities a decade before Stonewall.[28] As Nan Alamillah Boyd writes, 'In San Francisco the roots of queer activism are more fundamentally found in less organized (but numerically stronger) pockets of queer association and camaraderie that existed in bars and taverns.'[29]

In *A House Where Queers Go: African-American Lesbian Nightlife in Detroit, 1940–1975* (2007), Rochella Thorpe looks beyond the bar scene to find out how lesbians of colour socialized. Her research finds that many African American lesbians experienced intense racism in the lesbian community and that they did not feel welcome in predominantly white bars. She identifies parallels between the social lives of lesbians of the Harlem Renaissance and Detroit; in both cases, African American lesbians created the semi-public rent parties. The parties met their social needs and at the same time solved the problems caused by racism and homophobia that they many times faced when going to public bars. Rent parties were held at private homes for a fraction of the cost of attending most nightclubs. They not only offered food, music and alcohol, but these parties provided safety and privacy for African American lesbians who longed for a place where they could freely express themselves.

Many writers characterize lesbian bar space before Stonewall as 'dismal', where butch and femme identities were stringently enforced; other writers discuss the significance and pleasures offered by lesbian bars and the importance of these butch-femme identities in creating visibility and resistance.[30] While scholars such as Audre Lorde, Judith Halberstam and Rochella Thorpe discuss the prevalent racism that non-white women encountered in the lesbian bar scene, Kelly Hankin sees the bar as a locus of lesbian activity fraught with racial and class division. Hankin's *The Girls in the Back Room* is a study of the way that the lesbian bar is represented in mainstream cinema and documentary film and is concerned with the way in which these social spaces are imagined. The emergence of 'lesbian bar representation' in the 1920s and 1930s, she argues, coincided with a popular belief that the lesbian 'was invisible and thus uncontrollable'.[31] Perhaps the most influential lesbian novel ever written, Radclyffe Hall's *The Well of Loneliness* (1928), also contributed to popular imagination of bars as seedy places where mannish lesbians went to drown their sorrows for their social afflictions.[32] Along this vein, Maxine Wolfe argues that it is important that lesbian bars must be viewed in the light of the role that secular law and the sciences (medical and social) have played in defining some woman as 'deviant' during that time, 'as well as the role of the media in publicizing lesbian existence'.[33]

Feminist Androgyny and Anti-style

If there was such a thing as lesbian style in the 1960s and early 1970s, it was essentially anti-style, a refusal to submit to mainstream culture's standards of feminine beauty, behaviour and fashion, and a rejection of the strict butch-femme role-playing

decades earlier (reclaimed amongst lesbians in the 1980s). To the politically oriented lesbian feminists, butch-femme roles seemed to mimic the repressive male–female binary of patriarchal society, which suppressed and objectified women.

In the seminal text 'Towards a Butch-Femme Aesthetic', Sue-Ellen Case critiques this feminist argument, which calls for 'old', patterned heterosexual behaviour to be discarded in favour of a new identity as a feminist woman. This argument is based on the assumption that what is repressive about male and female roles is that they are based on difference, and that in order to achieve equality, this difference needs to be eradicated. Case argues that not only does the feminist devaluation of butch-femme roles fail to take into account the importance of these roles for working-class and other marginalized women, but it also fails to envision the subversive potential to exposing gender roles as masquerade. Heterosexual roles have been naturalized in dominant culture as innate, whilst the butch-femme role-playing exposes them as constructs with a specific agenda. Butch-femme roles are in fact anti-heterosexual in their ability to empower women by reinscribing their subject position.[34] Scholars such as Lillian Faderman critique butch-femme roles as replicas of heterosexuality instead of being unique and potentially subversive. She does not negate the way that butch-femme roles have shaped lesbians' lives, but attempts to understand how these roles shaped lesbians' identity.[35]

Many feminists were doubtful about the denial of gender differences rather than endorsing butch-femme dress codes; the lesbian-feminist community promoted an androgynous style of dress characterized as comfortable and loose fitting, such as flannel shirts, loose jackets and baggy pants. Hair was cut short and tennis shoes, Birkenstocks or fry boots were considered part of this lesbian clone style, which was strictly policed by lesbian feminists. As Karen Everett notes in her 1992 documentary *Framing Lesbian Fashion,* this perceived androgynous style became known as a uniform and was a way for lesbians to identify one another in solidarity. To most lesbian feminists, this style spoke about self-identity and belonging to the sisterhood and the women's liberation movement. As Arlene Stein writes, 'In a world where feminist energies were channelled into the creation of battered women's shelters, anti-pornography campaigns, or women's festivals, primping or fussing over your hair was strictly taboo.'[36] According to Barbara Creed, lesbians who rejected the feminist model of androgyny were given a difficult time: 'Some of us who refused the lesbian uniform were labelled heterosexual lesbians, an interesting concept that constructs a lesbian as an impossibility.'[37]

Mainstream fashion also drew inspiration from the subversive image of the an-drogyne with slicked-back hair and mannish suit photographed by Helmut Newtown. The image, which draws on the erotic representation of Marlene Dietrich, is shot in the dimly lit street and contains suggestions of desire and power. Designed in 1966 by Yves Saint Laurent, *Le Smoking,* which drew inspiration from popular culture and the women's movement, was the first of its kind to earn attention in the fashion world. *Le Smoking* was designed as part of Saint Laurent's Pop Art collection, in

the shape of a black jacket and trousers in *grain de poudre* with four button-down pockets and a straight-cut, high-waisted satin version over a white organdie blouse. The suit was adored by a chic collective of style icons including Catherine Deneuve, Betty Catroux, Françoise Hardy, Liza Minelli, LouLou de la Falaise, Lauren Bacall and Bianca Jagger.

The women's movement was not the only defining event that affected the lives of lesbian women; on 27 June 1969, patrons of the Stonewall Inn, a Greenwich Village bar popular with drag queens and lesbians in New York, responded to a police raid by throwing beer cans and bottles. Angry at police surveillance of their private lives, a crowd of 2,000 battled 400 uniformed police; the fighting lasted two nights and became known as the Stonewall riots. Stonewall was an important event in the lives of the lesbian community, but it was butch dykes that were arrested; they were the ones who were visible because of the way that they were dressed. Stonewall marked an important milestone in the lesbian, gay, bisexual and transgender (LGBT) liberation movement and represented a symbolic end to victim status. The riots received little publicity in mainstream media in the United States, but the emerging gay liberation movement captured the significance of the Stonewall rebellion within a year and turned it into an emblem of defiance of hetero norms. Gay liberation ideas soon spread overseas and began to proliferate; in Australia, the Stonewall legacy of gay pride soon became an important aspect of the LGBT movement's sense of identity, but there was no commemoration of Stonewall in Australia until 1978 with the establishment of the Sydney Gay and Lesbian Mardi Gras. This three-week festival of LGBT culture—arts, sports, debate—held during February culminates with a street parade complete with music, floats, costumes and dancing. Since 1991, the parade along Oxford Street has been lead by Dykes on Bikes, whose logo, Ride with Pride, is emblazoned on colourful banners amongst the rainbow flags. Dressed in leather pants or riding chaps, motorcycle boots and other leather accessories such as studded collars and wristbands, harnesses, corsets and leather caps, the women, who often ride topless or wear leather bras, have become a symbol of LGBT pride, defiance, liberation and empowerment.

Considered the largest LGBT event in the world, the Mardi Gras is a site where lesbian style and identities are performed, celebrated and made visible to the wider audience and community through media dissemination. Although the event appears to be all spectacle and glamour, with outrageous floats and costumes, it also has a serious political purpose: to achieve same-sex law reform in New South Wales, acceptance and equality. Although Oxford Street is considered a 'pink' precinct with LGBT venues, it has only been recently that lesbians have enjoyed the freedom and visibility of an 'out' lesbian club and bar culture, where diversity amongst lesbian women, whether stone or diesel butch or lipstick femme, and their associated dress styles are supported and encouraged.

Many feminist lesbians of the 1960s and 1970s also associated gendered fashion as a return to the strictly coded butch-femme culture of the 1930s, 1940s and

1950s, of 'forbidden love in smoky bars'.[38] This politically correct feminist style, which first applied to identifiable butches and later to all women, was interpreted by mainstream culture as either women wanting to be men—they were seen as aspiring to 'maleness' in their appearance—or *all* feminists were 'man hating, bra burning, hairy lesbians' and sexual outlaws of a kind. Even this cultural definition was and continues to be extremely useful because, as Elizabeth Wilson explains in her article 'Forbidden Love', it places women in a position to destabilize, by their very existence, the categories of male and female and to challenge the social construction of gender roles.[39]

Cross-dressing and Androgynous Style

By the 1980s, the blurring of gender and sexual boundaries had become prevalent across a range of entertainment mediums, from fashion catwalks to pop music, especially the so-called New Romantics. With the epithet taken from a line in the Duran Duran hit 'Planet Earth' (1981), the members of this group are not fixed but rather relate to the flamboyant, pretty-faced, mullet-hair style that began around 1980. Bands that are referred to under the New Romantic banner include Ultravox, Visage, Duran Duran, Spandau Ballet, ABC and Adam and the Ants. In terms of style, the New Romantics often dressed in counter-sexual or androgynous clothing and wore cosmetics such as eyeliner and lipstick. This gender bending was particularly evident in musicians such as Boy George of Culture Club and Marilyn (Peter Robinson). The style was based on romantic themes, including frilly fop shirts, in the style of the English Romantic period, Russian constructivism, Bonnie Prince Charlie, French Incroyables and 1930s cabaret, with hairstyles such as quiffs, mullets and wedges.

In cinema, the 1980s produced cross-dressing classics such as *Victor/Victoria* (1982), starring Julie Andrews as a struggling soprano in 1930s Paris who pretends to be a man pretending to be a woman and gets a job as a female impersonator in a nightclub, and *Yentl* (1983) starring gay icon Barbara Streisand. *Yentl* is based on the story of a young Jewish girl who dresses as a man and enters religious training. While Streisand probably did not have lesbianism on her mind, notions of supplementarity and alteration are central to queer style.

Many scholars have noted that butch-femme pairing, perceived in the 1960s by feminist lesbians as oppressive and mimicking masculine and feminine roles, became prominent again in the 1980s. Young lesbians began to reconceptualize role-playing and the stylistic cues that accompany gender identities and envisioned these roles as challenging dominant culture. The resurgence of the butch-femme binary, writes Alice Solomon, 'was marked primarily by a playful reassertion of sexual freedom through gender switching, cross-dressing, and gendered role playing'.[40]

Celebrities such as Madonna, the quintessential female fashion and gay icon of the 1980s, reinforced gender ambiguity in her performances by traversing the space

between the sexual mainstream and the sexual fringes of culture. Her 1990 video for her song 'Vogue' (recently revived in multiplex splendour at the 2012 Super Bowl) celebrated queer subcultural style and was a tribute to the underground dance form known as vogueing, which first found popularity in gay bars and discos of New York City. Consciously referencing gay and lesbian discourses and lifestyle in her work, Madonna signified (and continued to do so well into the 1990s) an affirmation of lesbian (and gay) culture as well as contributed to the politics of queer identity and sex.

As a fashion icon, Madonna constantly reinvented herself with codes and signifiers of lesbian style and identity. Her performances both on stage and in video clips were explicitly homoerotic, pastiching Hollywood icons such as Marlene Dietrich and Greta Garbo. In many ways, Madonna made intertextuality and homage familiar to every rapt teenager willing to take her work in. 'Where else, apart from a Madonna video', asks Sonya Andermaher, 'can millions of women see two women kissing on prime-time television?'[41] Madonna was both butch and femme with a stylized edge, constantly reinventing and embracing a look that asserted sexual and physical autonomy. When Madonna first came out in the 1980s, she was clothed in leather and accessorized with religious effigies draped around her neck, bows, lace and fishnet stockings. She was a stylized virginal rebel with platinum locks and a fashion sense that was a slew of edgy plus girly.

This material girl image later morphed into a dominatrix when Jean Paul Gaultier designed her the corset cone-bra for her Blond Ambition tour of 1990. The pink corset over a stylized version of a man's suit made reference to both the breasts and the phallus. In the interval of a decade, Madonna transmogrified from virgin to dominatrix to *Überfrau,* each time achieving iconic status. Until then only Bowie had multi-morphed; Madonna was the first woman to do so—and with mainstream panache and approbation. According to Andermaher, this über-femininity 'could be intimidating as well as seductive, reinforcing the fluidity of gender identities, and taking control of their identities'.[42] The best term to describe this subversive feminine, quasi-macho performance is *gender fuck.* The term was used in the 1970s and was applied to the music celebrities of the 1980s; however, the term *gender bender* was far more widely used. Transgressive music celebrities such as Adam Ant, Boy George and Marilyn and bands like Duran Duran and Spandau Ballet gained global popularity with their flirtation with the dissolution of sartorial codes. Along with the emergence of MTV (launched in 1981), the entertainment industry recognized the value of fashion and style as forms of visual codification in gaining audience popularity. As Andermaher states, 'At both ends of the fashion spectrum, couture and subcultural style, there is a space for experimentation, for transgression and revolt.'[43]

Madonna's popularity as a lesbian icon was endorsed by her obsession with drag and camp. Drag is the personification of the instability of gender par excellence, where masculine and feminine signs reveal both dress and gender as performance and masquerade. As Judith Butler argues in the same vein, 'There is no original or

primary gender that drag imitates, but gender is a kind of imitation for which there is no original.'[44] Within the context of lesbian culture, Madonna's deployment of drag (and camp) as a disguise, as simulation and artifice, acts as a mode of engagement with her audience, whilst simultaneously positioning her inside and outside of culture, straddling sexual borders.

'Justify My Love', recorded by Sire Records in 1990, is perhaps Madonna's most explicitly gay video recording. Populated by a cast of actors playing lesbian roles and sex workers, the song is a celebration of euphoric polymorphous sexuality. As Andermaher notes, 'Made up of a series of camp erotic tableaux', its androgynous, sexually and racially varied figures almost float through the scene, coming together to touch, kiss and flirt and move gracefully apart.'[45]

Banned by MTV because of its sexual explicitness, the music video was filmed in grainy black-and-white in the style of German Expressionist film, 1940s film noir and the European auteurs of the 1960s (who themselves were inspired by American noir). There are numerous subliminal and overt references to early film, not least in describing figures only as silhouettes. Much of the imagery evokes Isherwood's *Goodbye to Berlin* (1939), which includes a similar cast of characters. The action takes place in an elegant hotel that caters to alternative lifestyle couples. Madonna's character enters looking tired and distressed as she walks down the hallway toward her room. There she has a romantic fling with a mysterious man. Some of the doors to the other rooms are ajar, and we catch glimpses of various couples cavorting in fetish outfits: leather, latex bodysuits and corsets.

The stage performance of 'Justify My Love' as part of the Girlie Show tour (1993) contained visual themes and props reminiscent of the big top circus, but in this case, it was a sex circus. Rock concert, fashion show, carnival performance, cabaret act and burlesque show all in one, the concert's costumes for the tour were designed by Italian fashion house Dolce & Gabbana. Borrowing stylistic cues from nineteenth-century gentlemen's fashion, Madonna appears on stage as a Victorian dandy complete with attention to details such as an opera top hat, gloves, a lace-cuffed shirt, monocle and silk cape, cravat and waistcoat. Partially cross-dressed, Madonna is also wearing a black satin, tiered skirt and leather lace-up boots, conjuring a mythological half-man/half-women demi-god whilst simultaneously alluding to the power invested in phallic women. At the same time, Madonna's costume draws on the legends and curiosities of the circus sideshows and so-called freak shows of the nineteenth and twentieth centuries. The show's back-up vocalists and cast are also dressed in Victorian gentlemanly stylishness with narrow trousers, short coats and wooden canes and play with visual codes of fantasy and provocation, power, style and gesture in their performance. In 'Dandyism, Visual Games and the Strategies of Representation', Olga Vainshtein notes, 'In the early nineteenth century, the mannered accessory was central to a gentleman's appearance. The survival of the monocle into the twentieth century was noted for upper-class gentlemen as well as Sapphic ladies and women of great style.'[46]

Drag and androgyny, with its obsession to details, grooming, gestures, accessories and cosmetics, also highlight the contradictory qualities of fashion. Androgyny had been fashionable many times in history, but it was not until the 1990s that lesbian and bisexual women embraced androgynous style as a political force in queer culture. Until then, cross-dressing had been a recurrent theme in lesbian culture; however, it was closely aligned to sexual disorder or perversion and was bound to marginal underground identities.[47] Even though the history of cross-dressing is bound to gay and lesbian identity, in terms of 'drag' and 'voguing', argues Marjorie Garber in her analysis of cross-dressing as a site of cultural anxiety, studies fail to take into account the foundational role that they have played in queer identity and queer style.[48]

In 1984, Annie Lennox, the vocalist for the pop duo Eurythmics (with Dave Stewart), appeared at the annual Grammy Awards as the reincarnation of Elvis Presley. Wearing a black suit, white leather belt, silk, black shirt and a gold knit lamé tie, along with Presleyesque bouffant and facial hair, Lennox was impersonating the king of rock and roll himself as she stepped onto the stage to perform her musical hit 'Sweet Dreams (Are Made of This)'. As a rock god, Elvis is instantly recognizable by his performance, which involves gyrating his pelvis and wearing elaborately sequinned and embroidered costumes. What can best be described as a diva/camp moment, Annie Lennox, via her gender-bending performance, became an instant gay icon. Lennox's androgynous style, which drew parallels between her and male performers Boy George and David Bowie, was characterized by her endless transformations, constantly reinventing herself with various masculine and feminine personas: as a high-class, blond call girl; as Earl, a working-class Elvis lookalike with a confident charm; as a sexually repressed housewife; as a camp angel in a French rococo drama; and as an SM dominatrix—characters that have become quintessential drag king personas. Drag performance, writes Judith Butler, women dressing as men and vice versa, can be seen as a strategy of resistance and subversion, for drag is not an 'imitation of gender', she argues; rather it 'dramatize[s] the signifying gestures through which gender itself is established'.[49] And as Richard Middleton remarks, 'By the middle of the middle of the decade [1980s], particularly male style for girls, was ubiquitous fashion.'[50]

In the promotional video for 'Sweet Dreams (Are Made of This)', Lennox appears cross-dressed in a corporate boardroom wearing a dark conservative business suit, black, leather gloves and a flaming orange crew-cut hairstyle. Lennox may have dressed as a man, but she also performed as a woman dressed as a man dressed as a woman. She played with traditional signs of femininity (dresses, aprons and lace) and juxtaposed these markers with a raunchy, confident sexuality (black leather, studded cat suit). The sexual ambiguity prevalent in the Lennox's performance style is, as Garber points out, a type of subversive behaviour that was prevalent and popular, especially with cross-dressing girls in the 1980s.[51] Emerging from the social consciousness–raising movements of the 1960s and 1970s, feminism, civil rights and the rising influence of gay lifestyle politics, gender-bending possessed enormous

influence in popular culture and paved the road for greater diversity in representations of sexuality. As Lennox states, 'When I started wearing mannish clothes on stage, I tried to transcend that emphasis on sexuality. Ironically, a different kind of sexuality emerged from that. I wasn't particularly concerned with bending genders, I simply wanted to get away from wearing cutsie-pie miniskirts and tacky cutaway push-ups.'[52]

In her essay 'Drag, Camp and Gender Subversion in the Music and Videos of Annie Lennox', Gillian Rodger examines Lennox's earliest performance strategies and argues that her music video clips are essentially ideals of music hall and other theatrical performances of the late nineteenth and twentieth centuries (music hall drag artists, opera castrati, pantomime, boy actors, etc.) deployed to challenge twentieth-century gender construction. 'Unlike Madonna, Lennox did not seem to cite Marlene Dietrich, or the mannish lesbian figure of the 1930...instead she virtually transformed herself into male characters that were not always recognisable as Lennox to audiences.'[53]

Performers such as Madonna and Annie Lennox, with their fashionable androgynous style, became poster girls for a generation of lesbian women who were looking towards popular culture for style icons and positive role models. References to lesbianism have long been rife in popular culture, from singer/song writer Melissa Etheridge, who began performing in lesbian bars in Los Angeles in the 1980s (she is a gay rights activist who came out publically in 1993) and Tracy Chapman, to Madonna, who shared a passionate kiss in 1993 with her backup vocalist on the Girlie Show tour, to tennis player Martina Navratilova, who announced in 2010 that she was a lesbian. Until the 1980s, fashion was one of the most important signifiers of lesbian sexuality and consisted of clear definitions of identities such as femme and butch. Many women in the 1970s and 1980s played an active part in the second wave feminist movement and wanted to reject dominant models of femininity. In the words of Joanne Entwistle and Elizabeth Wilson, 'Feminist lesbians, visibly fought fashion as a constraining and feminizing force of capitalism and heteropatriarchy although fashion has always had a place within femme lesbian and bisexual cultures.'[54]

Lesbian style and desirability was embodied by such style icons as butch country singer k.d. lang, who appeared in 1992 on an American late-night talk show hosted by Arsenio Hall wearing a long, lacy gown (and no shoes) to sing the song 'Miss Chatelaine'. Lang, who was known at that point in her career as an 'out' lesbian, shocked Hall and television audiences alike who expected her to appear and perform in butch attire. Lang's femme-ness was a conscious political strategy of self-representation that was deployed by lang to debunk cultural stereotypes about lesbians—the way they look, behave and dress. In 1990, a young lang appeared in the ongoing Gap advertisement campaign 'Individuals of Style', photographed by Herb Ritts. She wore Gap stonewashed denim jeans and jacket and cowboy boots and looked dreamily out to the distance. Lang's image spoke to a generation of lesbians about popular fashion and style. To stone butches, she was a fashion icon to mimic

and admire; to femmes, she was a heartthrob pin-up girl to fantasize about and swoon over. Lang relied on fashionable garments and accessories to visually represent and articulate a queer identity, often appearing on stage crossed-dressed in masculine attire, whilst her performative style was inscribed with lesbian meaning. Arlene Stein wrote that lang was 'probably the butchest woman entertainer since Gladys Bentley',[55] and *Vanity Fair* journalist Leslie Bennetts described her in the following way:

> This was a woman who was clearly born to perform. Not that you'd necessarily know she's a woman at first sight. Tall and broad shouldered, wearing a black cutaway coat flecked with gold, black pants, her favourite steeled-toed black rubber shit-kicker work boots, she looks more like a cowboy.[56]

Lang's 1993 appearance with supermodel Cindy Crawford on the cover of the August issue of *Vanity Fair,* also photographed by Ritts, is another example of lang 'camping on her butchness'.[57] Dressed in a three-piece pinstriped suit, tie and brogues, lang sits on a traditional barber's chair whilst being shaved by supermodel (and straight) Cindy Crawford, who is dressed in a maillot. The *Vanity Fair* cover spread was a result of a growing trend in popular culture: lesbianism had become fashionable. As Entwistle and Wilson note, the media frenzy over 'lesbian chic was possibly fuelled by panic over the erosion of visible differentiation between straight and queer women'. Middle-class women have been inspired to 'reclaim fashion, and to muscle in on some of the "boyz fun" organized around the plethora of new clubs and bars'.[58]

Designer Dykes and Lesbian Chic

> We've arrived. The postmodern lesbian: not only butch and not totally lipstick chic but definitely demographically desirable—and Showtime's banking on it, big time. It's called *The L Word.* That's right, folks, L for lesbian—say it out loud, say it proud. We are about to become as common as that household phrase *Queer Eye for the Straight Guy.*
>
> —Kate Nielson[59]

By the early 1990s, lesbian style ascendancy was so entrenched in glamour that the French declared lesbians as officially chic, and terms such as *lipstick lesbian, neo-femme, stone* and *diesel butch* began gaining currency as fully fledged identity categories. Lesbian sexuality began to break free from the restrictive binary of femme-butch and began to explore the boundaries of representations (via dress, accessories and stylistic codes) in mainstream and underground culture. After her visit to the lesbian sauna Dykes Delight in London, Isabelle Wolff wrote in a June 1993 copy of the *Evening Standard,* 'Forget the old dungarees image, the latest lesbians are bright, chic and glamorous…Everywhere you look, the joys of dykedom are

being vigorously and joyfully extolled.'[60] As Guy Trebay pointed out in the *New York Times* article 'The Secret Power of Lesbian Style',[61] many of America's street fashion mavens are lesbians, with spiky haircuts, chain wallets, trucker hats and cargo pants.

When Showtime's *The L Word* debuted in 2004, many lesbian viewers complained that the characters were all too 'femmey' and that the fashion was too unrealistic. Viewers argued that rather than being inclusive of all women, regardless of class and ethnicity, the cast of lesbians was depicted as glamorous, middle-class professionals with the occasional token Asian, black American or Latino American lesbian added for political correctness. Cynthia Summers, costume designer for the series, stated that the show's creator and executive producer, Ilene Chaiken, wanted *The L Word* to be a show that spoke about fashion.

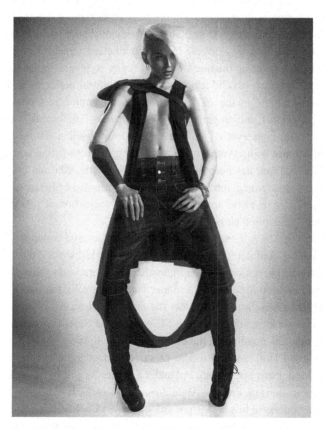

Fig. 2.4 Lesbian chic: pants, Opus 9 by Justine Taylor, Alexander McQueen jacket, A.F. Vandervorst boots, Chanel bracelet, Raphael Mhashilkar crystal pendant. Credits: photographer Michele Aboud, stylist Bex Sheers, make-up Angie Barton, hair Alan White, model Anna@CHIC Management.

The series is based on the lives and loves of a group of mostly lesbian friends who are glamorously affluent and ambitious, some talented and others creative, and living in Los Angeles. The cast, which consists of butch and femme characters, who are both gay and straight, depicts a sexually flexible style that can be characterized as L.A. Tomboy. The narrative of lesbian fashion and style marks an important aspect of understanding lesbian visibility (or invisibility) as a form of subcultural identity. As Aviva Dove-Viebahn writes, 'The unease born out of the overwhelming feminin- ity of the lesbians in *The L Word* originates from the extraordinary emphasis placed within the lesbian community on a style that runs counter to mainstream notions of women's fashion.'[62] Historically, femme lesbians were rendered invisible, whilst butch lesbians were deemed anti-feminine and anti-feminist because of their appro- priation of masculine style. Broadly speaking, mostly women who dressed in men's clothes, often termed *sexual inverts,* could be visibly distinguished from heterosex- ual women. Femme lesbians could always pass as straight and were often viewed by butch lesbians as women who sexually experimented with women but eventually would go back to the security offered by men in a heterosexual relationship.

Sue-Ellen Case takes up the question of a lesbian style and argues that butch and femme sexual styles are a valid aspect of lesbian cultural heritage. With the rise of second-wave feminism in the 1970s, the butch and femme role-playing that was a prominent aspect of lesbian bar culture of the 1940s, 1950s and 1960s was con- sidered backward, conservative and anachronistic by lesbian feminists, who were in favour of a more androgynous style, consisting of loose-fitting and comfortable clothes.[63] This position has been taken up by Joan Nestle, who not only challenges the assumption that femme and butch styles were imitative of heterosexuality sanc- tioned by patriarchy but also argues that feminism's rejection of role-play is tied to issues of race, gender and class.

The success of *The L Word,* which ran for six seasons and ended in 2009, rests in its portrayal of the confident, upwardly mobile lipstick lesbian and the designer dyke and their material successes. All the main characters are young and glamorous and are styled and dressed in high-end designer labels. Bette Porter, played by Jennifer Beals, an art museum director and later the dean of the school of art, is styled in a tailored menswear look, often wearing Max Mara and Balenciaga and occasionally dresses and skirts, depending on the occasion. Her long-time partner, Tina Kennard, played by Laurel Holloman, is a film producer whose signature style is best de- scribed as casual, jeans and a black bra under a white shirt, or business, tailored suits or flowing jersey and silk dresses. Alice Pieszecki (Leicha Hailey), the only bisexual on the series, is dressed in sexy, bright colours, often Cacharel or Marc Jacobs. The character Shane McCutcheon, a troubled and promiscuous hairdresser played by Katherine Moening, is styled in a rock chick look, which is loosely based on glam rock icon Mick Jagger. With wild, shaggy hair, tight-fitting blue jeans, vintage T-shirts and loose, white shirts under a black dinner jacket, Shane represents the butch character on the show. Meanwhile, Kit Porter (Pam Grier), Bette's half-sister and the

only straight member of the group, is styled in what can be described as a bohemian vibe look—sarongs worn over jeans, for example. Whilst the characters have their own individual styles, they are neither completely femme nor butch but represent ideas of conventional beauty and versions of mainstream femininity.

The discourse of lesbian chic, a media-constructed phenomenon of the 1990s and a fashion advertising and marketing trend, placed lesbian identity on the mainstream cultural landscape and produced a particular lesbian representation whilst erasing others. Some critics argue that the emergence of the lipstick lesbian, or the femme, has normalized, heterosexualized or even 'straightened out' lesbian sexuality in order to become more palatable to a straight audience. The butch lesbian, who has been associated in the cultural imagination with the idea of lesbianism, is erased, diluted or feminized, as in the case of Shane McCutcheon of *The L Word*. On the other hand, scholars such as Eve Kosofsky Sedgwick advocate that representations of lesbianism, such as those found on *The L Word*, are daring because of their normalcy. The show is appealing because it portrays a community of women and a variety of diverse interweaving narratives rather than one or two token lesbian characters. Despite the show's racial and generational gaps, 'a visible world in which lesbians exist in forms beyond the solitary and the couple, sustain and develop relations among themselves of difference and commonality...seems, in a way, such an obvious and modest representational need that it should not be a novelty when it is met'.[64]

What is of importance in any critique of lesbian chic is that it raises (or does not raise) issues concerning the construction of beauty, glamour, gender, sexuality and style. The masculinized power wielded by this new, attractive and assertive women demanded that she be incorporated into heteronormativity because she was not amenable to it. Imbued with a dynamism that melded traditional femininity with assertiveness, writes Linda Dittmar, this woman evoked lesbian codes of quasi-cross-dressing and female bonding but remained open to heterosexual readings of power dressing and cosmopolitan sophistication. Rendered both queer and safe, Dittmar points out, 'This new chic at once allowed heterosexuals the *frisson* of bisexual and lesbian desire, and opened up for lesbians—notable middle class and upwardly mobile white lesbians—a hospitable new space for self definition.'[65]

Several critics have argued that the construction of a lesbian chic by marketers is due in part with the rise of income, social mobility and class standing amongst lesbian women since the 1980s. A *New York Times Magazine* (1982) article reported that the peak advertisers were attracting the lesbian market. High-end magazines *Vogue, Newsweek, Cosmopolitan* and *Esquire* also echoed such findings, and *The Wall Street Journal* confirmed this in 1994 with the article 'More Marketers Aiming Ads at Lesbians'. In her article 'The Straight Goods. Lesbian Chic and Identity Capital on a Not-So-Queer Planet', Dittmar writes that this new lesbian look called *chic* is a category defined by class, not sexuality, and its main purpose is to encode power and to give women a place at the crossroads of femininity and authority. As Dittmar writes, 'Like so many other cultural products which sustain our economy and safeguard

dominant ideology, the sartorial design and photography that constitutes the "lesbian chic" phenomenon absorbs lesbians into heterosexuality even as they invite straight women to tour lesbian terrains.'[66] High-end designer brands such as Ralph Lauren, Gucci, Ungaro, Clavin Klein and Prada, to name a few, took the opportunity to market their designs to appeal to a lesbian sartorial taste. This media-hyped style contained codes and subtexts that corresponded to lesbian subculture whilst simultaneously reached out to a dominant heterosexual market.

In the 1990s, Calvin Klein was looking for an androgynous model to represent his new scent, CK One, and enlisted Japanese American supermodel Jenny Shimizu. A former mechanic, Shimizu went on to model for Versace, Anna Sui, Prada, Jean Paul Gaultier and Yohji Yamamoto and was featured in beauty campaigns for Clinique and Shiseido. The scent was tagged as 'the fragrance for a man or a woman.

Fig. 2.5 Lesbian chic: pants, Opus 9 by Justine Taylor, Alexander McQueen jacket, A.F. Vandervorst boots, Chanel bracelet, Raphael Mhashilkar crystal pendant. Credits: photographer Michele Aboud, stylist Bex Sheers, make-up Angie Barton, hair Alan White, model Anna@CHIC Management.

A fragrance for everyone', and the black-and-white media campaign featured young, hip, androgynous models casually conversing in small groups and laughing coyly at the camera. The script reads, 'The sexy one, the nasty one, the wild one, the male one, the female one, CK One, a fragrance for everyone.' The advertisement ends with Shimizu, who is dressed in faded, blue Calvin Klein jeans, a white, masculine singlet and a black leather wristband and has a large tattoo of a woman astride a giant phallic wrench on her bicep. Shimizu's appeal lay in her assertive and confident androgynous femininity, which became representative of butch style in the lesbian club culture of the 1990s but was also indicative of a lesbian chic that was being circulated in mainstream media.

In the May 1993 issue of *New York Times Magazine*, Jeanie Kasindorf's article on lesbian chic describes a lesbian bar called Henrietta Hudson in New York City:

> Outside the front stands the bouncer, a short young woman with a shaved head and a broad, square body. She is covered in loose black cotton pants, and looks like an out-of-shape kung fu instructor... [Inside] sits a young woman straight from a Brooks Brothers catalogue—wearing a conservative plaid jacket and matching knee high pleated skirt, a white blouse with a peter pan collar, and a strand of pearls. She chats with her lover while they sip white wine and rub each other's backs. Across from them, at the bar, sits a group of young women in jeans and black leather, all cropped hair... The Brooks Brothers woman and her lover leave, and are replaced by two 26-year-old women with the same scrubbed, girl-next-door good looks.[67]

The bouncer is coded with butch and masculine signifiers; her 'shaved head and broad, square body' is marked as undesirable, shapeless and menacing. 'An out-of-shape kung fu instructor' rather than feminine, curved, warm and inviting like the lesbians inside the bar. A binary of outside/inside is firmly established of what are acceptable and desirable in lesbian looks and beauty. The description of the lesbians inside the bar as Brooks Brothers women equates lesbian looks with consumption and as ideal fashionable icons on the pages of a shopping catalogue. As Sherrie Inness states, 'By emphasizing that lesbians are beautiful, well dressed, and born to shop... writers build up an image of lesbians as being "just like us", in other words, "homosexual = heterosexual."'[68]

Lesbian and queer lifestyle media did not remain immune to the hype that surrounded this new mediated identity. Reina Lewis and Katrina Rolley state, 'For lesbian magazines, which often inherited a feminist perspective, the inclusion of fashion was a conspicuous departure from previous feminist publications, whose opposition to the fashion industry is legendary.'[69] Magazines such as *Diva, Girlfriend, OUT/LOOK* and *Curve* (formally *Deneuve*) had an ambivalent attitude towards fashion imagery and spending, and emphasized images of women participating in everyday activities. They portrayed women playing sports, gardening, hanging around the park, tinkering under the bonnet of their cars, playing pool or relaxing by the pool or

the beach. The models pose casually, immersed in their activities with an air of indifference to the camera. By and large, 'the images appearing in magazines targeted to lesbian readers', writes Dittmar, 'are indifferent to the corporate chic of mainstream magazines'.[70] It must also be noted that in these images the majority of the women engaged in an aspirational lifestyle, whether skiing in the Alps or holidaying in Asia, are white and middle class. Whether straight or queer, when acknowledged, the Other is exoticized; as Dittmar writes, '*Vogue* and its counterparts continue to give us the tigress, slave, tribal woman and the other myths of the primitive, while *Curve* and its companions give us the ghetto kid, queen of the blues, and the bulldagger menace.'[71] Even lesbian photography posits whiteness as the norm.

This is not to say that the queer press regulates lesbian style or that lesbians do not participate in mainstream fashion magazines' construction of a lesbian subjectivity (albeit a femme one) via viewing positions. Writers have commented on how lesbian viewers of fashion magazines respond to images of women as narcissistic and objectifying. While editorials of women are intended to invoke buying power and promote consumption, for the lesbian viewer the photographs may also evoke desire for the image and desire to be the image. If the lesbian gaze is based on recognition and identification, then the pleasure of looking is simultaneously experienced with the pleasure of being looked at by another woman.[72] As Lewis and Rolley observe, 'The self-consciously lesbian viewer can take what the codes of the magazine offer and add to that an extra-textual knowledge that presumes the existence of other lesbian readers'.[73] This is different from Mulvey's conception of the male gaze; the lesbian gaze is not collapsed into the male even if the photography, company or destined audience is male. Rather, the lesbian gaze creates an elsewhere that is transgressive and liberating for its narcissism.[74]

This analysis can also be applied to the pleasures of looking at films which depict lesbian characters and story lines such as *When Night is Falling* (1996), described by *Premiere* magazine as an 'unabashed lipstick lesbian feast, with women who look like goddesses rolling around in crushed velvet'[75] and the neo-noir crime thriller *Bound* (1996), directed by the Wachowski brothers, about a woman (Jennifer Tilly) who longs to escape her relationship with her Mafia boyfriend (Joe Pantoliano). When she meets the alluring ex-prison inmate (Gina Gershon) hired to renovate the next-door apartment, the two women begin an affair and hatch a scheme to steal two million dollars of Mafia money. Such films are intended for mainstream audiences, but star lesbian characters and are coded with lesbian plots.

Inevitably, lesbian style is influenced by mainstream fashion and the trends that appear in popular culture; in fashion magazines, on the film screen, in advertisements and on the catwalks. In the late twentieth- and twenty-first centuries, politics has become more diversified, and the divide between butch and femme identities has become blurred and watered down.

–3–

Gay Men's Style: From Macaroni to Metrosexual

Yankee Doodle went to town
A-riding on a pony
Stuck a feather in his hat
And called it macaroni.

Most of us today, when we hear this famous revolutionary hymn, immediately associate macaroni with small, curving, tubular pasta. But the connotation here is quite specifically linked to a particular form of men's fashion associated with affectation and effeminacy. Macaronis of Yankee Doodle's day wore outlandish wigs that rivalled their female counterparts, applied excessive make-up such as extra beauty marks and rouge, and were unsparing in their love of sumptuous, garish clothing. As such, *macaroni* was a pejorative term for what went beyond the ordinary bounds of fashion. As the literature of the day tells us, macaronis were much the same as fops, who are the closest equivalents in the eighteenth century to queens, gays and queers. But Yankee Doodle was far from gay, as the next verse indicates: 'Yankee Doodle, keep it up/Yankee Doodle dandy/Mind the music and the step/And with the girls be handy'. Yankee Doodle was just playing at something more flamboyant. It is also believed that the song was started by the English to mock the rustic simplicity of Americans who may have thought that such small embellishments were sufficient to make them elaborate gentlemen.

It is one of the most telling ironies underlying the difficulty in giving gay men's style sharp contours that the names cited in the title to this chapter are not confined to male homosexuality as such. But we also see this as important, as gay men's style has always grappled in different ways with the perception—some even see as a debilitating cliché, a stigma—of effeminacy. The corollary of effeminacy with being gay has been, in the past two centuries, more than contingent, and has become portrayed as the most distinguishing feature, even if the quality cannot be essentialized. While this chapter will of course hover around the subject, the more compelling areas of focus are the ways in which being gay comes to inhabit particular styles that are not distinctively gay, changing them slightly but not entirely. A common thread is that, in the main, gay men wish to be recognized within the zone of maleness, while also not needing to succumb to the ignominy of assimilation and surreptitiousness. This

need to remain other but also be part of the one has been a constant source of conflict for gay men's identity and dress, for gay and non-gay alike.

Queer style as it emerged from early modernity did not have the same level of connections with homosexuality as it does today. This was because homosexuality had not, in its strictest sociological and psychological sense, yet been invented. Buggery and sodomy were still of course widely practised and also subject to grim persecution. But there are some fundamental distinctions to be made here that reflect the evolution of the concepts of self, gender and society. Until the nineteenth century, buggery did not distinguish the sexes. Its criminality was based on the connection between flagrant excess and gratuitous, unproductive pleasure. Sodomy was not part of the reproductive function and was thus an act spirited by the devil. But it is with the conjunction of the perception of a genital fixation and psychological illness that male homosexuality becomes a social quantity, be it as a threat to society or as a certain quality of person who expresses himself with a particular style. Effeminacy, the most common and clichéd marker of homosexuality in men, is no longer a trait as in the eighteenth-century fop or the French equivalent, *un fat*; it comes to be seen as the fundamental register of an anthropological condition. This is the difference between the premodern and modern era. Here we might recall Foucault's observation that it was only in the late nineteenth century that homosexuality appeared as 'a species' whose structure in society holds sway today. It is from this period onward that is the substance of this chapter, which is preceded by a short examination of the macaroni and the birth of the dandy in the late eighteenth century.

Macaronis and Fops

The term for the particular form of male style from the late eighteenth century, *macaroni* (or *maccaroni*), did in fact come from eating pasta (the Greek *makaria* literally means 'food made from barley'), which had become fashionable in the 1760s through men who had returned to England after exploring the European continent, especially Italy, on the Grand Tour. Macaronis typically took pains to announce their difference in outlandish examples of foreign clothing that was either foreign—French and Italian—or alluded to being foreign, while celebrating their common fealty by a club of the same name. To belong to the macaroni club, one had to be credentialed with the sufficiently worldly experience of having travelled and to have a commitment to clothing that was not the more restrained form of English tailoring. Despite the familiar paradox that the English loving French tailors and the French loving the English persisted irrespective of political enmity, English fashion was largely one that presided over a rural perspective whose simplicity reflected its utility. As opposed to French aristocracy, which was predominately urban—Louis XIV centralized the aristocracy in Versailles for his own personal control—the English

nobility were more evenly distributed across the country and still lived on their estates. The English gentry could avail themselves of filigree lace and ornate silk waistcoats, but it was not the rule since there was less onus to impress while living at home (only while holding parties and taking distinguished guests). From a cultural and philosophical perspective, the macaroni flew in the face of Rousseauian natural-ness and the English way of life by dressing in a way that made the most of over-played sophistication. In contrast to the eighteenth-century notion of taste—poise, balance and grace, all coalescing into the aloof yet sympathetic notion of courtly politesse—the macaroni insistently signified a way of functioning that was outside of his local social ambit in manners, dress, eating habits and more besides. The macaroni's appearance was anything but polite. By the early 1770s, he had swiftly reached the limits of tolerance, but this had not meant that he did not continue to excite fascination. The first issue of *The Macaroni and Theatrical Magazine* (1772) announced that 'the word Macaroni then changed its meaning to that of a person who exceeded the ordinary bounds of fashion; and is now justly used as a term of reproach to all ranks of people, indifferently, who fall into this absurdity'.[1] The magazine was a sort of macaroni-spotting gazette, for the interest in them was in inverse proportion to the actual numbers sighted on the streets, which were few. And as Amelia Rauser explains, illustrations of macaronis began to take a life of their own.[2] Taking style to its absurd limit, they lent themselves to caricature and were easy targets for opprobrium against social waywardness.

Macaroni fashion is a signal case study in the history of male gay fashion and of queer fashion in general. In many respects, it contains the imprint of the patterns it would follow until the present. For the macaroni literally inhabited a generic mould (a proto-clone), but in doing so found himself in conflict with the more moral and sober social codes of the day. In addition to having large hair, they saturated their appearance with accessories, from face patches to ribbons, while priding themselves on a slight bodily frame. The macaroni also encapsulates the false but abundantly in-sinuated equation between inauthenticity and effeminacy in gay men, despite the fact that macaronis seldom engaged in same-sex relations. Nonetheless, signs of sartorial artifice and wanton excess in form and in monetary expense were henceforward to take a hold on assumption. As Rauser suggests, in their day, rather than be perceived as our equivalent of gay, macaronis occupied a middle zone between what it meant to male and female.[3] They supplied the social prototype of the nineteenth-century typologizing of sexual invert as a woman in a man's body; neither one nor the other. (This idea would change its course substantially with the transsexuals and trans-gender individuals.)

There are other arguments that go much further than the sexual grey zone the-sis. In his detailed analysis of sexuality in eighteenth-century London, Randolph Trumbach finds that by the end of the seventeenth century, the rake, the libertine and the fop were categories without sharp definition, and all permitted of the possibility of same-sex relations. The sexual profligacies of the reign of Charles II gave way

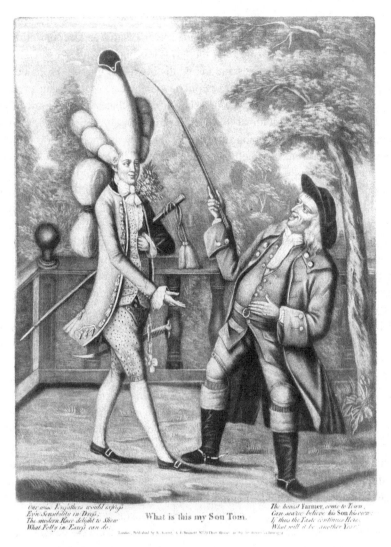

Our wise Forefathers would despise;
Even Sensibility in Dress,
The modern Race delight to Show
What Folly in Excess can do.

What is this my Son Tom.

The honest Farmer, come to Town,
Can scarce believe his Son his own;
If thus the Taste continues Here,
What will it be another Year?

London, Published by R. Sayer, & J. Bennett, N.º 53 Fleet Street...

Fig. 3.1 'What is this my son Tom?' Macaroni fashions of the 1770s. Courtesy: British Cartoon Collection, 1774.

to some broader speculation as to what maleness should be. In a slightly different category from the man of omnivorous carnal appetite was the effete, precious male who was roused suspicion for his lack of heroism—and the implication of being effete with ineffectuality still has currency today. With typical acerbity, the Duke de Saint-Simon supplies a portrait of Monsieur, the king's brother, whom he views as having all these undesirable traits, bedizened and so over dressed as to be all but unmaneuverable:

Monsieur was a short, potbellied man mounted on stilts, so high were his shoes, always adorned like a woman, covered with rings, bracelets, and jewels all over, with a long wig all exposed in front, black and powdered, and ribbons everywhere he could put them, full of all kinds of perfumes, and in every regard, cleanliness himself. He was accused of imperceptibly wearing rouge.[4]

Saint-Simon opines a travestied grandeur: he was in no way a 'great prince'.

Querulous observations like these yield more when viewed retrospectively. Manliness in the seventeenth century was defined by honour, wit and grace, qualities that, to modern eyes, could easily be misconstrued as queer. It is only at the beginning of the eighteenth century that male effeminacy began to be loosely, and only loosely, equated with same-sex desire. The so-called wedding date of effeminacy and homosexuality is tipped at the end of the nineteenth century.[5] In the seventeenth and eighteenth centuries, same-sex desire was not yet an individual category, since it was caught up with libertinage, which was the tendency to extreme promiscuity and sexual extravagance—the great Earl of Rochester, one-time friend of Charles II, immortalized in a film starring Johnny Depp, was the early epitome of this type and the epitome of how one was fated to end: Rochester's once-alluring face was carved up mercilessly by the ravages of syphilis, thus read as the disease having dealt him his moral comeuppance.

With new assumptions came new names—the molly and the queen—all of which were subcategories of the sodomite. Sodomy was henceforward the province of male relations. Male effeminacy became the standard by which maleness was measured.[6] On the other hand, however, Philip Carter argues that the fop was a social type different from the molly. As precursor to the modern dandy, he was a self-obsessed man disinclined to the more stringent laws of decency and thereby a threat to the polite, sociably gracious gentleman.[7]

Despite such conflicting views, the macaroni that appeared later became the archetype of aristocratic fecklessness. He was a symbol of mounting tensions between the aristocracy and the middle class, for whom morality and social responsibility were closely linked to notions of expediency and productivity. The macaroni was a strange breed of Enlightenment individualism, albeit on an exaggerated scale. In this regard, he anticipated Georg Simmel's famous observation that fashion is about both belonging and difference.[8] Of all the things that distinguished the macaroni, it was hair, the least functional part of the body. Wigs were trussed into gigantic, extravagant showpieces. The wig was one of the main accessories to the men's image in public life. Women, on the other hand, were expected use their own hair as the basis for their hairstyle, although it was helped along by more hair, padding and frame moulds. The sexual connotations latent within hair as signifier were foregrounded in macaroni hair but in a way as to confound sexual boundaries, since it competed with women's styles. A contemporary commentator quipped that macaroni hair, with its excessive powder and inordinate size, meant that 'grammarians are at a loss whether

to rank them with the masculine or feminine, and therefore put them down as the Doubtful Gender'.[9] Such speculations roused special interest with an outcrop of more magazines that stated the best ways for men to act, to be—guidebooks for gentlemen to behave respectably. Intrusive in appearance, macaronis were anything but polite. The gentleness of their effeminate ways was a perturbation of what was expected of the gentleman. The enormous hair of the pre-Revolutionary male would make its camp recrudescence in the annual New York celebration 'Wigstock', staged by the drag queen Lady Bunny (b. Jon Ingle, 1962) known for her Texan-cum-Marie Antoinette bouffant.

By any standard, the macaroni represented the final flush of extreme behaviour prior to the 'great male renunciation', to use the well-known phrase of J. C. Flügel. The macaroni was also the precursor of camp. For macaronis certainly had the qualities of play, irreverence and shock value. In the words of Susan Sontag,

> Camp responds particularly to the markedly attenuated and strongly exaggerated. The androgyne is certainly one of the great images of Camp sensibility. Examples: the swooning, slim, sinuous figures of pre-Raphaelite painting and poetry; the thin, flowing sexless bodies in Art Nouveau prints and posters.[10]

As we began to see in Chapter 1, the French Revolution stigmatized any form of dress or behaviour linked with aristocratic hedonism. It was at this time that both men's and women's clothing followed an idiom of thrift and restraint—by degrees, variations on classical themes, especially for women, who wore simplified muslin dresses and shifts. But as revealed in the discussion of Winckelmann, the revival of Greco-Roman ideals had implications that could easy spill into the homoerotic. For the images that were used as signal pieces for Revolutionary heroism and virtue, such as Jacques-Louis David's *Oath of the Horatii* (1784), were about solidarity between men, self-sacrifice, as in David's *Socrates* (1787), or their capacity for Republican virtue, as in his *Brutus* (1789). Stoicism, the clenched-jaw attitude to life, became an important public posture. Representationally speaking, the male revolutionary body had all the brawny solidity that bespoke a life of activity, of work and of war that had nothing to do with the effete indolence of aristocratic life. The latter marked its appearance, albeit in sublimated form in certain images, and no more evidently than in the work by Girodet-Trioson, *Endymion,* that appeared to great praise in the Salon of 1791. The winsomely languorous beauty of the naked male form makes homoerotic associations unmistakable (recall also Sontag's definition of camp above). A later painting, the *Revolt at Cairo,* sees his homoerotic penchant clothed in Orientalism. But again, as James Smalls notices, the homoerotic during this period, epitomized by Girodet but also exemplified in lesser artists such as Jean Broc, is viewed by many art historians as but a stage of transition before the headier period of Romanticism.[11] Although about art, these issues evidently have wider ramifications since they deal with perceptions of the body and the slipperiness of gender preference and stereotypes.

Queer, in the usage we know today, took on a new life during the Revolutionary period (1789–94). It is instructive to see how the historical evolution of the relationship between the wastefulness and artificiality and queer style. During the Revolution, suspicion shifted from the private body to that of the political body. Any fashion and dress that smacked of the old extravagant ways, any suggestion of frippery, was dealt a cold hand. William Hogarth did an engraving, which is now quite well-known, of the five orders of wigs, from 'Episcopal or Parsonic' to 'Queerinthian'— the latter in this case less macaroni-like as it did not feature a ridiculous amount of hair dangling from a bow. Wearing big hair was not just denigrated because of its obvious ostentation; it was also something that demanded a large amount of time to make. When big hair reached its zenith in the late eighteenth century, it constituted what Margaret Powell and Joseph Roach call 'the performance of waste';[12] time that, to the sternest Revolutionary middle-class mind, could be spent more sensibly. Any form of overwrought fastidiousness of appearance smacked of the same: it was an uneconomical use of time that could serve better ends. Even Robespierre, known for his immaculate clothing and his insistence on maintaining a wig, came in for criticism. In sum, all aristocrats were 'pansies': aristocratic values and fashions were all relegated to the status of effeminacy, a male effeminacy that linked to fecklessness, insincerity and improvidence.

With fashions ranging from the austere to the dishevelled, the Revolution witnessed the assertion of the middle-class body as distinct from the other orders. Previously collapsed into the Third Estate, the middle classes were anxious to create and preserve a set of values belonging to them that were not those of the lower classes. Dorinda Outram argues that the middle classes began to assert a 'closed body', as distinct from the 'carnivalesque body', of the workers and peasantry.[13] The latter refers to the graphically violent behaviour that the lower orders were disposed to during this time. With the hoi polloi on one side and the deposed nobility on the other, the middle classes were devout on finding a separate route that avoided the vulgarities of mob rule and what they also saw as the vulgarities of profligate lifestyles. But as Outram adds, the self-contained body that came to be associated with the bourgeoisie was also a somewhat inevitable consequence to preserve the self from an aggressive state apparatus and of superabundant signs of death.[14] The closed body, the domestic body of the bourgeois, was thus by extension a paranoid and suspicious body. It was a body that liked to be enclosed within a conformist shell.

However, the Revolution saw the birth of the capitalist notion of merit over entitlement, merit being a very malleable concept since it is tacitly governed by persuasion. The registers that roused suspicion were the open display of wealth, but this did not curtail expression, which ultimately devolved to the person (usually) himself. Except for in the bedroom or on the battlefield, the aristocratic temperament did not care much for talent, which was reserved for those who did service for them. In the bourgeois world, talent had to be displayed and sold. Eccentricity, the expression of a distinctive *je ne sais quoi*, was an important attribute to have if one was to sell

oneself as a noticeable quantity on the open social market. This was as true in France as it was in England, both of which were hungry for novelty. The growth of public amusements cannot be considered without the display of people themselves. But it was only in 1817 that *excentricité* came to be used in the French. It was Germaine de Staël who wrote of a particular English way of being that is 'completely original' and 'takes no account of the opinion of others'.[15] As with other social formations of this period, it could be met with fascination and loathing, and it also took hold of many different types, from charlatans to others who would be named geniuses. But eccentricity was the platform for queer as an integral subset within society that gave gay men among others leverage to be themselves by using a persona in which masquerade, exaggeration and misdirection were key.

Dandies and Aesthetes: The Early Days of Queer Style

> Thus one of the consequences of Dandyism, one of its principal characteristics—or better, the most general characteristic—is always to come up with the unsuspected, what a mind accustomed to the yoke of rules cannot arrive at using regular logic.
>
> —Jules Barbey D'Aurevilly[16]

As with the ironic marriage of a homosexual sensibility within the conception of classic style in Western modernism, when taken to an extreme, the closed body of the modern metropolis strains the boundaries of sartorial respectability. The post-Revolutionary progeny of the macaroni is the dandy and, like the macaroni, is not expressly homosexual but blurs the lines of sexual orientation. It was only toward the end of the nineteenth century that the aesthetic movement and the decadents, climaxing in the figure of Oscar Wilde, tightened the association. A conventional definition of the dandy is that he (the female equivalent was less prevalent and far less conventional, as we say in the previous chapter) is indolent, aloof, an outsider hostile to stereotyping. It was not for nothing that Barbey D'Aurevilly in the first substantive study of the dandy insisted on his elusiveness from definition.[17] Wilde himself in his productive and versatile literary output was a desecrator of industrialism and utilitarianism. He became spokesperson for artifice, antinomianism, mendacity and paradox.

Although there is no want of definitions of the dandy, many appear to revolve around the way in which he occupied a space of contradiction, much in the vein of the very meaning of irony itself. A dandy is at once bordering on the ridiculous, while at the same time a leader of fashion. Sima Godfrey identifies this conflict as essential to the dandy's character and entire state of being: 'An eccentric outsider or member of an elite core, he defies social order at the same time that he embodies its ultimate standard in good taste.'[18] The dandy is in this respect an exaggerated figure of fashion itself, standing above the crowd while representing an aspiration

of what the crowd should become. A prototype of the romantic model of the artist, the dandy underwent a minor evolution in the course of the first half of the nineteenth century from the effete fop to a figure known for his worldliness and wit. Stendhal, who criticized the dandy in *De l'Amour*, went on to shape one of the more memorable dandies in literary history, Julien Sorel in *Le Rouge et le Noir*. Julien is appreciatively told by Prince Korasoff that he possessed 'the natural *froideur* we try so hard to affect'. The word *affect* is important because impression took precedence over substance. Dandies had a mixture of smouldering, romantic fire and sangfroid, hidden depths masked by desuetude—what we might call the romantic epitome of cool. His beguiling presence, to quote Noël Coward, 'was immense calm with your heart pounding'.

The first great dandy was Beau Brummel. A close friend of the Prince Regent before falling out of favour, Brummel was a precursor to celebrity culture and arguably the first public fashionista. He played a cardinal role in modernization of men's clothing in which embellishment was jettisoned for tailoring, fit and line. Brummel was also a pioneer of the cravat, the only embellishment to an austere ensemble. Since it enframed the face, the cravat was a vehicle for emphasizing the male romantic subject. He is given the lion's share of credit for introducing trousers into mainstream fashion repertoire. Pantaloons and their equivalent can be traced back to the sixth century BCE; however, in the eighteenth century, they were primarily the simple dress of workers who could not afford, or whose work was unfit for, breeches. It was this association that raised them to an ideological item during the French Revolution. In Britain, where the tremors of French influence were always felt, workers, but also those engaged in sports, wore pantaloons. Brummell's trousers were always tucked into well-shined boots (often with tassels), giving his ensemble a more outdoor equestrian look. This fashion was entirely in keeping with its time as it combined the man of character (the cravat, highlighting the face) and a man of action (the boots: the country rambler, the officer hero). In retrospect, we can also say that is the precursor to the fashion concept of 'sport' that began in the 1920s and is now a subcategory in its own right (for example, Armani Sport). Consonant with the ironies and contradictions with Winckelmann and the birth of modern art history, the historical fashion in the early stages before the formation of the contemporary concept of queer style is also closely associated with two highly heterosexual dress genres: the suit and virile rural life. The contemporary designer to have harnessed these contradictions to great effect is Ralph Lauren. The advertisements for his male fashions show beautiful, young Hellenic males in clothes that draw prodigally from Royal Ascot pomp. The pouting ephebe arrives at Princeton.

Before the contemporary idea of labelling that implies that to invest in enough socially ratified material is to inhabit style, Brummell brought taste to the level of the person. Taste was a common topic of concern for the upper classes of the eighteenth century in both social manners as in the growing field of aesthetics. Brummell, before more than a century of artists in his wake, from Byron to Dalí, crafted

himself into the very personification of taste and thus his own person into a work of art. In English, he had panache, what Italians know as *sprezzatura* and the French, je ne sais quoi; by implication something that cannot be learned or easily mimicked. Its indiscernibility makes it the highest commodity, a symbolic value commensurate with that of art. Making appearances and fashion a whole-life philosophy, Brummell was the most fastidious guardian of his own creation, championing, among other things, the virtues of a tooth-brushing and an immaculate toilet. '*No* perfumes', Brummel stipulated, 'but fine linen, plenty of it, and *country* washing'. Or, in the words of another dandy, Max Beerbohm,

> For is it not to his fine scorn of accessories that we may trace that first aim of modern dandyism, the production of the supreme effects through means the least extravagant? In certain congruities of dark cloth, in the rigid perfection of his linen, in the symmetry of the glove with his hand, lay the secret of Mr. Brummell's miracles.[19]

In his heyday, while a favourite of the Prince Regent, it was not uncommon for the prince and members of his admiring inner circle to visit Brummel in the morning to watch him dress, which sometimes could last a rather long time, since Brummel's attitude to his cravat was monomaniacal. It was as if they wanted to get to the bottom of the secret. (This is made much of in the 2002 BBC TV movie *Beau Brummell: The Charming Man* starring James Purefoy and Hugh Bonneville.) Escaping to France because of colossal debts accrued through gambling, Brummel's influence was felt on both sides of the channel and held strong even after falling from the Prince Regent's favour. Brummel and his friends Lord Alvanley, Henry Pierrepoint and Henry Milmay were frequenters of Waiter's, an establishment that Byron called 'The Dandy Club' (1807–19).

Just as Brummel spawned his own cult of followers and adherents, dandydom gave birth to a literary subculture. The first, as we mentioned, appeared in 1844, four years after Brummel's death: Barbey D'Aurevilly's *Du Dandisme et de George Brummel*. This was followed by meditations on the dandy in Théophile Gautier's *De la mode* (1858), Baudelaire's *Le peintre de la vie moderne* (1863) and *Mon Coeur mis à nu* (1887) and Mallarmé's *La Dernière mode* (1874). The most cited of these is Baudelaire's, which defines dandyism as 'an institution outside of law' and 'a kind of religion'.[20] The dandy is most likely to appear 'in transitory eras when democracy is not yet dominant and when the aristocracy is but slightly unstable and discredited'. Dandyism was a particular way of being in that it combined dress, deportment, attitude and worldview, a worldview that was at once weary but engaged—after all, why would he take so much trouble in his appearance if not to stage the expert part of not caring? Exemplified by Sheridan, Brummell and Byron, the dandy had a 'certitude of manners' and a particular way of 'wearing his coat and of directing his horse'.[21] (Baudelaire, who was more interested in lesbianism than male homosexuality, was evidently undeterred by the fact that both Brummell and Byron were inclined toward

deviant behaviour.) The dandy was an expert flâneur, about which there is abundant literature after Baudelaire, from Walter Benjamin to Louis Aragon and beyond. Suffice to rehearse here that the flâneur is a hyper-individualized subject. At least in the capacity of roaming the metropolis, he is alone, unencumbered by family ties or responsibilities.

All of this would seem far removed from the subject of queer style and more in alignment with the stalwart straight bachelor, except that the romantic cult of self-conscious male detachment and independence easily spilled into a form of homocentrism that, if not sexual, was philosophical and psychological. It is of no great coincidence that when it reached its height in the fin de siècle, homosexuality had come out as a social ailment. The objectification of woman as either Madonna or whore was an effect of a polarization of men and women, a consolidation of gender stereotypes and the creation of some of the most varied and inventive misogynistic imagery of any time. Around 1880, ironically a century before AIDS, the spread of syphilis and other sexually transferred diseases reached epidemic proportions, with the blame falling on prostitutes rather than the male carriers (recall the grisly conclusion of Zola's *Nana* and the former courtesan's deformation through syphilis; Rochester's ignoble demise had shifted to licentious women). Fleeing the femme fatales and nurturing their more spiritual nature, men clubbed together in a way that differed from the officer's mess. Such cliques served an exclusivist function as reprieve from the vulgar, corrupting whiles of the outside world (poor people and women).

As evidenced by the Dandy Club, the circles of male bonding had evolved at the beginning of the nineteenth century into something sub-ideological, psycho sexual and with a set of private codes of speech and behaviour. The clubs that surrounded this social behaviour were places where men could feel they were in havens of class, conversation and belief—and dress. Dress codes today are a faint whisper of what was de rigueur at Waiter's: variations on the Brummellian theme; faun trousers, different versions of hair *à la grèque*—it was a place to pass judgment on another's cravat-tying. Naturally, such places attracted (privately) self-avowed homosexuals who had the inevitable effect of stoking the homosexual fires in others. These were places where self-officiated high-mindedness mixed with underlying seams of perversion. In his study of male friendship in France at this time, Brian Martin notices:

> Concomitant with the emergence of the dandy during the Revolution, Empire, and Restoration and the flâneur during the July Monarchy, numerous male clubs flourished in postwar France. After more than twenty years of almost continual war, several of these homosocial societies focused on a return to pleasure. In contrast to the brutality of combat and the severity of the army, groups like the 'Bad Boys', 'Companions of Idleness', and 'Society of Forty-Five Lovely Pigs' celebrated spontaneity and humour. Balzac's own social club, 'The Society of the Red Horse'—as well as his fictional 'Society

of Thirteen' and 'Revelers' in *History of the Thirteen* (1833–9) and *Lost Illusions* (1837–43)—also focused on drinking, games and amusements. From frivolous pranks to violent rebellion, Issoudon's 'Knights of Idleness' demonstrate increasingly deviant homosocial behavior.[22]

The academic equivalent in England around a century later was the Cambridge Conversazione Society, which included both Lytton Strachey and John Maynard Keynes, who were joined by Bertrand Russell, not himself a homosexual, whom they affectionately called Bertie. Such enclaves of class, education and ambiguous sexual orientation were mined by the likes of Monty Python and Derek and Clive, who represent the male English upper class as latter-day fops, laying on the knife-edge between class affectation and queer. Evidently, the male club had a twin birth. As the Harvard Club and the Playboy Club came into being, so did gay bars. It is not for nothing that after the middle of Proust's *Recherche,* the emphasis shifts quickly from the Jockey Club to Jupien's brothel.

Despite the dandy having no fixed type, his disposition to affectation made him open to satire and suspicion. His tendency toward disengagement could also be related to female passivity. Already in the late seventeenth century, there had been arguments for causal links between outré behaviour and sexual deviancy.[23] By the middle of the eighteenth century, assumptions were being made between foppery and buggery: effeminate fashions could have the dangerous side effect of encouraging deviant sexual congress.[24] When the dandy took over from the fop, the same corollaries were made. In 1821, the Prussian Prince Pückler-Muskau resentfully observed, 'The highest triumph of the English dandy is…to invert the relation in which our sex stands to women'.[25] In her learned account of the effeminacy since the seventeenth century, Susan Shapiro concludes with a statement that is a prescient contribution to the overarching concept of queer style:

> How can we explain this constant torrent of abuse hurled at the dandified 'effeminates' in their gaudy finery? It is not only that they threaten to seduce, corrupt, or debauch an otherwise pure populace; they menace the very foundation of civilization. They negate the assumption that sex and gender identity are immutable, for their androgynous dress is constantly blurring, overlapping, and tampering with the supposedly fixed poles of masculinity and femininity. Consequently, the tone which permeates all criticism from ridicule to raillery betrays an underlying fear that the fixed poles are in fact fluctuating. The satirist who castigates 'effeminacy', sneers at the 'hermaphrodites', and reviles the fop expresses in his urbane mockery or hysterical rage his unvoiced suspicion that gender is really socially constructed, and therefore a very fragile basis for the patriarchal system which rests upon it. What the voice of the satirist says silently is that if virility is so at the mercy of fashion, then 'nature' is weaker than artifice; perhaps 'nature' is in fact merely artifice, since 'nature' is only clothes-deep.[26]

It is a very Wildean connection to make, and it also makes explicit the other connection of dandy to queer, for the dandy as an urban type abjured naturalness; this

despite the naturalness of Brummell's clothing as compared to the wigs and powder of the older styles.

In tracing the genealogy of fashions that err from what is deemed the common weal, we are apt to say that confusions of type are an ongoing theme: the fop and dandy with a buggerer, the dandy with the bohemian, and the bohemian with the homosexual. In a broader sense, *bohemian* was used to lump together members of the middle and upper classes who had sought alternative lifestyles but also members of the lower classes who were seen as less disciplined than the abstemious middle class and by nature drawn to undesirable acts: felonies of property or felonies of the body. This perception was not confined to Britain but stretched across Europe and was prevalent in America as well.[27] There are many temptations to digress into a more detailed examination of bohemianism and queer style, given that both, by choice or default, are cultural and sartorial Others, and both have historically had their style co-opted by the mainstream. Suffice to say for now that if it is reality or if it is posture, bohemianism is more sensitive to the economic realm while queer is self-evidently more sexual. There were doubtlessly social examples of both queer and bohemian in one incarnation, but as genres and as bracketed styles, we can say that the place where they overlap is in aestheticism, which reached a head in the last decades of the nineteenth century when aesthetes, bohemians, decadents and dandies were commonly bundled into a single category which included urban misfits, artists, disenchanted middle-class youth or the idle rich, who saw it as the best way of getting back at their elders. (Regarding the latter, one thinks of Wilde's lover Lord Alfred Douglas.[28]) After Brummell's death in 1840 and from the revolutionary period in 1848, the concept of the dandy loosened away from the Brummell's disciplined rigidity toward a more elegantly dishevelled Byronic model, one in which romantic machismo was tinctured with dreamy effeminacy.

The post-Regency dandy was far less pared down that the Brummellian version and far more at peace with signs of consumption. Epitomized by the Count D'Orsay, dandyism became more theatrical and ostentatious, sporting the fabrics and accessories that Brummell had renounced: velvets, silks, diamantes and high hats. His watch chain was inordinately long, and on one occasion his use of a sailor's cloak spawned a whole new fashion. Men vied among one another for distinctive signatures, such as Balzac's cane covered in turquoise or Baudelaire's exclusive use of black.[29] Spurred by the Baudelairean example, by the end of the nineteenth century the dandy uniform was anything that might, by degrees, register something to *épater les bourgeois*. It could be summed up as a sartorial and performative registration of dissent. Sometimes a small accent to spruce up an otherwise conventional ensemble was enough, such as a green carnation, which became a lasting symbol of Wilde and his homosexuality, worn like a badge and without any coyness or surreptitiousness.

As to the appearance of Wilde himself, there is, ironically, precious little documentation of Wilde's appearance or what he wore. What does remain for us is rather unremarkable. When he returned from his lecture tour in 1883, he had abandoned his aestheticist dress and appeared rather restrained and reticent, described by the

World as looking 'more like a robust farmer than a poet'.[30] Later that year, he adopted slightly more flamboyance by wearing his hair in Neronian curls. He had, according to a contemporary, 'a certain fat effeminacy about him'.[31] When he was encountered at home, Wilde looked rather dowdy. In subsequent years, other colleagues and contemporaries observed that his appearance was well-groomed and unintrusive. Yeats wrote that Wilde 'dressed very carefully in the fashion of the moment'; Wilde even called the young poet to task for wearing an ostentatious pair of shoes.[32] These witnesses bear testament to the simple fact that Wilde was never interested in being marginal; rather he wanted to rise and excel in the best of society. George Bernard Shaw wrote that Wilde 'was an unconventional man'.[33] The fastidiousness that we discern in photographs of him is perhaps fed most by the Wilde legend.

The Wilde trial in 1895 was more than a trial between the outspoken son of a minor Irish baronet and a disgruntled aristocratic curmudgeon from Scotland. The trial put almost every modern liberty stake: political, personal, aesthetic, cultural, intellectual and, above all, sexual. A small detail is lost in the popular knowledge of the *Wilde* v. *Queensbury* case, a detail that soldered his fate, for he was not accused of being a 'sodomite' but rather as 'posing' as one. This has profound implications to our topic, for it has to the do with the vicissitudes of correspondence between sexual preference and outward appearance. At the end of the nineteenth century, one was threat enough if one adopted the outward signs of what constituted homosexual behaviour at the time. In his masterful essay on the subject, Ed Cohen locates this distinction as at the core of the contradictions surrounding male homosexuality and appearance in late Victorian London. Because he was conspicuous, controversial and culturally divisive, Wilde was the optimal candidate in the social and legal struggle for an acceptable model of manliness. The 'legal struggle [was] orchestrated precisely to "fix" male gender by "fixing" him'.[34] Cohen goes into great detail about the definitions of *pose,* most preferring 'An attitude or posture of the body, or a part of the body, especially one deliberately assumed, or in which a figure is placed for effect, or for artistic purposes.'[35]

Although he does not mention it, the definition goes to the heart of the web created between art and artifice, camp and homosexuality. It also helps to account for the popular connection between the arts and being 'gay'. Wilde was particularly vulnerable to such an attack because he had gone to great lengths to make a seamless connection between his life, his persona and his work. He built his aesthetics on empirical impossibility: nothing is obvious, common sense is naïve, everything is appearance—everything is rhetoric and 'pose'. In 'The Truth of Masks', Wilde railed against historical accuracy in staging Shakespearean plays as grossly smallminded: 'Archaeology is entirely out of place...and the attempt to introduce it one of the stupidest pedantries of an age of prigs.' And as Gwendolyn announces in *The Importance of Being Earnest,* 'In matters of grave importance, style, not sincerity is the vital thing.' A statement like this is likely to have its roots in remarks made by Wilde's mentor at Oxford, Walter Pater. Pater gnomically remarks, 'Art comes to

you frankly to give nothing but the highest quality to your moments as they pass, and simply for those moments' sake.'[36] One has only to make one step to the side to see the performative dimension to this statement. By living art, one celebrates beauty to its fullest in trepidatious anticipation of its imminent decay. Pater was also a prominent figure in the conception of Hellenism in the middle of the nineteenth century that turned to Winckelmann for inspiration.[37]

Despite what he would have us believe, Wilde did not shape his aesthetic single-handedly, as the virtues of artifice had been exclaimed publicly since at least Baudelaire, just as, sartorially speaking, the exotic was paraded by Gautier.[38] In England, the pre-Raphaelite brotherhood made an institution of imaginative fancy in which history became a vehicle for expressing dark and mysterious urges. But as camp as the pre-Raphaelites may have been (if we follow Sontag), Wilde gave aestheticism a strongly personal, homoerotic and political cast. The poet Swinburne wrote homoerotic verse, and Tennyson's *In Memoriam* is thick with similar undertones. But he and his contemporary, the painter Lord Frederick Leighton, carried their intimate preferences with propriety. Tennyson and Leighton were rewarded for their talents and their discretion no doubt, with many official honours. There was also an unofficial homo sociality in British schools (especially in public—i.e., private schools): 'fagging', whence the name 'fag', was a hierarchical dynamic of the servitude of a younger student to an older one, in which the connotations of the *hoplite-kineidoi* (manly male and womanly male) in ancient Greece were never too far away. In these environments, it was not unusual to give girls' nicknames to the best-looking boys, marking them as feminine.[39] These boys were sought out to become 'bitches' and sexual recipients. As D. S. Neff points out in his essay on Byron's sexuality, there was nothing hugely scandalous when boys were caught having sex with one another in boarding schools such as Harrow (Byron's school); it was just another one of the 'hazards' of school life.[40] Fagging was a school of practice of sexual-class initiation in which a younger student was informally indentured to an older one, usually to do personal chores but not uncommonly to perform more personal services. Until exposed in novels and movies, all this went on 'in house' for the upper classes, who set the course of taste. They were the most indulged so long as the establishment's interests were served.[41]

Wilde, on the other hand, used his pose to distinctive and memorable effect, which served him in good stead in the years leading to his literary successes. Wilde was fair and easy game for caricature: typically his distinctive head with the long hair and ample lips would be affixed to either a languid body or an aesthetic object such as a flower.[42] Cohen shows how Wilde's career of posing was his success and his failure, for the condemnation was that of the display of a lack of manliness, not proof of sodomy. But when witnesses confirmed that this was more than simply a position, that it was a way of life, all was lost. London had its share of transvestite minorities. But seeing as ideas of gay identity and the social face of homosexuality were in a nascent stage, the connection between cross-dressing and homosexuality was not as assumed

as it is today. Transvestism was far more equivocal. Whatever went on in the 'molly clubs' frequented by the likes of Ernst Boulton and Frederick Park, better known on the street as 'Fanny' and 'Stella', showed that cross-dressing, although infrequent, was not unusual and was a common quantity in vaudeville and theatre. In the words of Morris Kaplan, 'Their transgressing of norms, or, at least, their ambiguous manifestations of gender may have been among their principal attractions.'[43] When taking themselves outside such clubs, transvestites could merely be seen to be taking theatre—in which there had been a long history of boys dressing as girls—to the streets. Since the 1870s for instance, the main attractions of places like New York's Armory Hall were the rouged and powdered faeries whose exhibitions, or 'circuses', were used to thrill or appal patrons, who came there either for amusement or covert gratification.[44] Boulton and Park were exceptional for being charged in 1871 with 'conspiracy to commit the felony of sodomy'. In an effort to show the connection between being a transvestite and being gay, the prosecution failed to make a sufficient case. It was a public event, however, that brought the 'campish ways' (as Boulton said to himself[45]) of mollies and Mary-anns into the public limelight, closing the gap between appearance and behaviour. It began to expose the highly organized and covert networks of gay men that had built up in the burgeoning, expanding metropolises in Europe and America as the nineteenth century progressed. From at least the 1850s onward, there had begun to form a distinctively gay culture of which, hitherto, the public were either unaware or disinclined to acknowledge.[46]

The Wilde phenomenon brought queer style and homosexual behaviour closer together. As a master of ambiguity and contradiction, Wilde had only incited suspicion, but upon the trial certain queer traits which he was seen to embody—pose and style—what in today's jargon we would call performativity and multi-textual styling, became more decisively grafted to what it meant to appear and be a homosexual.[47] As Christopher Reed states, one of the long-term effects of the Wilde trial 'was to make Aestheticism the "look" of homosexuality, and thus a touchstone in the emergence of gay subcultures for decades to come'.[48] We can only now speculate as to what extent aesthetic, or aestheticist, posing was raised to such a level of importance because of Wilde's plight. He is the first modern queer martyr, who, by virtue of his martyrdom, elevated aestheticist artfulness and style, the hostility to naturalness, to a new symbolic order. ('That evening, at eight-thirty, exquisitely dressed and wearing a large button-hole of Parma violets, Dorian Gray....'[49]) In his memoirs of the era, the minor symbolist writer André Fontainas remarked that during Wilde's last years in Paris, he did everything to maintain his poise and distinctive style: 'Always elegant of bearing, a blooming flower in his button hole, holding forth with paradoxes, slow and fluent, spiritual and composed, a trifle mannered et graceful in his contrivances and repartees, he was always disposed to an audience.'[50]

Wilde's seismic influence calls to mind Proust's statement that 'through the influence of culture and fashion, a single undulation propagates identical mannerisms of speech and thought through a whole vast extent of space'.[51] After his trial, Wilde's

very name was tantamount to any derogatory byword for any appearances of gay behaviour, while amongst queers and artists it is sounded with reverence for fathering the concept of an autonomous, arty persona and the modern male gay identity.[52] What is sure is that Wilde added a new layer to homosexual effeminacy. For with him, the gay male became more rounded as a personality and as a social reality. He was not only a set of traits, he was also given a philosophical gloss in which wastage and narcissism were, to the chagrin of his middle-class heterosexual counterpart, no longer weaknesses but virtues. This was something to which social commentators of all levels of dispassion were quick to react. Not least of these was the Hungarian physician Max Nordau, whose vast tome *Entartung* (Degeneration, 1892), while aimed at the symbolists and decadents in general, had its sights firmly planted on Wilde and his epigones.[53]

Tracts of apocalypse were, as they continued to be, popular. By the time of Oswald Spengler's *Untergang des Abendlandes* (Decline of the West, 1918), Nordau's seeds had been well and truly sown. To the middle-class clinical eye, extravagances of dress were no longer disparagingly called aristocratic, as they had a century before, but were considered a symptom of a much larger social malaise and endemic of moral decrepitude. The violent responses to queer style today are resurfacings of the same fear. Degeneration as a social diagnostic was given its most grisly face during the Nazi years, when it was used to name acts and styles of art the Nazis did not support: avant-garde art was called 'degenerate' (*entartete Kunst*); the colour pink was used for the triangles sewn onto the uniform of homosexual prisoners, which proved to have a lasting legacy with gay male culture. An upward-pointing pink triangle became the emblem of the gay pride movement (the black upward-pointing triangle become a symbol of lesbian solidarity).

The Wilde affair of 1895 brought cultural sensitivities to the surface and not just to mollies, pederasts and perverts. (Think of 'the unspeakables of the Oscar Wilde sort' from E. M. Forster's *Maurice*.[54]) Turn-of-the-century Britain cast about for social stereotypes in dress and in name and to diagnose them as susceptible to sexual deviancy, either de facto or de jure. Predictably, *dandies* and *bohemians,* all but conflated, were singled out as bywords for social miscreants or louche individuals—a far remove from the dashing figure of Brummell—and such individuals comprised part of the social circle that Wilde was said to frequent.[55] Thomas Carlyle, in his scathing attack on the dandy in *Sartor Resartis* (1833), had already helped to fan the fire of antagonism against the dandy, which he called a 'sect' that was objectionably self-absorbed and parasitic.[56] In other words, dandies were out of the circuit of economically and biologically productive male desire. But as James Adams points out, for Carlyle and his early Victorian counterparts, 'the burdens of manhood were exacerbated by a bewildering loss of clearly defined structures of initiation'.[57]

Sixty years later, with the Wilde trial, the social pressure cooker had all but popped. Bohemians were the obvious choice as the butt of social blame, as they were not as definable a category as the working class but could easily combine upper

classes fallen from grace, unorthodox middle-class 'revolutionaries' as well as the underclass. Matt Cook, in his study of male homosexuality in London at this time, noticed how 'the adjective "bohemian" cropped up repeatedly during these trials. Alfred Taylor's flat was described as bohemian, and one of the witnesses professed himself unsurprised when Wilde kissed the waiter at Kettner's on account of the playwright's bohemianism'.[58] The markers in dress and manner for queer were as much a part of the wearer's nature and intention as of prejudicial interest: velour jackets, scarves, a swaying gait. While the dandy at the beginning of the century mixed amongst the upper classes, the bohemian in the caste of Baudelaire, Barbey d'Aurevilly, Gautier and Nerval all came from the middle classes, while the bohemian of fin-de-siècle London had become unmoored from class orientation. Long hair and long coats, even shaving, became suspect.[59] Brummell's example had evidently experienced a steep descent.

Turn-of-the-century London secured the social persona of the queer male as an urban phenomenon and an urban type. Like so much in the history of queer culture, this observation is a mixture of fact and myth. Certainly homosexual activity, because it was forbidden, was less likely to be exposed in a metropolis than in a rural village in which everyone is 'known', and there is the hope of far less action. In a city, and a city as large as London, homosexuality could absorb itself through the decoys of different social types. 'The city's scale and complexity offered the possibility of evasion, of personal transformation and anonymity, and of encountering other who might not conform to the projected "norm."'[60] But the city was also the place where masculinity and femininity were becoming stridently defined. Not only did narratives of perversion becoome more diffuse and entrenched, but so did those relating to what counted as normal. Beliefs of what reflected healthy behaviour and its connection to gender-made social stereotypes made modalities of 'proper' dress more exigent, and deviations more conspicuous. In Vienna, one of the homes of psychosexual diagnoses, men were encouraged to adopt a grave and mature look, even when young. Whiskers were extolled as having gravitas and a jaunty walk criticized for its frivolity. Neither was it frowned upon for young men to have a paunch and walk with a stick. To supplement one's air of experienced authority, one could buy glasses for the perfect-sighted and unguent to stimulate the growth of facial hair.[61]

Social paranoia was not limited to individuals but also extended to groups. In London, spurred by the publicity of its laws, a variety of occupations grew to be irrationally implicated in homosexual behaviour. As Cook reports, not only were the dandy and bohemian (now enlarged and nebulous social categories) targeted, but also the bachelor, theatregoer, actor, settlement worker, soldier and telegraph boy.[62] These groups were ultimately the scapegoats, since the spectacle of gay manhood was confined to the upper classes and, in elite enclaves such as amongst the Oxbridge set, tolerated.[63] Notwithstanding, at the height of the Wilde scandal in London, men's periodicals were strident in the their commentary of what constituted

proper male behaviour and what was deviant. *Modern Man* extolled he who was 'Full-blooded, Vigorous, and Clean' while 'ridiculing the dandy and his fake tan, powder and rouge'.[64] Corsetry was thought to be acceptable because it was worn by members of the army, while wearing scent was evident collusion with effeminacy. This is one of many examples of how changeable the indicators of queer have been, not least given today's vast male cosmetics industry.

Outside of London, in the other British cities including Dublin and in European cities such as Berlin, a homosexual subculture had begun to form. By the middle of the nineteenth century, homosexual liaisons could be had not only in brothels and bath houses but also in public toilets and parks. Under these circumstances, from a sartorial viewpoint, it was important to stress the normalcy of one's outward appearance but maybe supplement it with an in-the-know signifier such as a scarf. Whether they were intentional or not, outward signs became increasingly monitored by the authorities working under the act of 1885 in which sodomy, long before a punishable offence, became viewed as a male homosexual affair. Scarves were soon conspicuous markers; scrutiny was such that even an innocent smile or a wink could lead to an arrest.[65] From the late 1960s onward, scarves were worn with pride by the cruisers and hustlers of San Francisco, Cherry Grove and Fire Island on Long Island.

In fin-de-siècle Paris, like London, dandies were also grouped with bohemians, although they were far less stigmatized so long as they exercised discretion. One of the great aristocratic dandies of the era was the Count Robert de Montesquiou-Fezensac, the model for more than one literary immortalization, most memorably the formidable Baron de Charlus but also the Duc des Esseintes in what became the bible of the decadent movement, Joris-Karl Huysmans's *À Rebours* (1884), the book that Wilde alludes to that 'poisoned' Dorian Gray. A poet and socialite, Montesquiou is now best known for a portrait by Giovanni Boldini that shows him, his whiskers waxed to attention, clad in a dashing three-piece grey suit with silk-trimmed lapels, wearing white gloves and brandishing a cane. His cravat, to recall Robert Lowell's line from his poem on the Revolutionary Saint-Just, is 'knotted with pretentious negligence'. Huysmans's tale—more a series of episodes—of the neurasthenic anti-hero prone to the most extravagant eccentricities, such as encrusting a tortoise with gemstones, was not wide off the mark. If Montesquiou was indiscreet, it was in the area of erecting a world that was hallucinatory and sensorially overblown.

It is worthwhile digressing at this point to dwell briefly on the decadent movement, which was one of a handful of movements, styles and isms alive during the fin de siècle. In hindsight, art nouveau, Jugendstil, symbolism, aestheticism, decadence (or *décadantisme*) are all seductive styles as they brought sensuous delight to a point of saturation. Sometimes names in their own right and at other times for the same thing, aestheticism and decadence were in their time highly controversial. Their eclectic mythology and ornament made the most extreme cases easy game for social conformists. Coterminous with the era of psychoanalysis, decadence was

like the unconscious of the rationalization of society through industry. And it is curious to note that as the perverse becomes visible, so does the rhetoric of nature and naturalness, thus revealing nature as loosely coded, ideological structure. The more a world is made, manufactured and mediated, the more it fetishizes nature and by extension, natural, 'normal' sex. The return of the repressed is in a post-industrial society whose products protest their originality, naturalness or freedom from additives. Industrial capitalism has at its heart a paradoxical aspiration: to become one with nature by improving it while maintaining a sentimental attachment to a primordial state.

Although existing today in decorative remnants—erotically charged movies, decorative retro textiles, brilliantly illustrated coffee table books with the works of Mucha, Hodler and Moreau—it is the emphasis on artificiality that made aestheticism and decadence so radical. It is also what makes it queer, in the broadest sense of the term, and not just camp. Art nouveau harkened back to the eighteenth century as a period of hyper-stylization where art, décor and dress were as one. Because it was based more on invention than imitation, this distorted universe was, to extend Butler's radical analogy, a universe in drag.[66] Nature and normalcy, following not only Wilde's cue but also a cohort of artists and writers of straight, gay and undetermined sexual dispositions, formed the lacklustre raw material to be overcome with art, here understood as all forms of mediation and artfulness with transformative and performative intent. The spirit of the dandy was the internalization of these principles, extracting the oblique. As Jessica Feldman observes:

> Dandies flaunt what a culture usually attempts to ignore or hide, that the human body is never 'natural', or naked of cultural clothing, but is instead a system of signification, a cultural construct. The dandy's clothing, bearing, makeup, and so forth announce the necessarily 'made-up' quality of what we often take as one locus of unmediated nature, our own bodies.[67]

This was poignantly exemplified in Montesquiou. A connoisseur of another aesthete, Whistler, Montesquiou not only commissioned a portrait from him but also had his own interiors decorated in what could only be Whistler turned up to eleven. His bathroom was saturated with all kinds of decorative variations on his favourite flower, the hortensia, 'in every possible material and every conceivable art-form'.[68] Proust's first great biographer, George Painter, goes on to report that Montesquiou's bathroom also contained 'a glass cupboard with "the tender pastel shades of a hundred cravats", and above it "a photograph of La Rochefoucauld, the acrobat at the Cirque Mollier, in tights which do full justice to his elegant ephebic figure"'.[69] In the 1890s, Montesquiou, the 'greyhound in a greatcoat' as he called himself,[70] had pared down his former dalliances of dress and taken to wearing grey suits and basic black, as in the evening dress in Whistler's striking portrait of 1891–2. As Painter arrestingly describes him,

His face was white, long, hawk-like and finely drawn; his cheeks were rouged and delicately wrinkled, so that Proust, greatly to his annoyance, compared them to a moss-rose...In these early days he used only a little powder and rouge. Everything in his appearance was studied, for the artist, he felt, should be himself a work of art. But as this strange, black and white nobleman chanted, swayed and gesticulated, he acted a whole series of puppet characters, as if manipulated on wires pulled by some other self in the ceiling: he was a Spanish hidalgo, a duelist, his ancestor D'Artagnan, a screeching black macaw, an angry spinster, the greatest living poet. The sobriety of his colour scheme was mitigated by the coquetry of his lilac perfume and pastel-hued cravats: 'I should like admiration for my person to reach the pitch of physical desire', he confessed.[71]

The contemporary poet Henri de Régnier wrote that he never left the house except 'clothed in the choicest fabrics, in cravats of the most precious silks and in gloves of the softest hides'.[72] In his social life, he was known to be affectedly exacting to the point of querulous; as self-centred as his appearance and demeanour would allow. His poetry is of an untranslatable complexity that only leads one to surmise that it was an accessory to himself as a brilliant aesthetic construct.

The other model for Charlus was the Baron Jacques Doasan, who had the same portliness and offhandedness as Charlus. He was described by a contemporary as 'like a knight-at-arms in the Hundred Years War'.[73] But his face was 'bloated, blotched and heavily powdered, and newcomers were puzzled to find his hair and moustache changing from jet-black to white, and from white to jet-black again, though never simultaneously, for it did not occur to him to dye both at the same time. Nothing horrified him more than effeminacy in young men'.[74] This was a trait that Charlus also shared. He refers to Saint-Loup's friends as 'gigolos' because of their effeminacy: '"They're nothing but women," he was said to scorn. But what life would not have appeared effeminate beside that which he expected a man to lead, and never found energetic or virile enough?'[75] His bearing is also reminiscent of the laconic disdain typical of the dandy but also in which hetero-cool and camp appear to be vying for preference: 'He threw back his shoulders with an air of bravado, pursed his lips, twisted his moustache, and adjusted his face into an expression that was at once indifferent, harsh, and almost insulting.'[76]

It is worth dwelling on Proust because his novel is the most vivid account of the fashionable Paris in an era that was the final transition from the old to the new world. It is also a complex document about love, appearances and sexual dispositions. The debates as to the nature and courage of his inversion, which span from Gide to White, are not, however, within the ambit of this book. What Proust's novel so richly demonstrates, explicitly and implicitly, is the indeterminate relationship between the dandy's appearance and his sexuality and thus the difficulty of categorizing queer male fashion in this period. It is also yet more evidence that the coming to visibility of queer style at the beginning of the twentieth century was, as Shaun Cole and Alan Sinfield argue, a matter of class mixed with education, effeminacy

and aestheticism.[77] While we recognize the observations of Cole and John Clarke regarding the subcultural bricoleur who reorganized traits to suit his needs, ultimately to remake discourse,[78] we would suggest that for the dandy in this era, queer style was a matter of exaggeration and revealing, on one hand, but also subversion and concealment, on the other. Aestheticism and its attendant codes were channels that the gay male could use express himself through, both exploiting and being shielded by a social caste that was not exclusively gay. Whistler, famous for his moustache, monocle and 'diabolical' laugh,[79] was not a homosexual, nor was Proust's aesthete Charles Swann or his historical prototype Charles Haas. Hass was reputedly both immaculate in appearance (Swann comments that he has a grey top hat which Delion only made for him and Charles Haas) and spent a good deal of his time in pursuit of women. Meanwhile Legrandin, whom we meet early in Proust's novel, is another model of the dandy with his 'blue eyes, air of disenchantment, an almost exaggerated refinement of courtesy' and 'his loosely knotted Lavallière neckties, his short, straight, almost schoolboyish coat'.[80] He is not homosexual, but Charlus, whose bluster is typical of overcompensation and self-loathing, is. Apposite to our analysis, Proust highlights a world in which all is not quite as it seems. The dazzling aristocracy of the first half of the book descends into obscurity or humiliation. People whom the narrator once thought were imbeciles are in fact quality people, and people whom he thought were straight are revealed to be gay. As if through osmosis, or the slow coming-to-appearance of an atavistic trait, signs of people's sexual 'inner nature' seep through and find themselves in traces on the body:

> Sex has repercussions upon the personality, so that in a man femininity becomes affectation, reserve touchiness and so on. Nevertheless, in the face, though it may be bearded, in the cheeks, florid as they are beneath the side-whiskers, there are certain lines which might have been traced from some maternal portrait. Almost every aged Charlus is a ruin in which one may recognise with astonishment, beneath all the layers of paint and powder, some fragments of a beautiful woman preserved in eternal youth.[81]

Perhaps more than any historical or scientific document, Proust's *A la recherche du temps perdu* reveals the intricate ways in which upper- and middle-class European society at the turn of the century used titles, manipulated appearances and created subterfuges to satisfy their desires, be they social or sexual. Appearances were not only revealed, they are re-revealed, recast, remoulded and re-revealed anew (Odette the fay courtesan ends up marrying the once great Duc de Guermantes, and, as mentioned, people we once thought were straight begin to show truer colours). The book also provides the best context in which to see the sexual contradictions of the dandy and the ways in which homosexuals used this ambiguity as a conduit for expressing themselves. For in many ways, the turn-of-the-century dandy was a watershed figure for queer style, just as women were becoming more conspicuous with regard to their place and say within society. Burgeoning feminism found its object in bloomers,

the Turkish-style trouser worn under a dress, while the male queer acted out his difference under the more ambiguous but malleable persona of the dandy. Indecipherability and mystery were part of the dandy's allure, qualities that Jean Cocteau worked hard at cultivating,[82] but to his contemporary, the literary aspirant and eccentric Jacques Vaché, it came naturally. Vaché had been a patient at Nantes Hospital where André Breton was working in 1916 as a medical orderly, after which the two maintained an intense friendship until Vaché's demise by what was presumed to be suicide three years later. The historian of bohemia Jerrold Siegel describes him thus:

> Vaché was a remarkable combination of Baudelairian dandyism, Privatian *blague,* and Jarryesque refusal to let his identity by any conditions external to himself. He affected English clothes and an extreme, exaggerated elegance of manner. One of his favourite poses was that of an English tourist, unable to speak French. Sometimes Vaché would disguise himself in a costume and refuse to acknowledge his friends…His sexual life was part of the mystery, leading those who knew him to wonder whether he was a libertine, a homosexual, or chaste.[83]

Whatever the truth may have been, concealment was at the core of his charm. His is also a clear illustration that queer style was built on the paradoxical of posing as Other whilst simultaneously posing as oneself, a double helix of concealment and disclosure. It is precisely because the form of the dandy defies definition, or supposes to do so, cherishing some tacit agenda of resistance that is at once subversive, intriguing and sexy, that it is the most welcome surface for the performance of queer identity. The dandy's studied aloofness was the appropriate means for dissembling personality, taste and gender preference such that all three factors become integrated into one.

Before we conclude this section, it is important that we not ignore the presence of the African American dandy. In her groundbreaking book on the subject, Monica Miller shows how the sartorial mechanisms associated with the dandy were useful tools for the African slave diaspora in signalling signs of resistance. Dandyism was the early modern version of bling. She starts with the premise that African Americans are sartorially self-conscious and known for 'stylin out'.[84] She reaches back to the eighteenth century and explains how even the humblest slaves were active in styling out in order to salvage their dignity and to test the possibilities of the mobility that good dress can often afford. Miller explores the eighteenth-century phenomenon of 'luxury slaves', who could be either trophies or companions. The most notable instance of this was in the person of Julius Soubise, who became a habitué of fashionable clubs and mixed in distinguished social circles. While it was expected that slaves contain their sexuality, Miller explains,

> dressed in the latest fashions as a boy while at Kitty's [the Duchess of Queensbury] side, he was at once feminized and spectacularized, made into an object whose own desires could be ignored. Clad in elaborate outfits as an adult, with Kitty's purse in his hand, he was seemingly a different kind of curiosity able to act, at least sometimes, on his own will.[85]

Subsequent figures include the great W.E.B. Du Bois, who was revered for the meticulousness of his clothing, an important part of his campaign to demonstrate black abilities and values to the establishment. Then there are more recent examples in visual art such as Lyle Ashton Harris and Iké Udé, who dress themselves up in uniforms of the establishment, in ornate settings, with their faces heavily made up with eyeliner and lipstick. One image, *Sisterhood,* shows both artists: Udé sits on Harris's knee; the image displays all the dignity and reserve of an official institutional portrait for dignitaries after office. Harris wears a cravat, one of the covert signatures of gay men in the twentieth century. This and other images are decadent and self-loving in every sense of the word. Harris coined the phrase 'redemptive narcissism' as a method of escaping the 'tyranny and mediocrity'.[86] Narcissism not only led to death, but it had salutary consequences as well: 'rigorous meditation, cleansing and recuperation'.[87] Or, in Miller's words, 'Self-scrutiny is unapologetically affirmative and not reactive. This "appropriate fastidiousness" never considers the self as an object of scorn.'[88]

As several commentators are wont to tell us, gay men place a premium on appearance.[89] At the very beginning of his text on dandyism, Barbey D'Aurevilly announces the close connection of dandyism and vanity, a vanity whose queenliness and coquettishness outdoes queens and coquettes themselves. The dandy's hauteur and coldness rivals the games of hard-to-get and conceited self-absorption associated with women, inflected with a vaguely aggressive male edge.[90] The dandy's detachment is social and sexual; he doesn't need men or, more to the point, women. His self-involvement is truly homo sexual in the literal sense of the etymology. It is only natural that then that queer male style grew out of the dandy. Or rather, in the turn-of-the-century climate of scientific diagnosis and social suspicion, the early incarnations of queer style took over the dandy like some organism devouring its host. Historically, the dandy would continue to have straight exemplars, from Gabriele d'Annunzio to Claude Rains; however, it would be gay and queer men that would continue to make the biggest claims for dandy status, either bringing him up to date—Noël Coward, Quentin Crisp, Truman Capote, Rupert Everett—or redefining him, as Andy Warhol did. Even if institutionalized and historicized now—inasmuch as postmodern subcultures are frequently relieved of their former subversiveness and become a novel, codified entity—the dandy was the first significant crack in what Judith Butler calls the heterosexual matrix.[91] Unlike the macaroni, who was limited by expense and a style that was in the longer term logistically unsustainable, the dandy manipulated hetero-style by exploiting its limits. Normality's irreducibility, its tenuousness, was demonstrated through fashion and dress.

The Artistic Avant-garde and the Years Pending the Second World War

As literature and cinema have shown us in lavish abundance, the Edwardian age was an age of melancholy and leisure, a Belle Époque in the state of exhaustion. In the lead-up to the Great War, it was also a time rife with the cultivation of gay

male culture, if only in the upper echelons. Increasingly in more permissive France, homosexuality and queer style became more tightly intertwined with progressive artistic circles and the avant-garde. The birth of Dada in 1917 in a small Zurich bar, the Cabaret Voltaire, perpetuated the close ties between political revolt and sartorial strangeness.

The First World War's collapse of the old feudal world order meant that sartorial excellence shifted away from elegance for its own sake, and thus the arbitrary power of the aristocracy, toward the outward sign of capitalist merit. You got what money could buy. Equally, leisure was figured in clothing not in terms of the leisured class but as part of the endeavours of sport and the *vita activa*. What the dandy lost in sartorial exquisiteness, he gained in manoeuvrability and flexibility—he was even more a state of mind. The greater simplicity of dress meant that eccentricities were more evident, but it also meant a return to the refinements of detail: cufflinks, the cut of a jacket, hand sewing and the like. As always, these were by far the provinces of gay men, but gay men were apt to cherish these signs as worthy of the upper-class sensibility of queer taste. The sportier culture witnessed an increase in exposed bodies. Bathhouses, while around since the nineteenth century, in the 1920s were an even more popular place for gay men to meet. Understandably, nudity and semi-nudity became a focus. Places tolerant of gay clientele, such as the bathhouses at Coney Island in New York, were hang-outs for models and bodybuilders or where middle-class gay men could mix with the 'tougher' lower classes.[92]

The oppositional if not revolutionary character of the dandy—something that Albert Camus later called attention to—united with even more solidarity than before the artistic avant-garde with queers and odd bods. 'The dandy creates his own unity through aesthetic means', wrote Camus, for whom the dandy is at root 'oppositional'. 'He only maintains himself through defiance.'[93] This definition leaves a fair amount of room to encompass political radicals and artistic radicals. The dandy and the bohemian were to the turn of the twentieth century what communist would come to mean after the Second World War. Expanding ground in cultural currency, bohemian was increasingly used to refer to anyone with indifference to property, unconventional sexual tastes and a creative state of mind. To the consternation of some historians, Elizabeth Wilson in *Bohemians: Glamorous Outcasts* takes an ahistorical position on bohemianism that reaches beyond the period of mid-nineteenth-century Paris via hippies through to contemporary subcultures.[94] When one views her thesis from the point of view of sexual subculture, it is even more tenable. The use of bohemian after Wilde's fall ceases to have its snide and circumspect ring to encompass, as it did then but in a more consciously general fashion, all kinds of lifestyles at the edges of middle-class connubial bliss.

Surrealism, it will be remembered, started off as a revolution whose underpinnings were psychosexual, since they were a loose adaptation of Freud's theories. Much has already been written about the heterosexual male trajectory of this revolution, and its originators, Breton, Aragon and Éluard, were all straight stalwarts, as was Picasso, who became surrealism's first artistic show pony when it expanded

its ambit to art in the second manifesto of 1927; its most famous exponents, from Tanguy, Ernst, Dalí or Delvaux, were all fairly homophobic. Notwithstanding, surrealism was a conduit for examining deviant behaviour as having a creative, transformative force within society. Its two main literary prophets, the Marquis de Sade and Lautréamont (the nom de plume of Isidore Ducasse), created worlds within worlds in which the superego of social boundaries was all but non existent. As anyone even marginally acquainted with Sade's writings will know, sodomy features prominently on his menu of sexual delights. The stylistic quirks encouraged by the surrealists in their numerous get-togethers and parties were revived way after the Second World War and coalesced into discernible social types, particularly in the figures of the glam and pop dandy. By and large, the surrealists wore suits. And even though he too dressed in conventional clothing of the period, Marcel Duchamp created an alter ego, Rrose Sélavy, which was a standout of this period.

Although Duchamp in life hardly had a homosexual bone in his body (his biographer Calvin Tomkins makes much of his hetero-promiscuity),[95] and although Rrose Sélavy (*Éros, c'est la vie*—Eros, that's life) was a figure within the realm

Fig. 3.2 Marcel Duchamp as Rrose Sélavy, 1923 by Man Ray, gelatine silver print, 22.1 x 17.6 cm. Courtesy: J. Paul Getty Museum, Los Angeles; Copyright: Man Ray Trust ARS-ADAGP.

of art as opposed to subcultural style, the occasions of Duchamp's cross-dressing are significant historical instances in queer style, simply for the way they formalize performance, narcissism and the making-ambiguous of sexual desire. Between 1920 and 1921, Man Ray did a series of photographs of Duchamp in drag. The first shows a highly feminized Duchamp coquettishly caressing a high fur collar and wearing a short-brimmed hat with a modernist neo-geo design, worn low on the forehead and under which heavily mascaraed eyes look searchingly at the viewer. The other has him in a hat with an ostrich feather and beads. He is wearing a wig and less make-up. The angularity of the jaw is more evident, rendering the masquerade more jarring. In her close examination of gender in Duchamp's work, Amelia Jones observes that this example of dragging has been underplayed in more mainstream analyses of Duchamp as 'generative patriarch' of twentieth-century modernism and postmodernism.

This indeed is a curious omission since Duchamp's gender misalignment is none-theless coherent with Duchamp's aims as an artist to destabilize romantic notions of inspiration and the atomization of authorship: 'Duchamp's masquerade/drag as a woman, then, produces an ambivalence that allows for resistance to eroticized im-ages of women as well as authorially invested constructions of "Duchamp."'[96] Jones denies that Duchamp has fallen prey to the 'Tootsie syndrome' taken from the 1982 movie starring Dustin Hoffman (another straight actor), a syndrome that cultivates a space for man to claim woman for himself. Rather, like the indeterminacies at the heart of his work, Duchamp's Rrose is a purposely marginal, indecisive figure.[97] Notably, it is also an original instance of a more than occasional strategy for the French and American male avant-garde's penchant for cross-dressing.[98] Duchamp, it seems, was using his masquerade to queer the cult of heroic male authorship. 'The Rrose Sélavy gesture seems, then, to have played out the complexities of homo*social* desire rather than to have signified homosexuality per se (although this reading of the images will always have been possible).'[99] As was so typical of Duchamp, what is most certain is the uncertainty: Rrose is hard to situate either in 'herself' or what motivated her creation within the discontinuities of Duchamp's oeuvre. But it is pre-cisely the quandaries that Duchamp sets up that make the Sélavy case so important for the concept of queer style and for one of the central theses of this book: queer is not just another Other; it is a category of discontinuity and resistance, impossible to essentialize. We are conscious, too, of Tootsifying our theory, of repossessing an archetypally straight male as an example of queer style. But as a token of the imprint that Duchamp's forays made, we see that in the early 1960s Warhol dressed himself as Rrose Sélavy, in his own personal homage.[100]

Coming later than Duchamp was Pierre Molinier, a marginal figure to the surreal-ist group for whom Breton organized an exhibition of paintings in Paris in the early months of 1956. Molinier is now remembered for his photographs rather than for his paintings, in which his own body is the support for a private sadomasochist-like theatre. Molinier used early photo-manipulation techniques to turn himself into a perverse monster, sexually ambiguous but always with an air of hedonistic cruelty.

While again this is an instance of clothing and gender performance within art, it serves to indicate the general overlaps between art, artifice and queer style in the post-war era. With its self-recreation, the masquerade that points to a kind of hyperbolic self-perfecting, Molinier's work also exposes what was becoming a recurring motif in male queer style. In his psychoanalytic analysis of fashion, J. C. Flügel argued that narcissism was what separated women's fashions from men's, which is more restrained. This he attributed to the castration complex, woman's lacking a phallus. Women are less developed than men as they have not overcome their vanity.[101] An extension of Flügel's thesis is that homosexual men reproduce the female lack inasmuch as they themselves lack heterosexual desire. Or, there is the dandified reading of sartorial-performative narcissism: that it is ultimately self-serving, self-reflexive and elides rational justification. Presaging the self-portraits

Fig. 3.3 Pierre Molinier's *Self-portrait with Painting*, 1966, gelatine silver photograph, multi-negative photomontage, 17.5 × 12.5 cm. Courtesy: Art Gallery of New South Wales, Gift of Edron Pty—1996, through the auspices of Alistair McAlpine.

of Mapplethorpe, Moliner places himself on a stage of self-appreciation, like the adolescent school girl dressing up for the mirror, but many times more perverse.

Turning to New York, the early decades of the twentieth century were when Greenwich Village became the meeting point for lesbians and gays or, as George Chauncey puts it, 'long-haired men and short-haired women', phrases often used by local press at the time. Chauncey comments that the multiple overlaps between gay and lesbian culture within artistic bohemia troubled some straight members of the avant-garde, to the extent that the artists and writers of this place and era were occasionally slandered as queer and perverted. Oscar Wilde was also invoked as supplying a subtext for the connection between art and deviance.[102] In working class Harlem, there was far less lip service given to propriety. The speakeasies were generously frequented by gays and lesbians; drag queens were a regular feature in the streets. Cyril's Café was one place where drag queens were prone to park.[103] Thus a dichotomy became evident between the refinements of upper-class, of affectedly upper-class gayness and the more open, brazen and sensationalist performances of the lower class.

The queer sense of dramatic mise en scène, bringing stylized camp vaudeville into the street, was already beginning during the decadent swansong of the era that occurred before the 1929 Wall Street Crash. In his fictionalized memoir of his life in Berlin at this time, Christopher Isherwood describes how homosexuals felt safer in the more upmarket bars of the West End (Hallesches Tor, just south of where Checkpoint Charlie would be), which 'only admitted boys who were neatly dressed'.[104] However,

> in the West End there were also dens of pseudo-vice catering to hetero-sexual tourists. Here, screaming boys in drag and monocle Eton-cropped girls in dinner-jackets play-acted the high jinks of Sodom and Gomorrah, horrifying onlookers and reassuring them that Berlin was still the most decadent city in Europe.[105]

On occasions of police raids, which were few, only the boys were asked for their papers. Lesbianism was still not a threat, or a voice. On normal evenings, basking in the heat of the single stove, the 'boys stripped off their sweaters or leather jackets and sat around in their shirts unbuttoned to the navel and their sleeves rolled up to their armpits'.[106] This aspect of pleasurable informality was henceforth to become important to queer style and one distinct from the carefulness of the dandy.

Dragging has long been a way for gay men to explore their sexuality, and now cross-dressing and drag parties had reached a much larger scale and were less clandestine. In the 1920s, Berlin was something of a haven for brazen drag styles. Make-up was laid on thick, eyelashes crimped, lips pursed and painted. A favourite look was the Belladonna effect, the darkened eyes immortalized by both Theda Bara and Rudi Valentino.[107] Incidentally, both stars made their reputations through playing Orientalist roles, with Bara giving filmic life to the ornate and overblown siren figure

that had long been in circulation in art nouveau posters and illustrations. Once again, the generic Orient was a reservoir for the expression of otherness, the Muslim race meeting what Proust called the 'accursed race' (*La race des tantes*). Isherwood reports how in Berlin at Christmastime there was a ball exclusively for men in the dance halls of In den Zelten:

> Many of them wore female clothes. There was a famous character who had inherited a whole wardrobe of beautiful family ball-gowns, seventy or eighty years old. These he was wearing out at the rate of one a year. At each ball, he encouraged his friends to rip his gown off his body in handfuls until he had nothing but a few rags to return home in.[108]

A similar roughness carried into the bedroom. Isherwood speculates that 'mildly sadistic play was characteristic of German sensuality'.[109] We will return to this with regard to the Nazism in the chapter on sadomasochism. The role of male homosexuality in the rise of Nazism is a fraught topic, but what we know is that Berlin before 1933 was a melting pot of queer sensibility. Just as Germanophone culture had a large hand in the diagnosis of homosexuality, from Krafft-Ebing to Max Spohr and Magnus Hirschfield, it was also responsible for the first gay journal, *Der Eigene*, founded by Adolf Brand and lasting from 1898 until 1931. Evolving from an anarchist to literary gay journal, Brand's stated mission was to feed the 'thirst for a revival of Greek times and Hellenic standards of beauty after centuries of Christian barbarism'.[110] Brand was adamant that Christianity had robbed modern culture of its taste for beauty, which he sought, in his own Winckelmannian renaissance, to reinvigorate with the standards of the ancients. He was convinced that manifesting male nudity was in the best interests of 'racial health and purity',[111] a comment that strikes an uncanny and melancholy note when measured against similar rhetoric of the Nazis.

Hellenism enjoyed widespread popularity in homosexual communities the inter-war years, in England and France as well as Germany. It was due to this that the British Museum became popular and a haunt for gay men to admire the marbles and maybe get some action.[112] The cult of heterosexual nudity had a brief life in the early years of the twentieth century with the German Expressionists and their circle and was described in the paintings of Kirchner and his contemporaries. In 1906, writing in *Der Eigene*, Heinrich Pudor again praises the Greeks for whom clothed and naked did not exist in the same dichotomy as in modern societies.[113] By now, these kinds of musings carried quite different meanings from Winckelmann a century-and-a-half ago. Nudity, when displayed with ideological intention as it would increasingly be, was the performance of naturalness. This neo-Hellenism was the second stage of the semiotic of the gym body, a worked, self-conscious naturalness—which of course is a contradiction in terms. This contradiction would later be upheld in the epithet of muscle Mary, a more stylized form of the Hellenic body, which in the early twentieth century was far more ephebic, coy and feminized. In 1920s New

York, gay men made use of the feminized stereotype as a kind of 'scripted' type to try to 'turn' straight men, as Shaun Cole observes.[114] In the years leading to the war, male effeminacy had again become the undisputed trait for homosexuality.[115] In the words of Richard Dyer, 'Whether Victorian heliotropes, Weimar Belladonna eyes or Greenwich village beauty boxes, gay male style involved incorporating markers of the feminine into male clothing.'[116]

The Russian-born illustrator and designer Romain de Tirtoff, better known as Erté, was one memorable case of 1920s queer style. His flouting luxury was the ham-handed nostalgia for the age of the decadents of the Belle Époque. When he arrived in New York from Paris, he was described by the *Brooklyn Daily Eagle* as 'wearing a gorgeous crimson and black brocaded coat over his pajamas of pongee. The coat, sumptuous and silken enough to be enough for an eastern potentate, was lined with cloth of gold and sashed with the same; his pumps were inlaid with crimson leather'. Frank Sullivan in an article for the *New York World* that appeared on the same day describes Erté in the mould of a modern D'Orsay, with a watch chain

Fig. 3.4　Jean Genet. Courtesy: Hulton Archive.

'of large links, woven carelessly yet carefully through the buttons of his waistcoat of which there were many'. A later report from the *Daily News Record* paints a picture of a more restrained yet highly studied appearance, the aggregate of the fabrics and the immaculate cut of the suit offset by 'distinctive footwear', oxfords 'of soft calf which met low on the sides and extended up the eyelets'.[117] Erté was one of the standard-bearers for the modern dandy. But as to be expected, the Depression that came a few years later made these signs of moneyed luxury rarer, harder to justify and less tolerable. Although the sumptuousness of queer style would live on in the upper classes, or as try-hard travesty, the Great Depression bifurcated queer style into either the invisible homosexual or one that was visible-invisible through exaggerated traits of masculinity. Toward the end of the Second World War, with the publication of *Our Lady of Flowers* (1944), Jean Genet emerged as a serious author and with him the butch queen was officially born.

Genet was a literary wild card who brought street brutishness together with an unabashed attitude to being gay. Genet was sent to prison for three years from the age of fifteen for repeated acts of vagrancy, the first of a series of scandalous details, many of which he helped to propagate. Although born of loving parents, Genet invented (like Bob Dylan after him) a deprived childhood to ensure his bad boy image remained intact. The publication of the enormous tract *Saint Genet* by Sartre in 1952, while full of dubious assertions (prime among them was Sartre's belief that one chose one's sexual orientation), placed homosexuality firmly onto the philosophical landscape. Thanks to Genet, homosexuality was given an ontology, a frame of being. His alter ego Divine in *Our Lady of Flowers* stands at the centre of a coterie of 'aunties' and 'queens' but maintains a place of dominance. Genet was by all accounts a fairly conventional dresser—the only sartorial alternatives for gays at the time were feminine touches—but in more than one photograph Brassaï captures an assertiveness and defiance that harbours deeper strata of violence, contempt—and vulnerability. Genet was the consummate poseur. He is depicted as the writer-cum-street labourer, his sleeves rolled up high ready for work and holding his Galoise between forefinger and thumb. Genet's political activities with the Black Panthers and the Palestinians were significant preliminary steps to the politicization of the gay movement in the following decades. Curiously enough, the growth of the image of butch queen occurred at roughly the same time as that of the butch femme in America.

Genet is an example of a de-feminization of queer style from the 1950s onward. Unlike Genet, however, the everyday gay male did not have the opportunity to wear homosexuality with honourable defiance; on the contrary, he lived in fear of vilification or, worse, arrest. This led men to turn to convention, to meld into the crowd and become invisible.[118] Was perhaps J. Edgar Hoover the ultimate invisible gay man of this period? To those who had the confidence and the context to reveal them, signs of being gay were confined to small, oblique symbols such as the pinkie ring or suede shoes. (In the 2010 BBC revival of the series *Upstairs*

Downstairs, the first scene introducing the new butler, the presumably queer and primly tea-tootling Mr. Pritchard [Adrian Scarborough], begins with a close-up of his hands toying with his pinkie ring.) Cole explains that one of the popular styles of dress in 1950s Britain was the New Edwardian: overcoats modelled on army greatcoats, tapering trousers and small bowlers that could be worn rakishly askew.[119] But like wearers of pinkie rings and suede shoes, not all who wore such fashions were gay, although the net effect was decidedly camp, recalling, in the words of Christopher Breward, 'the Edwardian race track and the music hall'.[120] Pinkie rings were loaded with quasi-aristocratic connotations. Suede shoes had a very definite semiotic in that they could only be worn under specific circumstances of leisure, not out in the rain or during work, as they are cleaned with difficulty. Clothes and accessories that carried signs of eschewing manly hard labour and connoting a rare and distinguished way of life have long been the recourse of a particular element of queer style. That stands at the opposite pole of the rough trade that Genet helped to introduce and that would find more extreme, brutalist visual types in bears and leathermen.

These elegancies had begun to have something of a genealogy that arose from the middle of the previous century—climaxing in Huysmans's Montesquiou pastiche, Des Esseintes—when dandyism began to take on signs of what Rosalind Williams calls 'elitist consumption'.[121] Less formal dress was just as restrained and maintained a preppy edge. A discernible factor of being gay was a high level of fastidiousness: the best Liberty scarf and so on. To complement the pinkie ring was the cravat, giving the gay wearer yet another quasi-aristocratic edge. Another trait was to wear bright colours—red ties were associated with gay attire. It is curious to think how bright colours have had a mixed history in Western fashion since the mid-nineteenth century with the generic Other. Here again the bohemian and the queer overlap, and one of the richest sources for motley fabrics and fashions was the Orient. Sombre colours have the status of reason and rectitude.[122]

A memorable name from this period is Bill Green, who set up Vince Man's Shop in a back street in Soho. Green, who had started his career as a physique photographer, was inspired by the contrast in men's fashion after a sojourn in France, where men were wearing black shirts and jeans. Generally regarded as the first London men's boutique, Green had similar clothes specially made for his store, and soon he was supplying a sleek continental look to a predominately gay clientele.[123] Green's use of fabrics and colours was adventurous, and he was the first to pre-fade denim. A significant theme of Vince clothing was to accentuate the shape of men's bodies. It was becoming increasingly evident that the she-man was out and the he-man was in. The Torso Shirt, a tight-fitting design to show off the pectorals and biceps, was a particular favourite. Heterosexual men who shopped at Vince were usually from arty circles or sufficiently rich not to worry about being called a 'poof'.[124] Until the 1990s, it was not unusual in British and Australian culture to designate any form of unusual or mildly outrageous clothing as 'poofy'.

When it came to private parties, the sober fashions were jettisoned for drag and fancy dress. One of the more famous venues for the Arts Ball was the Aquarium in Brighton. It was a tradition to spend many hours in preparation for this event, as Cole reports, 'sewing sequins on the gowns...by the hundredweight'.[125]

An Artistic Bent: Warhol, Glam and Pop

Dandyism, as Elizabeth Wilson and later Amelia Jones have argued, is a personified manifestation of capitalism's transitory nature. It is the affirmation of self that flies in the face of bourgeois convention.[126] We have dealt with this rebellion to middle-class values at some length but as yet not with dandyism's position within capitalism. Dandies have always played a part in shaping popular culture, and in this regard Andy Warhol occupies a special place. Warhol's famous inscrutability in art, his deadpan, mirrors the nature of the commodity itself, insofar as the commodity fetish is extracted from its use value or the labour that produces it and becomes its own free-floating quantity. In a sense, Warhol became the embodiment of the commodity fetish, the commodity as performed within a lived being. We might recall that the self-proclaimed virtues of queerness and queer style lie in its shameless celebration of the artificial and the flamboyant—the decorative remainder to a stratified and utilitarian idea of society. Given that Warhol was the very embodiment of the decentredness of capital, it was either serendipitous, or perfectly logical, that he was gay. Warhol's glamour accrued to him by the glamour that surrounded him, which he reproduced in his work. It was also Warhol who muddied the lines between the glamour of celebrity, the obsession with glamour in the press and the glamour of the private gay parties and balls.

Glamour, like dandyism, is a tantalizingly elusive concept. As if channelling Barbey D'Aurevilly, Stephen Gundle in *Glamour: A History* declares, 'Glamour is notoriously hard to define.'[127] It is an aura that maintains a bewitching effect on the beholder. In his *Philosophy,* Warhol tells about 'some company' that was 'interested in buying my "aura". They kept saying, "We want to buy your aura". I never figured out what they wanted'.[128] But Brigitte Weingart in her essay on Warhol's glamour notices how the idea of 'screen magnetism' is confined to one's presence as it emanates after being mediated by film or photography. This, she demonstrates, is a key factor of Warhol's *Screen Tests,* which investigate what she calls the 'grammar or glamour'.[129] Everyone wanted to have a piece of Andy, and the desire to see the 'real' Andy was a quest, a thankless quest, for countless observers and hangers-on. What the humanists fail to see was that Warhol was a ready-made self, a walking, performing artwork. Duchamp had donned a Sélavy garment as an exception; Warhol wore it daily. Victor Bockris in his biography of Warhol revealingly shows how 'being Andy' was something of an arduous occupation. Warhol reportedly said that sometimes 'it's just great to get home and take off my Andy suit'.[130] This is illuminating

for the way in which queer identity melds dress, temperament and performance, shattering, as Wilde had already showed, the distinction between essence and appearance. Of Warhol's uncanny ability to seem to live out a television show, Elisa Glick writes:

> This sense of experiencing life through the mediation and aesthetic distancing of the image (a characteristic of the post-Fordist society of the spectacle) also points to the ways in which Warhol's quest for fame and reified experience ultimately moves him toward the depersonalized abstractions of Pop dandyism.[131]

Warhol helps to position the carnivalesque aspects of queer style and culture within popular mainstream but also helps to understand its staging within mediated representations. Gay types, or clones, would become increasingly conscious of their precedents as represented in mainstream culture and how they would be represented. Just as Warhol would famously leave a party once he was photographed there—the ultimate reduction ad absurdum of 'being seen'—gay dress from the 1960s to the present day, especially when it is for parties and get-togethers, is seldom an informal, vernacular affair, for it anticipates being made into a picture, enframed as a type or by the friend who photographs you for an album or, preferably, for the social pages of a magazine. To paraphrase Madonna, another celebrity who benefited from Warhol's shape-shifting, queer dress is worn socially to 'strike a pose'.

Warhol was the complex personification of the collapsing interrelations between art, fashion and popular culture, collision between high and low, that were happening in Britain and America and, at a slower pace, in peripheral countries as well. Warhol helped to expand the dandy persona to give him a more pronounced gay edge. But it was also Warhol who almost singlehandedly helped to cultivate the alternative scene in New York through his studio, the Factory, which also served as a party house, performance venue and general meeting area. It was a home for transvestites and rent boys, femmes and butches.

The prize stud among them was Joe Dalessandro, with whom Warhol had an abiding infatuation and who starred in a series of Warhol-Morrissey movies, including *Trash* and *Heat*. Dalessandro was a bent bisexual and a centrepiece of the Factory scene. He was 'Little Joe' in Lou Reed's 'Walk on the Wild Side' and the star of *Flesh* (1968), which beat *Midnight Cowboy* at the box office. Dalessandro played a male hustler, and it was the first time full-frontal male nudity featured in mainstream cinema, and male with a slightly ephebic air, that could be the object of both male and female desire. This was followed by *Trash* (1970), where Dalessandro played a heroin junkie with his girlfriend, the transvestite Holly Woodlawn. *Heat* (1972) saw Dalessandro play a former child star with a ponytail down to his waist who sleeps with Sylvia Miles and her lesbian daughter. He also starred in the *Flesh for Frankenstein* (1973) and *Blood for Dracula* (1974), both contestably retro-horror masterpieces. In both he plays the aloof hetero-stud, and his co-star is Udo Kier, who

went on to star in Fassbinder's *Spermula* (1976). The famous opening credit scene of *Blood for Dracula* ingeniously transposes into the horror idiom a drag queen applying make-up for a show: a blood-starved Dracula paints his hair black so as to appear his best before he and his camp attendant pay a visit to an impoverished aristocrat on whose three daughters he intends to feast. Kier continues to exploit the queer-horror persona (he reappears in 2000 in Elias Merhige's *Shadow of the Vampire*), and in 2009 Dalessandro won the Teddy Award at the Berlin Festival for his contribution to gay cinema.

Glam style began in London and New York in the 1970s together with punk and other subcultural styles. By now being or just looking gay had become much more hip and counted as part progressive, part cutting-edge practice. It was for this reason the likes of Alice Cooper pretended to be gay.[132] Other groups such as the Beats brought together a trash and freedom aesthetic built on friendship, spontaneity and aggression. William Burroughs was an example of what Glick terms 'gutter dandyism',[133] which is a graphic epithet of early underground glam before it was institutionalized in the 1970s by David Bowie's Ziggy Stardust and Gary Glitter. Bowie came out as a bisexual at the time, while Glitter from the late 1990s on was subject to a series of child pornography and pederasty charges. It was also during the 1970s that sexual adventure combined with the use of illicit substances, both rites of passage to what mainstream society viewed, and continues to view, as dangerous places.

From the 1960s onwards, popular culture has placed a premium on sex to situate subjective meaning. Early stars in Britain such as Rod Stewart, Mick Jagger and Bryan Ferry all relayed very rounded images of their sexuality, which played directly into how their work was understood. Bowie's Stardust look from 1972 was a wild mixture of sci-fi and commedia dell'arte. He was clearly dragging 'clown' but with a sharply revamped edge: self-deprecating but at the same time obscure and predatory. What is not widely known is that Bowie did not invent the look single-handedly. His costumes were made by Freddie Burretti (who once, when arrested, gave his profession as 'seamstress') and were based on ideas offered by Bowie's then wife, Angie. Angie also suggested that they bring in Bowie's mother's hairdresser to do his hair.[134] Bowie's thin physique played the androgynous waif to Jagger's hip-gyrating saturnalia. Stan Hawkins writes that Bowie's 'artistic identification with Mod culture and lifestyle played a decisive role in his turning to fashion'.[135] His sensibility found its best expression 'as a bisexual space alien'—where space travel met transvestism, positioning Bowie in opposition to the heterosexual conventions of rock. With his red, spiked hair and tight-fitting glitter costume, Bowie turned the Elvis look into an amphibious alien. Together with his lead guitarist, Mick Ronson, he made a sham of 'cock rock'. Hawkins concludes that Bowie's 'transformation from Mod to hippie, to Ziggy Stardust to Aladdin Sane, throughout the avant-garde rock style of *Low* and *Heroes,* to the pop dance style of *Let's Dance,* his queering renegotiated masculinity'.[136] In the 1980s, Bowie's suit-wearing for *Let's Dance* decentred the already left-of-field oversized suit of David Byrne in *Psycho Killer,* as well as bringing

slick together with sleaze but more ambiguously than the narcissistic hetero-dandy Bryan Ferry of Roxy Music whose hetero-sleaze, especially the album covers, tips precariously into camp.

While the 1980s youth of Britain were swaying to their faux-sinister glam pop dandies, the lower-middle-class middle-agers of American were in the last years of getting their culture filtered to them by Liberace. Liberace, who died in 1987 and who won a libel suit over an insinuation he was homosexual, had transformed the vampire look of big cloak and tuxedo into camp bling. He was famous for his gigantic and numerous rings ('Like my rings?' followed by a toothy smile) and his capes with high-standing collars. Everything in Liberace's appearance, the satin, the velour and the glitter, was a campaign to stand out. It was also the outward appearance of wealth by wearing wealth on one's person. As Margaret Drewal notices, 'Liberace presented himself as a conspicuous consumer, [and] empathetic audiences responded with a disoriented desire of capitalist desire, the realm of the hyperreal vampire value.'[137] The embodiment of capitalist wantonness, Liberace reduced the pageant and the carnival down to a single figure: himself. In the name of blue-collar vulgarity, Liberace made a career of undermining value and taste.[138]

Gay Activism and Gay Pride: Clowns and Clones

Until the 1960s, homosexuality in dress and identity was still an attribute and a feature: not all dandies were gay, nor all effeminate men. The term *gay* is an invention of this era and with it is the proverbial new dawn for gay and lesbian pride. Sidestepping the word *homosexual* with its positivist and pseudoscientific connotations, the terms *gay* and *lesbian* lay claim to a set of rules and beliefs, diffuse as they are, that are substantive, real and worth lobbying for. In the 1950s, gay men found themselves at a loss as to expressing their identity if they did not wish to go down the path of flamboyance and effeminacy. As opposed to the 1920s, which was tempered by the hysterical relief of having outlived a violent and protracted war, the decades after the Second World War were an unprecedented boom time in the United States in which the codes of heteronormative behaviour seemed all the more normal and unchallengeable. In the protest era of the 1960s, gays joined hands together with other minorities, the dispossessed and disaffected with a sense of assertiveness that bordered on violence.

One signal example of this was the protests that occurred in Los Angeles at the end of 1966 against the 10 p.m. curfew laws and arbitrary arrests of boys with overlong hair or unconventional clothing. Before the police called in bulldozers, the crowd expanded to over 2,000. Among them were gay people who delighted in cross- and countercultural dressing. As one contemporary notes, 'We used to dress up in the most outrageous outfits on weekends, and the [hippie] styles gave cover to us gay kids.'[139] Hippie fashions were everything that the suited uniformity of male 1950s fashion was not: bright florals, paisleys, motley flared pants. It is curious again to

pause to reflect on the way in which Orientalist fashion, to which hippie dress availed itself to a considerable degree, was used by groups who identified themselves in terms of some form of otherness. Conducive to queer fashion, hippie dress could easily be taken to extremes: bright colours made lurid and wide-bottomed pants tapering to butt- and ball-hugging tightness. Hippie styling was also the first instance in modern Western male dress of conspicuous jewellery, which, as opposed to the shoulder chains of the Renaissance, hit a sexualized, tribal note. Hippie fashion marks one of the turning points in post war men's dress that made feminizing touches permissible, even desirable. Something of a reversal was taking place: whereas for a decade or so gay men had disappeared under conventional dress, straight men could now appear in clothes that were also worn by men who were openly gay. The sexual revolution, which such fashions were part of, compounded the former divisions of sexual relations to a point where it was fashionable to be experimental.

In the age of bed-hopping and cross-dressing, the Gay Pride movements of the late 1960s effectively turned the effeminate male back to where he had been a century ago: to a category rather than a stereotype of gay identity. But unlike in the nineteenth century, gay men, for the first time in history, had independent agency over how they were perceived. Sartorial signs, just as places of meeting, were no longer secretive; the toilet and the beat were more a matter of choice than necessity, as were pinkie rings. Gay men had begun to take decisive ownership over how they were seen. Signs of gay identity became more forthright, from earrings in the right ear (or two earrings; why hold back?) to back-pocket coloured scarves and bandannas. The latter evolved into something resembling the semantic intricacy of a naval flag codes. For example, a red scarf or hanky in the left pocket indicates a 'fist fucker', whereas one on the right means a fist recipient; green in left pocket means a hustler selling; in the other pocket, hustler buying.[140] Heaven help the colour blind!

Gay identity and dress were no longer under the aegis of equivocation, misdirection and irony. These qualities still prevailed but as countervailing to a variety of others, with the 'fairy' (or 'faerie') on one hand, and the bear and leatherman on the other. The dandy was now but one figure among what was a mountingly large taxonomy of queer types. The best example of this in popular memory is the Village People, known for hits such as 'Macho Man' and 'Y.M.C.A.' Formed in 1977, it was known as a 'concept disco' group in which each member was dressed up: the cowboy, the cop, the American Indian, the leather boy, the G.I. and the workman. Unwittingly of course, their garments have had a great deal to say socio-sexually about queer men's style from the 1970s onward for, apart from the leatherman, there is nothing ostensibly queer about these types. On the contrary, many of them fit the mould of what it means to be heterosexual; one only has to remember the recent furore surrounding the admission of gays into the military, with the 'don't ask don't tell' policy, which existed from 1993 until it was repealed in September 2011. The act of dressing up perpetuates not only the performative aspect of gender and sexuality but also the vaudevillian side, which has always been part of the modern gay

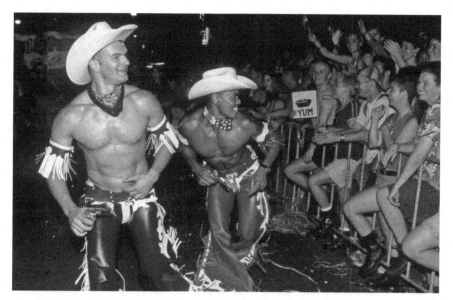

Fig. 3.5 Marching male couple from Melbourne on Oxford Street at the Sydney Gay and Lesbian Mardi Gras, 1997. Courtesy: Moore Hardy Collection, City of Sydney Archives.

sexuality. In Mardi Gras parades in Sydney Australia, it is not common yet expected to have floats that travesty the mores that continue to condemn or disavow queer culture, ranging from the military to the Pope. This kind of ebullient and self-conscious dressing up, dressing up writ large (as opposed to dressing up to conceal), also reveals an expansion of the ways of the dandy; where once only the dandy or bohemian were sites or repositories of queer style, now there are many.

Finally, the ambiguity of these types, namely that they are both straight and gay at once, is a tangible example of the subversion that is a fundamental characteristic of queer style. There is no queer style in and for itself; rather it exists as a multilayered form that both celebrates and desecrates in the same movement. From looking at the official 1978 video of 'Y.M.C.A', if there was any marginal doubt of it being about gay relationships—maybe it is just a bunch of crazy guys in fun outfits giving a 'young man' advice about where to hang out in a new town—then the clip from the year before of 'San Francisco' leaves no grain of doubt. Lauding the 'city known for its freedom', the Indian is shirtless and one member is in a T-shirt and jeans supported by suspenders, another accessory attractive to queer male style particularly when it is functionally redundant. The lead singer, Victor Willis, is dressed in a stovepipe hat and a leather vest that opens to his bare chest adorned with a couple of gold chains. Indeed, in 'San Francisco', the anthem to gay pride and place, the Village People are dressing up as themselves. There is more to this than the anecdotal fact that the group was formed after its founder, Jacques Morali, became inspired after visiting a gay bar in Greenwich Village. Each band member dressed in particular garments that

reflected the sartorial styles prevalent in gay club culture that would become iconic as gay 'looks' in popular culture. In 2005, Ang Lee directed *Brokeback Mountain,* a film adaption of the 1997 short story by Annie Proulx of the same name, starring Heath Ledger, Jake Gyllenhaal, Anne Hathaway and Michelle Williams. Based on the sexual and emotional relationship of two cowboys, Enis del Mar and Jack Twist, the film's significance has been attributed to its portrayal of a same-sex relationship without reference to the history of the gay civil rights movement but rather in terms of a tragic love story.

The Village People's hit 'San Francisco' offers a fundamental insight into queer style. Given that queerness has no access to myths of essentialism or autochthony, it inhabits other styles that it then reworks to make them its own, like some celebratory parasitism. The Village People, who went through several incarnations as members came and went, is also an example of the masculinizing of gay identity, which had begun to take wing from the 1970s onward. Gay men began fashioning clothing styles that allowed them to 'blend in' to mainstream culture. 'The idea was to look more masculine', writes Joseph H. Hancock II, 'somewhat straight become accepted by the social order, and thus appear more attractive to each other'.[141] It was the birth of the hyper-masculine clone with a standardized dress style consisting of flannel shirt, baseball hat, jeans, fatigues and hiking boots. The culture of manliness of the 1970s anticipated the full-scale body culture of bodybuilding when anabolic steroids became more freely available in the late 1970s. (It is also worth observing that it was only in the early 1980s that female bodybuilding began as a culture, unearthing some very interesting questions of gender resemblance and convention; for example, should the breast be left to develop into muscle or should it be re-articulated with a silicone implant?) As Hancock observes,

> Unlike the straights, gay men, overcompensated and recontextualized these traditional masculine appearances with rituals that included: weight lifting and body building routines to pump-up their muscles; engaging in extensive grooming regimes that kept their hair, skin, nails, and teeth nicely polished; and wearing their new ensembles fitted to every curve and crevice of their muscular bodies.[142]

Masculinizing gay identity cannot be seen in isolation as an impatience to the effeminized stereotype but, first, as a touchstone for opening up the possibility for different queer identities; second, to claim masculinity for gays as well as straight males; third, to internalize and re-embody the desire for maleness and, indeed, the desire to conquer males felt by many gays; and fourth, to recognize the complementary counterpart of the effeminate male in which the more male member is conceived as the giver and the girly boy, the receiver.

An outstanding model, and symptom, of the growing taste for manliness among gay men was the fictional creation of the Helsinki executive Touko Laaksonen: Tom of Finland. Tom of Finland was to the world of soft porn and comics what the Village

People was to the disco set. Touko dressed in leather, becoming Tom, and dreamt up a whole menagerie of pumped, ripped guys, 'a gay utopia' in the words of Guy Snaith, 'full of horny lumberjacks, sailors, policemen and construction workers, all bursting out of their uniforms or their jeans and T-shirts. Tomland is a fantasy world in which masculinity is held up as the highest ideal'.[143] Laaksonen invented a universe in which jutting chins and full, pursed lips gazed longingly at biceps and pectorals that bulged with exaggerated rotundity or, to use the correct gay expression, 'big pecs, tight abs and bubble butt'.[144] Snaith goes on: 'Through his fantasy of total maleness, Tom sought to eliminate gay guilt, to correct injustices, to validate gay men, their desires and their experience, to destroy the stereotype which equated homosexuality with effeminacy.'[145] Laaksonen may have come from Europe, but his characters are definitely New World. Due to their depiction in the American movie industry, American males, especially those of the working class, were seen as more virile than their European counterparts, who bore the legacy of the aesthete, the effete, pruned and groomed dandy.[146] (Americans wear boots; Europeans wear suede loafers.)

Manliness and muscularity had already began to be popular with publications such as *Physique Pictorial,* which had illustrations of groups of buff, scantily clad men; construction workers pausing for a drink was a favourite.[147] Laaksonen did his own cover illustration for this magazine in 1968, and this time, with penises straining within the tightest of pants, there was little left to the imagination. Tom of Finland took masculinity to an absurd extreme that went so far as to parody heterosexual aspirations, transposing it into the gay-o-sphere. Heterosexual pornography had long relied on exaggeration—huge tits, long legs, small waist, big lips—which was best realized in the comic blonde in *Roger Rabbit,* and Tom did the same with manliness. But it was so tipped as to be a threat to heterosexual male desire, not least because it confronted straight men with traits that they aspired to as well. The effect of Tom of Finland on the male, gay community was immense, liberating many from inhibitions and to assert that maleness, such as it is, is an idea to be shared between gay and straight men.

A particularly easy-to-spot gay type in the 1970s was the clone that worked from a James Dean or Marlon Brando-esque cue of T-shirt, jeans and leather jacket. The jeans had to be 501s, and the bodies beneath the T-shirt were usually gym-toned. Musculature was again an important component (as opposed to just the interior armature) of the style, and a flat stomach was a visual launching pad, if you will, to a bulging crotch in jeans that were invariably too tight. The introduction of stretch denim jeans in the early 1980s, such as those by Lee, were particularly welcomed, although gay men were wary of their similar popularity amongst women. A reigning motif seems to be salient by this time in gay male dress, in that it tropes on working-class roughness. The clone was a stylish thug. In colder weather, plaid or checked shirts could be added to the ensemble, and a hoody could be seen to emerge from the leather jacket. Shoes were usually construction boots, but if the weather was warmer, Adidas sneakers were acceptable, and if the jacket had to be shed, then a Lacoste polo was

needed. The latter, which was eventually monopolized by Ralph Lauren, became the mainstay of the next phase that took hold in the 1980s, which was the preppy look.[148] This was like the end of the twentieth century's equivalent of the New Edwardians many decades earlier: clean but sportier. If anything, gay male style placed, and continues to place, a premium on cleanliness. The polo shirt has since had a special place in gay male dress, as it is also a staple form of dress of straight men and of straight bodybuilders. It is popular for the way holds a buff physique admirably, and the lengthiness of the Ralf Lauren polo lends itself to tucking in, producing the pronounced 'V' physique of Tom of Finland.

In the 1970s and 1980s, the voice and visibility granted to gay men in America, Australia and most of Europe, at least, widened the ambit of self-creation. The theatrical, performative aspect of gay identity still applied but with greater diversity and energy. In one of the earliest books on gay identity in the cinema, Parker Tyler organizes his chapters according to sets of gay types. Here is an abridged list of names that occur simply in his chapters' contents: Mother Superiors, Father Superiors, Charley's Aunts, drag queens, drag dolls, Paulines, Purviances, Hustlers, male Dorian Grays, female Dorian Grays, courtly cupids, hustling cupids, young gods in drag, Baby Budds, poets of drag and non-drag, in-group innocents, imperilled privates, high-fashion tantes, low-fashion tantes, green carnationists, kittenish werewolves, uncle-aunties, gunsel-bosses, Greenwich Village tomboys, female girl-getters, soldiers, supersoldiers, subsoldiers, high and low schoolboys, fascist finaglers, draft-board daisies, boyish bonnes, kingly kampfs, sissies, tomboys, Nervous Nellies, delicate delinquents, male war brides.[149] Many of the references will be familiar to any reader of gay-oriented literature or the reader at this stage of the chapter—green carnationists obviously refers to those interested in mimicking Wilde and his circle. There are a handful of reasons for this rather motley taxonomy. As we have seen, gay style, and queer style in general, has a habit of inserting itself into both normative and already established queer stereotypes. These role-plays provide arenas for expression that are alternatives, humorous or serious, to the everyday course of events.

But it would be inaccurate to overplay the freedom that gay men exercised at the end of the twentieth century. The AIDS epidemic that commenced in the United States, Europe and elsewhere in the early 1980s did much to diminish the gains of the previous decade, especially since it gave conservatives the opportunity to connect homosexuality with one of the world's most insidious diseases. The stigmatizing of the gays with the disease—as if an act of divine retribution was being visited on them for their 'unnaturalness'—was compounded by the neoconservatism of Reagan and Thatcher. But forces of oppression can give vent to some of the most explosive opposition. The standout figures in male queer style are Leigh Bowery and Boy George. Born in the same year (1961), both helped to reinstate the gay persona as one instituted in invention and extroversion.

Bowery studied fashion briefly in Melbourne, Australia, before leaving for London. While he initially failed as a commercial designer, he succeeded as a

performer. A cult flowing soon grew around Bowery and his outfits, which he performed in in London's constricted club scene during the Thatcher years. By the mid-1980s Bowery was firmly identified as a fashion designer and clubber. His designs achieved some success, showing in the fashion shows in New York and London. Being large in height, frame and girth, Bowery fitted neither the mould of the muscle man nor the lithe pansy. His costumes were designed to compensate for the discomfort he felt in his own skin. Bowery was happy to call himself gay, despite having had relationships with women, usually playing specific roles (he married Nicola Bateman in 1994, about six months before he died). The outrageousness of his outfits and designs drew on clown outfits since the seventeenth century, the lively chromatic discordances of 1940s Technicolor film and a veiled taste for perturbation and horror. Enigmatic but never aloof, Bowery was the next stage after Warhol in the ambiguous art-fashion divide. The sinister element is what ensures that Bowery's outfits and designs cannot be confined to camp. Rather, they inspired the next generation of designers, such as Thierry Mugler, Alexander McQueen, John Galliano and Gareth Pugh. That he died of AIDS at the early age of thirty-three lends his work a certain periodizing specificity. In retrospect, we can speculate that many of the designs and personas express an air of corruption and queer in the broadest sense of the term to the epoch obsessed with its own overproduction and overconsumption. It was as if Bowery led insight to the adolescent blindness to the era's inevitable demise.

Boy George was one of the original punk/New Romantics who influenced Bowery's move to London. Bowery learned a lot from Boy George, with his mixture of dandy and clown, sexually ambiguous and always outlandish. In 1979, Boy George was painting his face in lurid yellow, which no doubt influenced Bowery's red-and-blue face in his 'pakis from outer space' look from 1982. Boy George's outfits at the height of his success with the group Culture Club in the early 1980s were exaggerated suits that called to mind the 1920s zoot suit with a mannish geisha. He was always heavily made up. But the use of heavy eye make-up was by then not exclusively effeminate, as it had been claimed by subcultures such as mods, and pop music had begun to establish make-up as all but de rigueur. Bowie's example had spilled into all forms of make-up used by straight and gay alike. Boy George's outfit in 'Karma Chameleon' is an undersized hat (remember the New Edwardians?) tipped back and embellished with exotic feathers; his hair is topped with a sizeable quiff and falls down in long strands braided with bright yellow and red string and ribbon. The coat is of ordinary khaki-beige plaid, but it is the support for a brightly checked shirt, which is finished with a chest decoration of iridescent pom-poms. His sharp features are sharpened even more by highly accented mascara and high-key eye shadow.

Boy George and Bowery were, for all intents and purposes, anti-clones. The costumes of cowboy or lumberjack—worn with care and cleanliness and not serving the actual function of cowboy or lumberjack—had become established types which emanated from connotations of butch masculinity. The sole principle was

outrageous invention, taking performativity to an extreme to become almost like living sculptures. True enough, Boy George had his clones amongst men and women in his day, but they were of the same category as children who painted their faces like Gene Simmons from the all-make-up band Kiss. Certainly, New Romantics were noted for their narcissism. As will be recalled from the previous chapter, the openly straight bands Duran Duran and Spandau Ballet wore heavy make-up for their promotional shots and during performances. They, like Bryan Ferry, were aggressively dandified: inscrutable, self-satisfied and well-dressed (don't forget the shoulder pads). Band members, such Duran Duran's Nick Rhodes, who were also svelte and small, adopted a visible effeminacy, although they were/are not technically gay. In the visually stunning and clever extended video to the 2011 song 'Girl Panic', which was directed by Jonas Akerlund, the four principal Duran Duran members are played by supermodels Naomi Campbell, Eva Herzigova, Cindy Crawford and Helena Christensen. They are surrounded by a coterie of other models, who are in some scenes dressed in bondage gear and kiss one another. The song is periodically broken for a faux interview, to which the women literally mouth the titbits of testimony of the original band members. At the very end of the video, an interviewer played by Rhodes comments to Herzigova, who plays Rhodes, 'Now you have been described as the world's first metrosexual.' She replies with dandified nonchalance: 'I don't read that stuff.' The many layers of sexual role-play and desire are too complex to explore here, but what the video brings out is a spectacle of heterosexuality that is far from straightforward.

Another New Romantic dandy was David Sylvian who eschewed outward manliness, was a lover of dramatic blow-dried hair and was known for the cooing vulnerability of his singing—he too is not publicly gay. Adam from Adam and the Ants not only wore futuristic make-up but also wore a fist full of rings—Liberace was evidently no comparison. The following generation of performers would use make-up and gender ambiguity to more perverse effect, notably Marilyn Manson who seeks to personify Udo Kier's Dracula from the Warhol-Morrissey *Blood for Dracula* together with a deeply disturbing, aggressive evil. While again openly straight, Manson's face is androgynous and helped along not only by dark eye shadow but also thick applications of blood-red lipstick. In 2004, a Maori rugby player appeared on the field wearing eyeliner.

Like Bowery, David McDiarmid (1952–95) was born in Australia and received his success overseas, and he also died of AIDS. He was an artist whose principal output was himself in various performative acts of being gay, being seen. Being seen, as we've mentioned, was a performative ploy mastered by Warhol, and McDiarmid expanded the notion in what Sally Gray calls 'performative self-presentation' in a life-as-art mode that brought being gay to the fore.[150] Clothing played a critical role in his self-staging, and the many photographs of himself show him in different guises, playing out different gay stereotypes. But it was his aim, Gray argues, to liberate stereotypes from their 'entrapment' through irony and appropriation.[151] McDiarmid's

studies in 'self-composition'[152] were in many respects the gay male counterpart to Cindy Sherman's critical masquerades. What Gray fails to observe, however, is that what made McDiarmid's work possible was a certain flattening of gay male stereotypes into mainstream culture. His acts had ceased to be transgressive or even alarming. For one can only historicize once one feels outside of the moment—never within it. By the time McDiarmid died, the gay stigma of AIDS had receded, and gay men were increasingly reflexive about their persona and their public face.

Contemporary Queer: Hard to Say

Writing in 2005 in the *New York Times,* David Colman asks:

> How about that guy you see in the locker room, changing out of his Prada lace-ups, Hugo Boss flat-front pants and Paul Smith dress shirt and cuff links into a muscle T-shirt and Adidas soccer shorts. Does he wear that wedding ring because he was married in New York—or in Massachusetts?[153]

The result, he says, is a 'new gray area that is rendering gaydar', the radar for discerning who's gay or not, 'as outmoded as Windows 2000'. This new 'convergence of gay-vague style is not to be confused with metrosexuality';[154] rather it has to do with an indifference about whether one is read as gay or not. He then goes on to list straight men that are repeatedly pigeonholed as gay. As members of the 'cult of the self', the metrosexual, a term coined by journalist Mark Simpson in 1994, has much in common with the Victorian dandy. While dandyism existed in the realm of the elite and aristocratic, and metrosexuality is a mainstream, mass-consumer phenomenon, both subjectivities embody the 'spirit of the times', namely decadence, excess, artifice, beauty and aestheticism, and both, most importantly, problematize and blur the gender binaries of homo/hetero and masculine/feminine, opting for a more hybrid or queer identity.

Gay sensibility and queer style has, it seems, broken down. 'The lack of any one gay sensibility has meant that *Out* and other gay publications have struggled to reconcile a host of identities, while gay-vague magazines like *Details* and *Cargo*', which are aimed more at the simply fashion conscious, are enjoying success.[155] There are, to be sure, things that are still pretty 'gay', for example liking Kylie Minogue and wearing super-tight jeans in a gay bar, but that is not the point. What we are seeing is a society in which acceptance is more widespread and visible gayness is more a matter of choice than of a political mission. This view was echoed in 2001 by the fashion designer Julien Macdonald when he stated that gay men were less likely to go for the uniforms of leather or the like that had come to be universal signs of being gay. He asserted, 'Nobody wants to look gay or camp. I think that the older generation of gay men still hang on to this overtly gay look, but younger guys just want to blend in... It signals a need for conformity, for not standing out.'[156] Other commentators, such

as Rob Cover, agree with this to a degree but also vouch for a level of visibility in style and dress. Being restrained does not mean invisible.[157] There also appears to be little consensus whether gay males are more brand conscious in the early twenty-first century than straight men.[158] But, if homosexuality and lesbianism are less sexual categories and more dimensions of human identity, why are we still obsessed with sexual identity? After all, gay is used as an everyday expression for uncomfortable, cute or lurid, whereas straight has far less currency and is a more conventional descriptor as opposed to an idiom.

When gay men, by nature or choice, do not fall into a clone or stereotype, we would argue that there is a new millennial identity that is both assimilative of some normative while at the same time signalling slippage.

In the words of Jeffrey Weeks:

> The preoccupation with identity cannot be explained as an effect of a peculiar personal obsession with sex. It has to be seen, more accurately, as a powerful resistance to the organizing principle of traditional sexual attitudes, encoded in the dominant and pervasive heterosexual assumption of the sexual tradition. It has been the sexual radicals who have most insistently politicized the question of sexual identity. But the agenda has been largely shaped by the importance assigned by our culture to the 'correct' sexuality, and especially to the correct sexuality of men.[159]

Although Weeks was writing in the mid-1980s, his assertions still hold. The fact that we still inquire about whether someone is queer more often than straight is abiding evidence of this. But today, the devil is in the details. And it is also contentious whether queers wish to be fully 'accepted', especially in the sense of being repatriated into heterosexual habituation. Registers of difference, or what Cover more appositely calls 'disturbance',[160] in mannerism and dress, small as they are, grains of dissent, are key to queer style and identity. It is also incontestable that gay men's fashion and dress is multiple and now works from a range of subtle historical references.[161] More gay men are subscribing to the Brummellian ethos in which, in the words of T. Burnett, 'To attract attention to one's dress was the supreme mortification, and yet paradoxically to dress in such a manner was itself a defiant statement, expressing scorn for the values of ordinary men.'[162]

During the 1970s and 1980s, advertisers and marketers began actively to solicit affluent young gay male consumers through strategies that mobilized homoerotic imagery and latent homosexual messages. As Rob Latham suggests, 'The basic approach of these ads involved appealing to consumerist narcissism by fetishizing images of sleek young bodies living a dream of glamorous affluence and perpetual adolescence.'[163] In the process, argues Latham, the advertisements blurred the distinction between heterosexual and queer consumers, 'since all were linked in their common narcissism: the consumers' desire to *be* young and beautiful, was conflated

with the desire to possess youth and beauty as incarnated in the beguiling models'.[164] It was at about this time in the 1980s that new discourses began circulating in Britain about masculinity, with one motif occurring repeatedly, the image of the 'new man'. 'A hybrid character', writes Frank Mort, the new man 'could not be attributed to one single source. He was rather the condensation of multiple concerns which were temporarily run together'.[165] For the advertising and marketing industries, the appearance of the new man signalled the growing cultural and commercial confusion around gender privilege and masculinity as well as subjectivity and sexuality. In its 1988 spring issue, *Arena* magazine posed the question, 'How *new* is our New Man?' According to journalist Jon Savage, the image of the new man was initially circulated by the style culture through style magazines such as *ID* and *The Face*. 'The image is up to date yet aspirant, recognizable male yet admitting a certain vulnerability, still able to be interested, obsessed even, with clothes, male toiletries and new gadgets.'[166] The style culture, Savage argues, 'has effectively helped to fuel a new type of consumption and have codified a fresh marketplace: the 19–45 year old male'.[167] According to Savage, the gay milieu informs male representation, and images of men's bodies on display have been exacerbated by renewed social sanctions on homosexuality.

The influence of gay pornography in the 1990s, through the work of photographers Bruce Weber and Herb Ritts, also contributed to key developments in the representation of masculinities in fashion iconography. This homoerotic style of photography, where men were depicted as narcissists, also found expression in the work of fashion stylists including Nick Knight and Ray Petri. Men were presented before the camera as actively masculine or passive, inviting men not only to consume the products but also to look at themselves and other men as objects of desire to be purchased and consumed.

A watershed instance of public recognition of gay male sensibility came with the reality TV show *Queer Eye for the Straight Guy*, which was launched in 2003 through the US Bravo channel. Under the modern epithet of making the metrosexual, the premise of the show is an old one: that gay men have a better grasp of fashion than heterosexuals. A group of gay fashionistas, each representing a particular portfolio of grooming, assembled to remake a straight man; the straight man is configured as dishevelled and likably inept when it comes to urbanity and taste. *Queer Eye* was a case of gender performativity at its best, with the gay compères actively playing out their superior taste. And as a constructive yet wryly satirical encounter between gay and straight men, it blurred the gender boundaries and, if only within the televisual frame, tipped the balance of power. The coinage of *metrosexual* suggested a new stratum of style that embraced qualities of different kinds of men, so long as they subscribed to cutting-edge urbanity. With gay men having a say over style, they were thereby deciding the contours of attractiveness and desirability, with the question always hanging, whose desire for whom?

What can be answered with all sureness is that this desirability was set within fairly fixed parameters, which had essentially been established and ordained by a heterosexual universe. For while the show showed a handful of gay men who were garrulous, magnetic and smart, Jay Clarkson warns that what they stand for represents 'a potentially dangerous capitulation to a market-driven masculinity that depends on a high level of consumption'.[168] Clarkson goes on to observe that the gay viewers who both liked and disliked the show nonetheless shared a traditional view of masculinity and were hostile to characterizations of gay effeminacy.[169] But most curious of all is that certain gay men resisted the articulation of consumer masculinity because, indeed, it was too gay. It situated a wonderful convolution of historic types in our contemporary urban society, namely that the male sartorial codes that come to us through gender polarization, if done *too* well, threaten that polarization. Oh, dear.

Queer Eye emphasized that a major facet that has contributed to the complexities of contemporary queer identity is the widening of perceptions of what is acceptable for men to wear and use. Social movements of the 1970s such as feminism, movements for sexual liberation and a range of identity-based political movements, such as gay and civil rights, have also influenced constructions of contemporary masculinity. These social movements disrupted traditionally held views of race, sexuality, class and identity and promoted a model of democratic gender equality. The outcomes of these movements challenged hegemonic models of masculinity, articulated as a 'crisis in masculinity' and created new ways of conceptualizing and articulating masculine identity. Since the late 1980s and the emergence of the new man, a proliferation of masculinities has challenged conventional categories of male subjectivity, including the 'emotionally sensitive new lad' of the 1990s and the narcissistic twenty-first-century gender-bending metrosexual, who is in constant flux with his feminine side. Straight men were being introduced to products, particularly cosmetics that had previously been the province of effeminacy. Eau de cologne was publicly available for sale since the mid-nineteenth century; men, usually dandies, would use it to scent gloves and handkerchiefs. It is true that the turn-of-the-century aesthete would wear perfume—Guerlain's Jicky was perhaps the first unisex scent—but by the 1940s aftershave was associated with an emollient used at a barber shop. One of the revolutions in male perfume came in 1994 with L'Eau D'Issey by Issey Miyake. It marks the beginning of the fresh cucumber and green tea styles for men that are wholly un-woody and tobacco-like. The fresh style has been emulated by almost every major perfume house, successfully becoming a unisex brand, as in CK One by Calvin Klein. For over two decades, the industry of male cosmetics has been lucrative. Although admittedly not up to that of women, it is now very much here to stay. We do not think twice about men hovering about these counters and stands in department stores and airports; it is a chastening thought to think that the same action in the 1920s may have had one arrested.

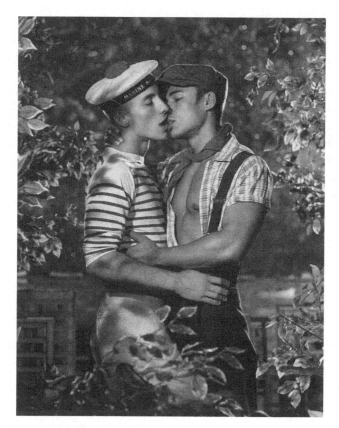

Fig. 3.6 Pierre and Gilles. Courtesy: Galerie Jérôme de Noirmont; Copyright: Pierre et Gilles.

To show the extent to which sensibilities have changed since even the 1990s, the perfumes for men by Jean Paul Gaultier, commencing in 1995 with Le Mâle, were universally dubbed gay perfumes. To avoid any ambiguity, for its promotional campaign, Gaultier enlisted the artist pair Pierre and Gilles, known for returning the sailor and other types masculinized by Tom of Finland back to a camp, feminized fold. Their work is known for an obvious, kitschified beauty that refers back to the old Technicolor films. Like them, Gaultier and Mugler's fashions often spill precariously into kitsch,[170] a precariousness that at its worst is bathetic and at its best is enticing for all sexes and dispositions. But camp, it seems, is more malleable than ever before; straight men can be camp, too.

Heady and bold, in the late 1990s Le Mâle was worn predominately by gay men but also by heterosexual males who wished to show that they did not subscribe to aggressive, heterosexual male stereotypes. The bottle itself, the shape of a muscular

male body wearing a sailor's uniform, is a design tour de force and heavily homo-erotic. Today, however, these semantics are a distant memory. It is now just another male fragrance and is the number-one-selling men's fragrance in Europe. Another fragrance of this genre is Thierry Mugler's A*Men, one that is rich in wood and spice and takes masculine notes to an extreme, much like the muscle Mary over qualifies for manhood—or we might again recall Proust's Baron de Charlus, who at one point over-asserts his masculinity because he is really a woman. The desecration of Mary for male queer perhaps is in the same department as Mugler's pun on amen—the Hebrew for 'so be it', as apposite a phrase if ever there was—for gay identity in the twenty-first century, in which charitable tolerance is increasingly ebbing to give way to acceptance.

–4–

Kiss of the Whip: Bondage, Discipline and Sadomasochism, or BDSM Style

You modern men, you children of reason, cannot begin to appreciate love as pure bliss and divine serenity; indeed this kind of love is disastrous for men like you, for as soon as you try to be natural you become vulgar. To you Nature is an enemy. You have made devils of the smiling gods of Greece and have turned me into a creature of evil.

—Leopold von Sacher-Masoch[1]

Readers may be divided as to why the clothing, trappings and style associated with sadomasochism (SM) and its affiliated fetishes should be included in a book on queer style. For it might be argued that this is a tendency that has as much to do with straight couples as not and that it is the term for a set of extreme sexual games. But the fact that so-called straight couples have taken possession of such practices in no way plays out of the hands of our concerns. For SM and BDSM are the names for a range of perversions, from the ludicrous to the terrifying, involving highly codified clothing and accessories. Indeed, as will be argued, these practices are at the very nub of queer style since they are a self-conscious realization of its inherent, avowed artificiality. And it has nothing to do with human reproduction, per se (even if that is an after-effect for likely couples); on the contrary, it can displace genital congress and its aesthetics—its look and its experiments are purposely repugnant to the straight-laced bourgeois. This is a practice in which sexual activity is inextricable from its style: what is worn and how it is worn, where dress and adornment, from bra to wig to make-up, are one seamless event. That it can be so unpalatable to some of us is also key, since it ritualizes modern gays and lesbians into a transgressive transaction that is about ecstasy and ruin.

SM, sadism and masochism, were defined as psychic concepts within Krafft-Ebbing's *Psychopathia Sexualis,* the same tract that coined *heterosexuality* and *homosexuality.* As a measure of sexual behaviour, both sadism and masochism are associated with a certain amount of paraphernalia, with accoutrements, or stuff. Recall the opening of this book: paradigmatically, the heterosexual imaginary carries itself in an Adamic imaginary before the Fall—it is nude and natural; the queer couple (or group) exists after the Fall and is naked, divested and therefore requires supplements and replacements for what is lacking. According to this schema, the sadomasochist

is at the horizon of what is already a limit; she or he takes pleasure in pain and has an unconventional sense of beauty. What we must emphasize at the outset is that most such behaviour exists as an idea; SM and bondage and discipline (BD) involve the consensual, anticipation, allusion and threat of pain as opposed to its rigorous material enactment. In this respect, BDSM is even more dangerous to the heteronormative perspective than if pain were manifest. For whereas the heterosexual experience is deemed as present, natural and productive (it can produce offspring if it wants to) and thereby exists within the continuity of nature (the mythic Nature), the BDSM experience is not a simple dialectical repudiation of the hetero-sphere in the way that an atheist requires a god to reject. Rather, BDSM displaces any rejection of heterosexual sex through foregrounding ideas (the threat of pain; the prospect of an orgasm at the end of a session) over acts. In this respect, we might go to an audacious limit and suggest that BDSM is a much purer form of (recreational) sex, since it puts psychological values before biological ones.

As such, BDSM occurs within a complex setting, a theatre such as a dungeon, kitchen or a prison in which sexual narratives can be acted out. Its props and avatars (bonds, chains, ropes, blindfolds) and its scenes are what constitute its style. As Robin Linden explains, the BDSM scenes

> can involve a variety of paraphernalia, props and costumes which are called 'toys' and equipment, including ropes, dog collars, handcuffs, enemas, bondage tables, racks, cages, etc. In San Francisco medieval-style torture chambers, referred to as 'dungeons', are available for rent by sadomasochists.[2]

It is because BDSM is so firmly entrenched in these props and its ritualistic metaphors, fetishes and relics that it is impossible to distinguish between dress and costume, for everything is a self-conscious enactment. A BDSM 'scene' is highly dependent on the garment and its accessories, whips, handcuffs, rubber masks and crops, for the desired effect. Black leather, military uniforms and police regalia induce sexual excitement with their connection to discipline and domination, whilst rubber and Lycra are also acceptable BDSM wear based on their sensuality. Although fetish dress changes according to the scene or the desire of the participants, it always oscillates between authority and outlaw. Popular fetish scenes may include Czarinas in furs whipping their servants, executioners branding prisoners with iron rods, Abbesses flagellating postulants, or schoolmasters and mistresses caning students. Equestrian paraphernalia—with its riding crops, whips, leather riding boots, chaps and gloves sets up a contrast between power and powerlessness with the implied relationship between human and animal.

The economy of BDSM is the economy of conversion: slave to master, adult to baby, pain to pleasure, and back again. As Foucault puts it, it 'is not a name given to a practice as old as Eros; it is a massive cultural fact which appeared precisely at the end of the eighteenth century, and which constitutes one of the greatest conversions

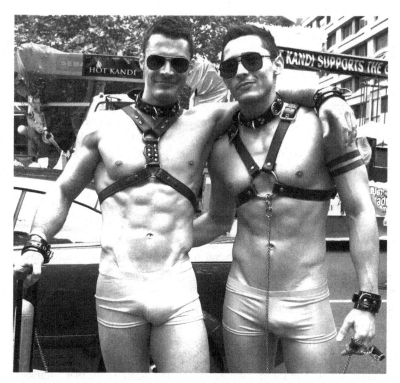

Fig. 4.1 Hyde Park, Sydney Gay and Lesbian Mardi Gras Parade, 2011. Courtesy: C. Moore Hardy Collection; City of Sydney Archives.

of Western imagination; unreason transformed into delirium of the heart.'[3] Consensual BDSM 'plays the world backwards'.[4] The exchange of power between consenting adults in BDSM exchanges is one that is based on trust and negotiation. This is one of the basic conditions of sadomasochism: a contract that is founded on trust. The idea of a 'pleasure contract' of mutual fulfilment is alien to the sadist (and in the writings of the Marquis de Sade). Only the contract between the top (sadist) and bottom (masochist) makes possible the play scene that is negotiated before commencement of any sexual encounter. Given the specific dimensions of consensus, which may include a safe word to postpone or cease play when pain exceeds the masochist's threshold of physical tolerance, notions of embodiment are constantly challenged by the possibility of being transgressed and subverted. The individual quest for pleasure is predominant over any authority or institution.

In what is perhaps in philosophical circles the most famous book on masochism, *La Présentation de Sacher-Masoch* (1967), Gilles Deleuze argues that the opposition between individual and institution is what distinguishes sadism and masochism as two different organization and structural contexts. Both imply power and control, but the representations between the two differ in terms of their practical realization.[5]

Sadism is strongly associated to the institutional aspects, as masochism appeals to the notion of the contract. According to Chantal Nadeau, sadism refers to the political aspects of control (policies of sexual behaviour), whereas masochism refers to the individual dimension of the sexual games.

> Sadism is then sketched as a conspiracy—often a group against an individual—as masochism is seen as the perfect expression of personal fantasy—one individual abandoning themselves to the will of the other, a will totally delimited by the limits of the abandoned. One can be read as the sexualisation of control [sadism] the other [masochism] as the liberation of sexual imagination. One evokes the repressed, the other the free spirit.[6]

According to these differences, BDSM is strongly associated with dress codes that represent the rules that characterize the two roles. Sadistic dress codes are depicted as rigid and organizational, apparatuses of institutional control such as the military and police uniform, the executioner and schoolmaster/mistress, whilst masochistic dress codes reflect fantasies of consent such as the leather harness and collar. The paraphernalia of BDSM—boots, whips, chains, rope, uniform—is the paraphernalia of state power, public punishment converted to public pleasure. These dress codes manipulate the signs of power in order to refuse their legitimacy as putatively natural, as in heteronormative sexual practices. Sadism is closely related to authoritarian forms of clothing, usually conventionalized and codified, particularly the uniform. In particular sadism has a longstanding close relationship to the black Italian fascist uniform, the Nazi Brownshirts or the grey SS uniforms with their attendant associations with the Holocaust, rampant racism and taboo. BDSM style has a natural, if not pathological, affinity with the exaggeration common to the streamlining germane to industrial design of the 1930s: repeated hard lines, angularity, tapering, metallic shine. As in the stock-standard analysis of the pleasure of horror film, it gives delight in expressions of danger that will never come to pass in reality.

Two Italian films produced within ten years of one another and based on fascist regimes, one by Pasolini, *Salò* (1975), and *The Berlin Affair* (1985) by Liliana Cavani, help to situate BDSM within our present era. *Salò*, still banned in several countries, is Pasolini's harrowing evocation of fascist barbarism seen through the lens of Marquis de Sade's *The 120 Days of Sodom* and Dante's *Inferno*. Set in 1944 after the fall of Mussolini, a group of upper-class Italian libertines repair to a villa together with four prostitutes and eighteen young men and women whom they have kidnapped for the purpose of performing a series of sadistic rituals on them. One of the more famous scenes is when a girl and a youth are forced into coprophagia, or eating faeces. The film does not follow any specific narrative although the group degenerates as a result of their indulgences, which climax in the bloody ritual in the yard in which the young and beautiful men and women are tortured and disfigured. Synchronous with Sade, each scene is described in dispassionate detail, in a protracted deadpan that travesties pure reason. Throughout the film, a simple opposition is set up between the clothed captors, the wealthy fascist libertines and the victims,

who largely remain naked—they are the natural innocents who are to be schooled in the 'true' passage of culture: acculturated defilement. The brilliance of Passolini's film is not only in its illustration of the political depravity of fascist Italy (Salò was the town outside of Rome from which Mussolini ran the government), but also the systematic callousness of fascist cruelty.

The Berlin Affair can be interpreted as a critique of the pathologization of deviance and perversion, and like *Salò* the film grapples with themes of fascism and racism. The plot develops around the erotic attraction between Louise Van Hollendorf (Gudrun Landgrebe), an upper-class wife of a Nazi party diplomat and heir to an aristocratic German family, and the 'Oriental' Mitsuko Matsugae (Mio Takaki), the daughter of the Japanese ambassador in Berlin. Heinz, Louise's husband, informed by members of the party of the possible lesbian affair, urges Louise to stop seeing Mitsuko as the Nazis intensify the homosexual witch hunting amongst their ranks. Later, Heinz, Louise and Mitsuko begin a ménage à trois under the supervision of Mitsuko and the rules that she establishes. The film's dress code is embedded and coded with discourses of Orientalism. Louise's attraction to Japanese culture, which is constructed as fragile (she calls Mitsuko the 'porcelain doll'), is consumed by Mitsuko, who is dressed in a kimono to accentuate her exotic appeal. As Nadeau comments, 'The contrast in the garments between the occidental (read modern) Louise and the oriental (read exotic) echoes the fetishism of the Other—represented as racial difference—as a central fantasy in a masochistic scenario.'[7] But instead of positioning the Other as the submissive in the role of the slave, according to the representation between the Occident and the Orient, the film suggests that Mitsuko is the dominatrix.

Salò and *The Berlin Affair* share the depiction of the connection between aristocracy, eroticism and BDSM. In fact, in *The History of Sexuality Volume 1* (1978) Foucault traces the social and political control of sexual practices to the emergence of the bourgeoisie. The SM theatre of erotics in *Salò* is set in a castle in the Italian countryside, while *The Berlin Affair* is predominately shot in a bourgeoisie Berlin townhouse. The characters in both films are aristocrats by birth or by profession, and their dress codes and garments establish a clear reading of class and power.

However, it would be a grave error to imply that BDSM seeks to revive ideological authoritarianism and violence. It is also not a sacred ritual; secularity is central. With neo-fascists, violence is desired as an act, whereas with BDSM it is imagined. This is also why we chose our analogies from film: BDSM is to neo-fascism what film violence is to the actual thing. The former gives us the conditions for reflection (sublimated enjoyment, disgust), whereas the latter is outside the boundaries of morality and civility. It is also essential to emphasize that BDSM is a playing out of unconscionable acts as theatre rather than submitting to their reality. Like an actor in a vaudeville theatre, a dominatrix or a mistress may be involved in a number of eclectic fantasies before the rubber or leathers are placed on the washing line at the end of the night and sluiced by the garden hose.

At this point, it is worth returning to Deleuze, who argues that sadism and masochism are qualitatively different approaches to language and the body: 'With Sade,

the imperative and descriptive function of language goes to the level of a purely demonstrative and instituting function; with Masoch it also goes to another level, but to a function that is dialectical, mythical and persuasive.'[8] These latter qualities are intricately caught up with fetishes and theatricalized demonstrations whose purpose is not to find the 'real thing,' but rather generate a fertile semantic environment in which narrative scenarios and encoded verbalizations can continue to circulate. In this, masochism is closer to the Lacanian Real because it is an encounter with the dynamic of desire as opposed to its material satisfaction. In this respect, the Sadean objectification of pain does not reach to a deeper level of desire (drive) because it institutes a fictive hiatus (the cut, the trauma, the death). Sadism ends in termination; masochism is aimed at propagation. With the former, the law is provided through a metaphysical perversion of reason stretched to its unreasonable limit; with the latter, the law is circumstantial and based on a contract, verbal or otherwise, made between the two participants.[9] Deleuze also suggests that complex psychic and physical configurations of masochism take it into realms that cannot be equated with the conventional understanding of sex that emanates from Freud and his generation since its authority and order exists elsewhere than in the superego. *Sadism* and *masochism* are both words coined after male authors and involve male protagonists; Deleuze's essay allows for a rethinking of the Freudian formula of sadist male and masochist female. It also helps us to emphasize that the BDSM is the other's other with respect to gender identification, sexual transaction, satisfaction and desire.[10]

By and large, the theatre of BDSM embodies something germane to a Wildean paradox, since it is present, willed and desired, although constructed and imagined. Writing in the *New Times* in 1979, Edmund White observes that BDSM-related practices were on the rise, despite official efforts to prevent it. Predictably, one gay restaurant had its waiters all dress up as police. Violence is primarily hypothetical and often satiric: 'Naturally there are sadists who, like Sade himself, who can be aroused by inflicting pain, but these are in the minority. Ankle restraints are plush-lined; the paddle is *commedia dell'arte* slapstick.'[11] Violence is confined largely to language. Its actions are 'filmic'.[12] To the accusation that BDSM mirrors the violence of straight male society on gay men, and identification with a straight oppressor, White rejoins that one would expect that oppressor to fall in more with straight stereotypes. He also suggests that a large portion of BDSM players are drawn from the educated classes. And the covert nature of perverse sexuality has, with BDSM, less outward shame, given that it is more often worn as a stamp of the ritual it portends, the scenes it imagines rather than truly enacts.

> The leather man, far from hiding in a business suit, is the most conspicuous figure on the streets. Garbed in chains and skin-tight cowhide, he has the nerve (so like that of the despised drag queen) to wear openly the badge of his fantasies. Leather is always a sexual statement, as much as a prostitute's high-rise wig and six-inch heels. Would someone who hates his own homosexuality proclaim it so loudly?[13]

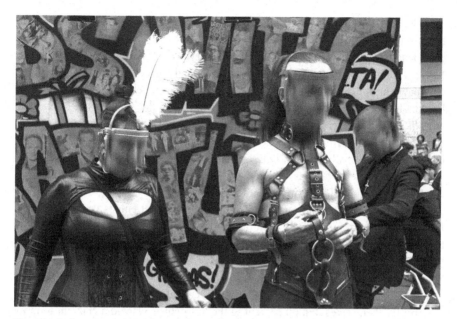

Fig. 4.2 Sydney Gay and Lesbian Mardi Gras, 2011. Courtesy: C. Moore Hardy.

If violence is not the norm of BDSM encounters and relationships, it is nonetheless unequivocally connoted in outward appearances. What is curious to mention is that BDSM style evolved in parallel with 'power dressing' as it came to be conceived in the 1980s. Power dressing belongs to both men and women and is the outward assertion of a particular institutional corporate domination, expressing aggressive upward mobility—and greed. What it shares with SM style is the penchant for taut angularity, and the expression of physical strength; with power dressing, what are most distinguishable are the exaggerated shoulders. In their own fashion moment, accents such as padded shoulders together with a sleek gathering near the waist, for instance, announce a corporate killer instinct. Out of their moment, they are absurd relics of an era of dissolute avarice and call to mind sci-fi costumes and Nazi uniforms.

Military Uniforms and the Gestapo

In their book *The Pink Swastika: Homosexuality and the Nazi Party* (1995), Scott Lively and Kevin Abrams try to ignite the controversy that homosexuality is a socio-sexual malady firmly connected to the rise of Nazism and ergo, the Holocaust. For all its objectionable histrionics, the book is a useful account of the many seams of homosexuality in the ranks of National Socialism, most memorably in the figure of

Ernst Roehm, the leader of the SA Brownshirts which, after Roehm's execution, was transformed into the SS. Roehm, together with Hitler and Joseph Goebbels, went to great lengths to advance the Hellenic ideal of Aryan manhood. The authors use the Nazi persecution of homosexuals as a convenient and outward ploy that was, in fact, only put in motion against those hostile to their regime.[14] Their text is more useful, at least indirectly, in subsequent chapters where they trace the ongoing life of Nazism and with special association with the rise of the gay movement in the United States. This strange book provides one example of the anxiety that 'violent' fashion can instigate in unsympathetic (and ignorant) minds. Nazism's connection with BDSM style is undeniable, but it was woven after Nazism proper. In other words, BDSM is a not a precondition of Nazism.

BDSM's sublimated and orchestrated theatre of conflict enlists uniforms by default. But it is very much dress uniform that has been distorted by several degrees, taking liberties with style to the point of becoming cumbersome. Nazi uniforms lend themselves to BDSM style since they had a level of seductive exaggeration (big hats, big, shiny belts) that teetered precariously on the kitsch. According to Valerie Steele, in a survey conducted by Townsend, 'Only 10 percent of the Masochists wanted a Nazi uniform for themselves, but 60 percent of the Masochists wanted a Nazi uniform to be worn by the Sadists.'[15] A point of clarification: BDSM style riffs on rather than appropriates Nazi dress. As Jennifer Craik observes, the place of uniforms within society is mostly belonging but also transgression. Since a uniform is ipso facto a statement of conformity, it lends itself best to forms of debasement that question or undermine the authority it is meant to affirm. In Craik's words, 'Uniforms are ambiguous masks of appearance, on the one hand, intending to unambiguously place the attributes and role of the person, yet, on the other, part of a complex social play that can be deliberately appropriated, subverted or rejected.'[16] She explains that when it comes to the use of uniforms as components of 'sexual excess', they are usually components of parody as well as signals of 'citizenship' to a certain perverse but fun code:

> Dressing up is a precondition for sexual fantasy whether it be in the form of bondage, discipline, sado-masochism, fetishes, erotic fantasies, role play, cross-dressing or master-slave contracts. The costumes employed range from uniforms—of authority (police, military—frequently Nazi or sailor suits, dominatrix, nanny) to ones of servility and subservience (maid, nurse, school boy/girl, baby) as well as devising a customized black leather/latex/plastic array of uniforms of sexual excess adapted for particular peccadilloes. The latter includes black bodices, bustiers, corsets, G-strings, jackets, gloves, boots, stilettos, collars, hoods and fishnet body stockings, fastened with a multiplicity of chains, zips, straps and buckles.[17]

Such paraphernalia have an important function in the 'performance of self' and as conduits to reinvent and displace identity. Craik suggests, however, that such props have changed their transgressive import since the 1960s and 1970s and have become

tired with continuing use.[18] According to Valerie Steele, 'The uniform itself can also be a fetish, even apart from an erotic psychodrama.'[19] It is not the *actuality* of power or submission that holds the sadist and masochist in thrall but the signs of power: images, words, costumes, scripts, uniforms.

We will take up this point—which we argue is the central variable within all BDSM's different 'bits'—by returning to the role of Nazi uniform. The word *tiredness,* which Craik uses in a pejorative sense, we prefer to use positively: it locates one of the semantic complexities of camp style. To begin with, stylistic tiredness is the standard definition of kitsch and therefore redolent of death. To adopt a tired style is also to grasp the retrograde without the will to retrieve or revive it. It is to like a style steeped in the taint of disapproval. It is surprising that the Nazi connotations in BDSM have not been explored in much detail. The masquerade of horror in the BDSM ordeal is inscribed with all manner of atrocities, which make the references to Nazism attractive and, possibly, inevitable—if all roads lead to Rome, all BDSM pathways lead to Nuremberg. However, to imply that a BDSM practitioner shirks his or her ethical responsibility is altogether moot. If we are to recall the beginning of this chapter, to accuse sadomasochists of moral turpitude is analogous to doing the same to directors who describe horrible events in their films. We might also recall sensational passages in Genet's *Thief's Journal* in which Hitler takes a youth, Paulo, to a secret chamber to have his way with him. Edmund White, in his biography of Genet, describes this well:

> Hitler was, according to Genet, castrated by a stray bullet during the First World War; now he remains a 'dry masturbator'. The first scene is written from the point of view of Paulo, who alternates between seeing Hitler as the Fuehrer (whose 'damp lock of hair across the forehead, the two long wrinkles, the moustache, the cross-belt' had turned him into the most 'illustrious' man in the world), and as a 'faggot' ('But this bombo's just a little old guy over fifty, after all'). The narrator becomes Hitler and imagines licking the arms of his victim (who is Jean D.'s half-brother), playing with his penis and killing him. The scene is intercut with sexual scenes between Riton (Jean's killer) and Erik (Riton's Nazi officer in Paris). Genet makes clear that he is writing out of shame and, in the face of that shame, an ambition to profane what is sacred . . . Thus the entire book can be read as incantatory (or as literary critics say, 'performative') in two senses: as a ritual to resuscitate Decarnin; and as an exorcism through profanation of Genet's grief and mourning.[20]

This passage draws out not only the use of the Nazi motif once again, but also the tragicomedy of BDSM. This tragicomic posturing is both an outpouring and a solution to feelings of pain, guilt and anger, emotions that are almost always caught up in the sexual act.

Genet's *Thief's Journal* also demonstrates that the allusions to terror in BDSM are arbitrary, fanciful and always travestied by the pathos of the act itself—because terror is not physically transacted. Violence is held in abeyance. The violence that the garments express is an outward challenge to the disgust of heteronormativity to queer or, especially, queer types. Here BDSM style joins hands with punk, whose

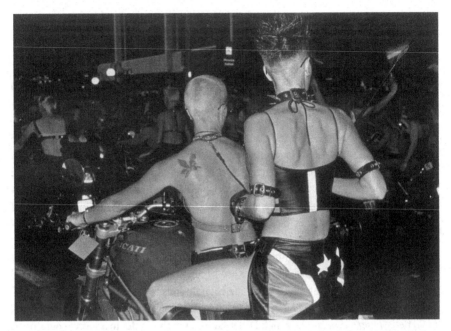

Fig. 4.3 Fashion designer Justine Taylor and Rush on a Ducati motorbike, Dykes on Bikes, Sydney Gay and Lesbian Mardi Gras, c. 1995. Copyright: Justine Taylor, all rights reserved.

initial incarnation in the 1970s and 1980s was to cause aversion and discomfort in middle-class complacency. Punk is perhaps less resistant to tiredness than queer, although both live on as statements of defiance.

Clips, Clamps, Leather and Accessories

Leather subculture originated in the 1950s with the establishment of the first gay biker clubs. As part of the drop-out generation of disenfranchised youth, comprising war veterans and the Beat generation, these young men considered themselves as misfits, loners and rebellious outlaws. This increasingly public gay biker culture, which flourished in major port cities in the United States, would impact the sartorial style of gay men. The close-cropped hair, black leather jacket and riding boots, clinging T-shirt and rugged Levis jeans would become a symbol of rugged masculinity.

The year 1954 saw the establishment of the first gay motorcycle club, the Satyrs in Los Angeles, with others soon following. Inspired by Marlon Brando's classic cult classic film *The Wild One* (1955), which depicted a gang of youth riding Harley Davidson motorbikes down a highway and terrorizing a sleepy hamlet. Based on a true incident in the town of Hollister, California, the film glamorized the social misfit and the outlaw rebel. With this film, Brando's name would henceforth be used to

identify the leather jacket with button V-lapels, which is now as classic as 501 jeans. Brando became, for all intents and purposes, a mascot for the leather look and show pony for the gay movement that identified itself with this look. The movement did not revolve around leather per se but around the motorcycle, which became a countercultural symbol of individuality and nihilism. Outrageous acts and contempt for authority connected the biker culture with the outlaw tradition of the Old West. The popular press was littered with sensational stories of biker gangs dressed in black leathers terrorizing towns. While the motorcycle gang the Hell's Angels cultivated the bad boy image represented in popular culture, it was Hunter S. Thompson's *Hell's Angels* that offered a more realistic portrayal of the motorcycle club's honour code and way of life.

The open culture of the motorcycle clubs proved a haven for gay men who looked for tolerance and acceptance. Rebelling against the effeminate stereotype, they adopted the motorcycle gang's sartorial style. Phil Andros's *Stud,* published in 1966, contains a fictionalized account of this nascent sadomasochistic leather culture, which, like its nonfictional counterpart, had the following characteristics: the denim look, black leathers, motorcycles, boots, T-shirts, chains, tattoos, colours, runs, open sexuality and honour amongst outlaws and outsiders. The purpose of clubs such as the Satyrs, writes Daniel Harris, was to 'subvert the prevailing stereotypes of effeminate homosexuals by creating a hyper-masculine environment in which members could cultivate the machismo of their heterosexual heroes'.[21] BDSM was not a major focus of these clubs, but their prevailing tolerance abetted its practice in a subculture that was itself an homage to automation and industrialization. As Harris explains, part of the reason that the outlaw biker image carried so much weight is that it encoded

> the consummate expression of the Western world view, a cult that revolved around technology, a machine...In the earlier gay biker clubs, studded leather jackets were the ceremonial vestments of a vehicular religion whose central totem was an unlikely god, a mode of transportation, a device manufactured by a highly industrialized culture. The leather fetish in its earliest forms were rooted in the body of iconography that grew up around heavy equipment and the internal combustion engine, a symbol of Industrial power.[22]

Motorcycles enabled many disenfranchized and emasculated young men to construct powerful masculine narratives of the untamed frontier and the lure of the open road. For gay men, a prominent erotic component was involved in the fetishization of the motorcycle.

> One of the enticements of leather was its connection with an ultimate heterosexual symbol of masculinity—the straight man on a bike was one of the earliest and strongest images of straight trade...It wasn't just that those men represented the fantasized outlaw; they were also an unquestionably sexual male image. Part of the attraction of the motorcycle was the power and vibration of the big engine between a man's legs.[23]

It was not until the 1970s that the focus of the fetish shifted from the motorcycle to the equally masculine accessories of the uniform: the studded belts, eagle insignia, stencilled images of skulls and crossbones and the leather gauntlets, jacket and boots. A greater integration of leather culture began to enter larger gay and lesbian subcultures as well as popular culture. As we have seen already, members of rock bands such as the Village People appropriated some of the accessories and symbolic elements of leather culture as part of their performance. The psychological thriller *Cruising* (1980), starring Al Pacino as an undercover policeman assigned to solve a series of murders terrorizing the New York gay leather community, introduced mainstream audiences to the SM club scene, albeit in a negative way.

Since the 1970s, the popularity of leather, especially accessories and garments associated with military and motorcycle groups, such as the Sam Browne belt (which crosses the chest), leather chaps and heavy boots, have increased amongst queer BDSM practitioners. However, there is an assortment of leather garments, accessories and accoutrements that have emerged as part of the leather culture, and serve an important role in the identification of the dominatrix (dominant top) and submissive (subordinate bottom), and in BDSM play. These items fall into two categories: first, garments and items that constrict and second, objects of effectuation. The items that constrict, either haptic or olfactory, tend to compress the body to the point of sensory deprivation. These are conventionally made of leather, rubber or vinyl and include corsets, bondage straps, gimp masks, harnesses and collars—all of which cling tightly to the skin to create a heightened awareness of the body as an erotic field. Objects of effectuation include gloves (leather or rubber) and shoes, especially the stiletto (the heel with a phallic connotation), and the black leather engineer or military boot popular amongst gay and lesbian fetishists. Valerie Steele comments, 'For lesbians leather evokes both SM and gay sex. The "leather dyke" is as familiar today as the lipstick lesbian. Lesbians did not merely copy the leatherman look, they combined it with elements from punk street fashion to create a powerful new style.'[24]

A large assortment of restraints, such as padded and unpadded cuffs, restraining boots and mittens, collars and belts with restraining rings, leg spreaders, neck and back restraints and so on, are made of leather. Most of these items, which are amongst the most common BDSM accessories, are designed to be used with padlocks or to have buckles for tightening. Long strips of leather or rubber are often used by BDSM practitioners as rope substitutes. Objects that pinch and bite, such as alligator clips and nipple clamps, are also popular accessories.

As a subculture, one of the characteristics of BDSM is the eroticizing of scenes, symbols and contexts that heteronormative culture does not recognize as erotic: uniforms, boots, leather and so on. As a style, BDSM, with its exaggerated emphasis on dress and scene, provides a space where power is transgressed, destabilized, negotiated and challenged.

–5–

Drag: Of Kings and Queens

The story of drag in Western culture is bound with the story of the stage and queer identity and style. The relationship between drag and transvestism and the articulation of a queer identity through cross-dressing has come full circle from the molly houses of the eighteenth century, where men went to dress, gossip and have sex with one another, to the lesbian styles of the 1920s—men's formal dress, top hats and tails—popularized on stage by performers Marlene Dietrich and Judy Garland.

In the popular imagination, drag is often mistakenly conflated with transvestism; however, the two are radically different aesthetically and politically. The transvestite's concern is to pass as a woman or a man in a crowd using mannerism, clothing and dress codes to construct the illusion of the opposing gender, whilst drag mimics and exaggerates ideal characteristics or stereotypes of women and men. The story of drag began on the stage, in pantomimes, minstrel shows and vaudeville, whilst transvestism belongs to the domain of the fetishist. In the words of Daniel Harris:

> The stylistic ideal of the drag queen, is screaming vulgarity, the overstated look of the balloon-breasted tramp in the leopard-skin micro-mini skirt who strives to be loud, tawdry and cheap…unlike the lone fetishist who in an effort to 'pass', squeezes into corsets and tapes his breasts together to create the illusion of cleavage.[1]

In short, the transvestite tones it down while the drag king and queen pump it up.

Drag kings parody and mimic stereotypes of masculinity that represent the bastion of patriarchal culture: the trucker, the red neck, the crooner, the 'sleazy' Latino lover, the racist skinhead or the professional boxer. Kings' drag names are also chosen to reflect the traits associated with such stereotypes such as Mario from the Barrio and Vinnie Testosteroni, drag kings from San Francisco, and Rocco D'Amore, who is based in Melbourne, Australia.

Drag queens have tended to imitate legendary Hollywood icons: the Mae Wests, the Marilyn Monroes, the Joan Crawfords, the Greta Garbos. The drag queen craves nostalgia and longs for the days when women wore white kid gloves, pillbox hats, flapper headbands, mod go-go boots, fox furs and opera-length evening gowns. The drag queen rejects contemporary fashion with its

Fig. 5.1 Drag king Rocco D'Amore. Courtesy: Kellyann Denton.

unisex and androgynous styles and opts for a sartorial look that represents the days before the women's liberation movement of the 1960s and 1970s, when women were expected to stay at home and raise children. Cultural and social equality for women was a major issue in the second wave of feminism. The movement campaigned against the social and cultural stereotyping of women as only capable of becoming housewives and nothing more. It advocated for equal civil rights for women, sexual liberation, childcare, health, welfare, education, work and reproductive rights including the right to abortion. Drag queens embody and parody the stereotypical effeminate behaviour endorsed by patriarchy such as the dutiful housewife dressed in lingerie and kitten heels who waits for her man to arrive home from work, dinner ready in the oven and martini for him in her hand. The drag queen parodies sexualized feminine stereotypes like the sex kitten, the trophy wife, or the vamp. The drag kings' and queens' performances are all about camping it up.

In the classic ethnographic study *Mother Camp: Female Impersonators in America* (1979), Esther Newton deals with the symbolic geography of male and female styles, as enacted in the homosexual concept of drag (sex role transformation) and camp. For Newton, drag queens deal with their alienation through camp. She defines camp not just as a role-play but as a 'strategy for a situation' and 'the camp ideology'. She traces three aspects to it: incongruity (the juxtaposition of things; say, garments or items of clothing, not usually meant to go together), theatricality (the performance of that juxtaposition; its stage quality) and humour. This is point where drag and camp merge, producing a particular type of aesthetic and style.

The drag show and the stylistic impersonation of men and women via performances act as forms of male and female mimicry and parody, or camp, in order to challenge and destabilize gender practices that prioritize mainstream hegemonic masculinity. By appropriating (stereotypical) exaggerated masculine and feminine behaviour via dress and mannerisms, drag becomes a strategic weapon, via camp humour, to counteract positions of disempowerment in cultural practices by undermining and reinscribing gender roles.

Camp functions as a set of practices and styles appropriated from popular culture and reformed within the context of gay (male) culture. Drag is merely one incarnation of camp, writes Andy Medhurst, 'just one room in camp's mansion'.[2] As Newton points out in *Mother Camp*, 'Camp humour is a system of laughing at one's incongruous position instead of crying', and 'camp undercuts all homosexuals who won't accept the stigmatized identity. Only by fully embracing the stigma itself can one neutralize the stigma and make it laughable.'[3]

This relationship between drag and camp in gay culture has been acknowledged and debated by many scholars, from Susan Sontag to Judith Halberstam. Yet as Halberstam notes, little attention has been paid to drag kings and male impersonators, or 'women behaving like men'.[4] As to whether *camp* can be ascribed to butch or femme lesbians or drag kings is debatable given that the term was coined under different historical and cultural differences to describe gay men. As Andy Medhurst explains, 'Butches' social and cultural position as women cannot be lazily equated with queen' social and cultural position as men, and to use the term "camp" as a blanket term for both...conceals the crucial difference.'[5] Furthermore, Medhurst claims, 'Lesbian camp is as impossible as gay male butch-femme.'[6] Halberstam notes that when drag king performances are campy, it is because the actor allows her femininity to inform and inflect the masculinity she performs and suggest that such performances require another term to describe not only the humour but also to distinguish them from the gay camp and drag queens. She suggests that *camp* be replaced with *kinging* to avoid collapsing lesbian social histories and practices with those of gay men. 'Some drag king performances may well contain a camp element', she writes, 'but the kinging effect...depends on several different strategies to render masculinity visible and theatrical.'[7]

Dames, Divas and Queens

Drag is a theatrical performance whose beginnings were first recorded in the drag balls of the nineteenth century, which attracted audiences that wanted to experience the forbidden pleasures of decadent urban nightlife. Female impersonators have always performed in pantomimes, vaudeville shows and cabarets. Some simulated feminine glamour, passing at times as glamorous divas and dames (the pantomime term for female roles played by men), while others created the illusion of femininity by lowering their voices, then taking off their wigs in the performance finale. Peter Ackroyd has written that the female impersonators evoked fears of female aggression and overt sexuality as well as fears about homosexuality. By subtly and humorously representing such fears, the dames would diffuse them with laughter.[8] In England, female impersonation was not so much part of the pantomime but the music hall, which grew out of the song and supper clubs at all-male taverns where the host would persuade the clientele to get up and do a bit, which many did as female impersonators. In the United States, minstrel shows and vaudeville acts were the first venues to bill female impersonators as stars in shows. One such star, Francis Leon, told a reporter during his appearance in New York in 1870 that he wore 'genuine women's clothing, not costumes, and that his wardrobe included some three hundred dresses'.[9]

With the gradual decline of vaudeville and the development and growth of cinema, female impersonation moved to the cabaret and the nightclub. Such a club is described in one of Christopher Isherwood's book of short stories, *Goodbye to Berlin* (1939), from which the musical *Cabaret,* which features a female impersonator, was developed. Although female impersonators appeared in gay bars and nightclubs in America as early as 1871, it was not until Stonewall in 1969 that drag queens were made visible and politicized as part of the queer community, and gender-bending was given public expression. As lesbian cross-dressers and drag queens fought with police during a raid on 27 June, photographs of their arrest were made public on news broadcasts and in the public media, galvanizing the drag queen as a political identity.

It was not until after Stonewall and well into the 1970s that mainstream cinema began to feature drag and female impersonators in major productions. The 1978 film version of *La Cage aux Folles*, based on the 1973 French play by Jean Poiret, tells the story of a gay couple: Renato Baldi (Ugo Tognazzi), the manager of a Saint-Tropez nightclub that features drag entertainment, and his partner, Albin Mougeotte (Michel Serrault), a female impersonator dressed in sequins and feathers. The popularity of drag queens and their parodies of femininity have given rise to drag celebrities such as Dame Edna Everidge, a female impersonator created and played by Australian performer and comedian Barry Humphries. Famous for her lilac-coloured or wisteria hue hair and cat glasses, Edna was originally styled as a drab Australian housewife, satirizing the conservatism of Australian suburbia. Later

in her career, Edna adopted an increasingly outlandish 1960s wardrobe and satirized the cult of celebrity, class snobbery and prudishness as part of her drag performance. American actor and songwriter RuPaul, considered the world's first drag super-model, also parodies femininity, often appearing wearing an afro wig and a tight-fitting kaftan or knee-high stiletto boots and hot pants. After signing a contract with MAC cosmetics, advertising billboards featured him in full drag, often with the text 'I am the MAC girl'.

Giving popular expression to gender identities, drag queens in the 1970s took on costumes and camp pastiches from popular culture for radical effects, particularly from glam rock music with its glittering outfits and cosmetics. In particular were David Bowie and his gender-bending, androgynous allure embodied in his alter ego Ziggy Stardust, and Freddie Mercury of the rock band Queen. In the music video for 'I Want to Break Free', Freddie and the other band members are dressed in full drag, complete with hair rollers, pink earrings and lipstick, imitating suburban British housewives. The order of queer nuns The Sisters of Perpetual Indulgence engaged in political activism through parodying traditional drag by mixing beards and hairy chests with fake, long eyelashes, net stockings and nun's habits. In the cult film *The Rocky Horror Picture Show* (1975), Tim Curry plays the hero, Dr Frank-N-Furter, whose character is a mad scientist. Although dressed in a corset, black lingerie, fish-net stockings, garters, stilettos and a pearl necklace, he is still recognizable as a male. In *The Adventures of Priscilla, Queen of the Desert* (1994), an Australian comedy-drama film written and directed by Stephan Elliott, two drag queens and a trans-sexual woman travel across the Australian outback from Sydney to Alice Springs in a tour bus that they have named Priscilla. Containing elements of comedy, the film's title is a pun on the word *queen,* a slang term for a male homosexual. Costume de-signers Tim Chappel and Lizzy Gardiner were inspired by gay musical icons Shirley Bassey, Gloria Gaynor and Carlotta from the Australian all-male revue Les Girls, which began in the 1960s and continues today. Les Girls was responsible for intro-ducing drag performances to mainstream audiences and was inspired by Miami's The Jewel Box, which opened its doors in 1938 and was one of the first clubs in the United States to offer revues of female impersonators. Equally famous were Finoc-chio's in San Francisco, The Club 83 in New York, Oh-My-My in New Orleans, The Purple Onion and Chez Ivy in Sydney.

The influence of popular culture, music and cinema also found expression in the dance craze of voguing, which grew out of the drag queen ritual of 'throwing shade'. Inspired by breakdancing, the angular movements and aesthetics of kung fu and Egyptian hieroglyphics, voguing started to make inroads in the music industry in 1989 with Malcolm McLaren and the Bootzilla Orchestra's 'Deep in Vogue' music chart hit. In 1990, voguing and drag ball culture made its screen debut in Madonna's hit single 'Vogue' and Jennie Livingston's documentary film *Paris is Burning* (1990). Filmed between 1986 and 1989, the documentary explores the elaborately structured drag ball competitions in which contestants, adhering to a very specific category or

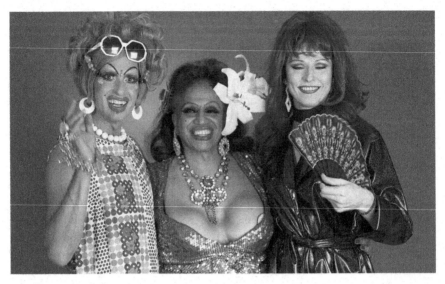

Fig. 5.2 Vanessa Wagner and transgender artists for the 'Safe Drinking' campaign, Starfish Studios Clovelly, 1998. Courtesy: C. Moore Hardy Collection, City of Sydney Archives.

theme, must walk (much like a fashion model's runway) and subsequently be judged on criteria such as the realness of their drag, the beauty of their clothing and their ability to dance.

Drag Balls

The culture of drag ball and voguing can be traced back to the second half of the nineteenth century. The Hamilton Lodge in Harlem staged its first queer masquerade ball in 1869, followed by one at the Walhalla Lodge on Manhattan's Lower East Side in 1889. By the end of the decade, masquerade balls were being held at Madison Square Garden, the Astor Hotel and the Hamilton Lodge. Harlem Renaissance activist Langston Hughes proclaimed the drag balls to be 'the strangest and gaudiest of all Harlem's spectacles in the 1920s', describing them as 'spectacles of colour'.[10] Noting the presence of 'distinguished white celebrities', Hughes wrote that 'Harlem was in vogue' and that 'the Negro was in vogue'.[11] Held annually, the balls featured a procession known as 'the parade of the fairies', which involved drag queen contestants in a costume competition.

Prior to the 1960s, drag ball culture was a mix of African American, Latino and Caucasian participants. Competition was tough, and ideals of beauty were governed by dominant ideology. African American drag queens were expected to 'whiten-up' their faces if they wanted to stand a chance of winning a contest. By the early 1960s, drag ball culture began to divide along racial lines, with the first 'Black Ball'

recorded in 1962. As Michael Cunningham describes, 'It was Vegas comes to Harlem. It was the queen's most baroque fantasies of glamour and stardom, all run on Singer sewing machines in tiny apartments.'[12] The House of Labeija was the first 'house' to be established in 1972 by the drag queen Crystal 'Pepper' Labeija. Referencing the glamour of Parisian fashion houses, others soon followed: the House of Corey, the House of Dior, the House of Dupree, the House of Chanel and the House of Wong. Houses continued to multiply and diversify well into the 1980s.

As Barbara Vinken writes, 'Fashion is a disguise, a disguise that operates not according to fancy, but following a determinate code. The code pretends merely to represent reality; one clothes oneself "appropriately", when one dresses oneself as a man or a woman…Here, fashion disguises the fact that it disguises.'[13] Vinken is referring to Livingston's *Paris is Burning* and alluding to the displacement that characterizes the entire film. She writes, 'Paris, the city of cities, city of luxury, of fashion and beautiful women, is the phantom pursued in Harlem, the New York ghetto and slum, the district of poverty, fear and homosexuality. The connection is forged between Paris.'[14] Set in the fashion houses in Harlem, the film chronicles the ball culture of New York City and the gay and transgender African American and Latino men that participate. The film depicts drag performers in a variety of stage roles parading down the catwalk: hip-swinging runway models dressed in haute couture fashion, Vegas showgirls with feathers and sequins, cardigan-wearing college students chewing on gum, and aristocrats. *Time Magazine* described the film as

> an attitudinal affectation that mixes model-like poses with the athleticism of break-dancing and the wry sophistication of gay male humour. Voguing began in the 1960s in Harlem, where transvestites parodied Seventh Avenue by calling their social clubs houses and holding annual balls that featured the dance style.[15]

'"Realness" is indeed the issue here,' writes Majorie Garber. 'Realness not only in the drag world but also in the world that it mirrors and critiques.'[16] Or, as Vinken quite aptly argues,

> what the drag queen brings to light and on to the catwalk is 'woman' as disguise…The world which is here imitated is the world of the television, of the models, of the fashion magazine. It is the world of appearance, which produces the effect of the real, the real as effect.[17]

Referencing the glamour of fashion houses (i.e., House of Chanel), the contestants vying for trophies are representatives of drag houses (House of LaBeija) headed by a mother and sometimes a father who serve as intentional families, social groups and performance teams. Houses and ball contestants that consistently win eventually earned a legendary status. While Pepper Labeija

declares, 'I've been a man, and I've been a man who emulated a woman. I've never been a woman,' Venus Xtravaganza, a younger drag performer, contends, 'I would like to be a spoiled rich white girl living in the suburbs.'

It is in the phantasmatic excess via the performative space of the ball that the world of glamour and privilege, afforded to high fashion and celebrity culture, is imitated. A lifestyle closed to the disenfranchized African American and Latino men, 'their dream is *Vogue* [the magazine]; the object of their desire is the Other exhibited therein', writes Vinken, 'another skin colour, another class, above all another sex: at last, to be something from what they are themselves'.[18] In *Bodies that Matter*, Judith Butler undertakes a reading of drag balls in New York City and asserts that the balls illustrate the nature of performativity—the repetition and ultimately the displacement of dominant discourse of race, gender and sexuality. According to Butler, the ball 'involves the phantasmatic attempt to approximate realness, but it also exposes the norms that regulate realness as themselves phantasmatically instituted and sustained'.[19] By disrupting the assumed correspondence between a 'real' interior and surface markers (clothes, walk, hairstyle, accessories, etc.), drag balls make explicit the way in which all gender and sexual identifications are ritually performed in daily life.

Kinging and Club Culture

Club culture was a dynamic site for performances of drag in the 1990s, as representations of drag king contents, venues and events became popular forms entertainment amongst queer communities in New York, San Francisco, London, Adelaide and Sydney. Whilst drag queens had been visible in gay circuits for over fifty years, drag kings were still a minority until the 1990s, which saw the emergence of clubs such London's Drag King Club, Club Casanova in New York, Kinselas nightclub in Sydney and Club Geezer in San Francisco. Although women have had a long and rich history of wearing male attire and passing as men, and much has been written about butch and femme dress codes and relationships, little attention has been paid to the emerging drag king phenomenon of the mid-1990s. Drag king contests and events such as Gender-Blender (part of the Sydney Gay and Lesbian Mardi Gras), the International Drag King Community Extravaganza (IDKE), the first of which was held in Columbus, Ohio, in 1999, and Drag King Rebellion in Wisconsin provided spaces where lesbians could act out diverse gender roles and sexual desires.

Scholars have located the cross-dressing drag tradition among women on stage as early as 1840 with performers such American Charlotte Cushman, who played male roles in Shakespearean theatre, and British vaudeville star and male impersonator Vesta Tilley. And since the mid-1600s in England, women appeared in what were known as 'breeches roles' (tight-fitting knee-length pants), where an actress wore male clothing. The operatic concept of the breeches role assumes that the character

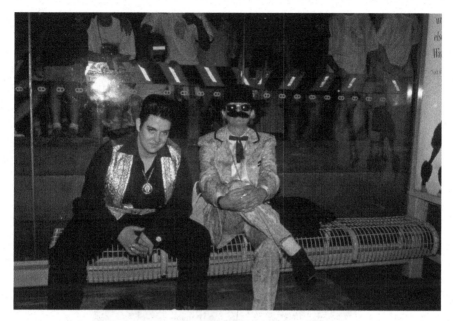

Fig. 5.3 'Elvis-her Selvis' performer and friend from the United States, College Street, Sydney Gay and Lesbian Mardi Gras Parade, 1993. Courtesy: C. Moore Hardy Collection, City of Sydney Archives.

is male, and the audience accepts him as such, even knowing that the actor is not. Out of some 375 plays produced on the London stage between 1660 and 1700, it has been calculated that 89, nearly a quarter, contained one or more roles for actresses in male clothes.[20]

Throughout the nineteenth and twentieth centuries, women often appeared on stage impersonating men. Perhaps the most citable and extraordinary example of a woman dressing as a man in social circles in the nineteenth century is the French novelist Lucile Aurore Dupin, better known as George Sand (1804–76). She argued that she found dressing as a man more comfortable—and cheaper. But there was much more to her dressing than mere utility. What is certainly true is that she was able to manoeuvre her way around Paris and enter places forbidden to women. Sand also smoked in public, which was considered outré for women until the 1920s. What Sand was to literature, her contemporary Rosa Bonheur (1822–99) was to painting. Bonheur dressed in men's clothing throughout her life (more than Sand), smoked freely and consorted with women. She too argued that men's clothing afforded her easier movement, and since she specialized in painting animals, it was more sympathetic than women's clothing to the places she frequented for finding subjects and inspiration.

From the 1930s to the early 1970s, the Jewel Box Revue, a company of twenty-five female impersonators and one male impersonator, Stormé DeLarverié, toured the United States and performed to sell out audiences. DeLarverié began wearing men's

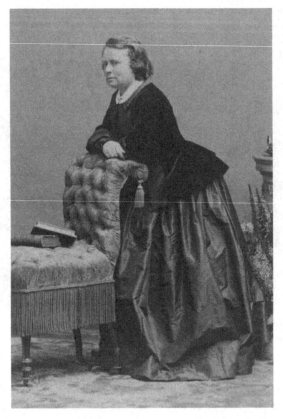

Fig. 5.4 Rosa Bonheur by Disdéri. Courtesy: National Portrait Gallery, London.

clothes on and off stage shortly after joining the company. According to Elizabeth Drorbaugh, 'Male [and female] impersonation enjoyed what has been called its golden age as family entertainment during the first twenty years of the twentieth century.'[21] When the Hollywood Motion Picture Production Code (1930) banned all performances that were deemed 'perverted', drag shows went underground. However, most scholars agree that no extensive drag king culture developed in lesbian bars and social clubs to fill the void left by male impersonators in the theatre tradition.

In queer subcultures, drag is considered a temporary performance and representation of gender. In *Female Masculinity,* Halberstam writes of the drag king as 'a female (usually) who dresses up in recognizable male costumes and performs theatrically in that costume'.[22] Halberstam divides female masculinity into three distinct categories: the drag king, the male impersonator and the drag butch. She contends that while 'male impersonation has been a theatrical genre for at least three hundred years, the drag king is a recent phenomenon'.[23] Whereas the male impersonator

attempts to produce a plausible performance of maleness as the whole of her act, the drag king performs masculinity (often periodically) and makes the exposure of the theatricality of masculinity into the mainstream of her act. Both the male impersonator and the drag king are different from the drag butch, a masculine woman who wears masculine attire as part of her quotidian gender statement. Moreover, 'whereas the male impersonator and the drag king are not necessarily lesbian roles, the drag butch most definitely is'.[24]

For some kings, performances of masculinity are about decentring and deconstructing dominant paradigms of masculinity, whilst for other drag kings, masculinity is about expressing an aspect of their own identity. Drag kinging is more than the visual and stylistic presentation of the performance; it is also about the act of revealing the instability of gender roles—in this case masculinity, what it is and how it is produced. As Halberstam has argued, drag kinging is one mode of making 'assaults upon dominant gender regimes'.[25] It is about rearticulating representations of masculinity and male agency and as such destabilizes femininity as conceived by popular convention. In doing so, the drag performance calls into question butch/femme subjectivities and their complexities: bull dyke, stone butch, diesel butch, soft butch, top and bottom butch, lipstick, neo-femme and so forth. In imitating gender, drag implicitly reveals the imitative structure of gender itself. It also calls into question issues of ethnicity and race as signifiers of otherness and marginality, as cross-ethnic performances draw attention to the disempowerment produced by racial discourses.

In her study of drag king culture and performances in New York and San Francisco in the mid-1990s, Halberstam identified four modes of kinging: impersonation, understatement, hyperbole and layering. All four modes represent the inauthenticity between acting and being, as drag kings 'perform their own queerness, whilst simultaneously exposing the artificiality of conventional gender roles'.[26] A drag king incorporates dancing and singing or lip-synching in her performance and often performs as über or exaggerated male personas from a taxonomy of masculinities. These characters range from the popular white trash trucker to the suave gentleman crooner and the macho Latino lover and attempt to reproduce the stereotype with or without a twist. Like the drag queen, the drag king adopts a stage name which tends to evoke sexual innuendoes such as those by well-known Australian drag kings Jonnie Swift, Sexy Galaxy, Rocco D'Amore and Mo B. Dick, and Buck Naked and Buster Hyman from the United States.

Drag kings produce an acceptable masculine aesthetic via the use of props (suits, ties, greased hair, facial hair) and through role-playing and mimicry. They generally tape down their breasts, add the illusion of male genitalia by wearing a prosthetic penis and erase some, if not all, forms of feminine features to appear more masculine and to create gender illusion in their performances. Kings walk with a swagger and drink beer from a bottle, and their legs are always, in stereotypical male style, spread comfortably when seated.

Scholars of female masculinities have argued that drag king culture is more than the visual and stylistic presentation of men, but rather that these representations are about dissolving associations of masculinity with men. The performances of drag kings, writes Jennifer Patterson, 'provide forums in which lesbians can act out and interact with fantastic masculinities, examine their responses to different female masculinities and experience...different gender roles and sexual desires'.[27] Kinging is about performance, excess and politics. It is about exploding the normative gender system, and stretching sexual codes to open a space to redefine masculinities and femininities. Drag kinging produces new erotics, new genders and new modes of power.

–6–

Crossing Genders, Crossing Cultures

In every human being a vacillation from one sex to the other takes place, and often it is only the clothes that keep the male or female likeness, while underneath the sex is the very opposite of what is above.

—Virginia Woolf[1]

While it is true that homosexuality was not only constructed—invented—in the latter half of the nineteenth century, it is also true that it occurred in Europe. Harnessed to this are sets of presumptions that inevitably co-opt other parts of the world. But, however much we may estimate the pervasiveness of Europe's influence at this time, we also have to acknowledge the sui generis nature of the sexual and sartorial tendencies of other cultures, even within Europe itself. The variety of ways in which people choose to dress their bodies affects how others will perceive the individual within culture. Dress codes also vary across cultures; what is considered appropriate attire in one culture may be deemed inappropriate in another. Similarly, not all cultures make gender identity as central, as stable or as unvarying as it is perceived in Western culture. In many societies, gender competes with other identities, such as age, ethnicity, kinship status and class as a significant basis for identity.

As Linda Arthur writes, 'Dress provides a window through which we might look into a culture, because it visually attests to the ideas, concepts and categories fundamental to that culture.'[2] Sex and gender role differences exist in varied cultural contexts and take many forms. Many societies regard sex and gender variants as merely natural, albeit unusual, phenomena, while other societies make accommodations for sex and gender differences through the construction of alternative roles. While most recorded alternative gender roles are associated with males, others, such as the sworn virgins of the Balkans, the *tombois* of Indonesia or the Mohave *hwame,* are associated with women. Still others, such as the Hawaiian *mahu,* the Thai *Kathoey* or the Indonesian *bissu,* originally applied to both men and women, though they now refer mainly to feminine males. Roles transcending sex and gender binaries are clearly a widespread cultural phenomenon. In many contemporary societies, individuals exhibiting non-normative or transgressive gender behaviours and identities may be treated with ridicule, fear and/or disrespect. In other traditions, such individuals were believed to possess sacred powers and occupied special prestigious social roles.

The relationship between gender, appearance and sartorial style has been well-documented by scholars not only within fashion and dress studies but also across such disciplines as sociology, popular and cultural studies and social anthropology. As an embodied practice, dress is a marker of class, status and gender distinction and has often been deployed as a means of transgressing social boundaries. Cross-dressing is an example where women and men have incorporated gender-specific garments and accessories as expressive of masculine or feminine identities. Such items include the three-piece suit, neckties, bows, fedoras, eye monocles, sock garters, walking sticks and crew cuts, as well as pearls, tiaras, make-up, bodices and stilettos. Dress styles and codes act as insignias to the prevailing values and ideologies of a culture, creating a typology for a semiotic reading of institutional or subcultural boundaries of style. As scholars and writers increasingly incorporate the individual voices of alternative gender identities into their research and writing, they reveal that individuals vary from each other, may change over a lifetime and are associated with different degrees of experiences.

Garber claims that cross-dressers create a 'third sex', which marks a space of ambivalence and possibility because their appearance destabilizes and denaturalizes gender and calls into question claims of normativity and originality.[3] Throughout *Vested Interests,* Garber uses the notion of cross-dressing 'thirds' to explore 'the extraordinary power of the transvestite as an aesthetic and psychological agent of destabilization, desire and fantasy'.[4] However, in his study of transvestite beauty pageants in the Philippines, Mark Johnson criticizes Garber for reducing transvestitism to 'the realm of literary or aesthetic psycho-sexuality, [to] that which escapes cultural categories but which makes their reformulation possible'. It is very important, he writes, 'to examine experiences of people as they negotiate gender, sexuality and identity in the context of political and cultural formulation'.[5] Gender and sexuality, as a number of scholars remind us, is a dense transfer point of power, and dress is the embodiment of power. Communicating gender, sexuality, occupation and rank, dress conveys a person's relationship to power and status. As a social phenomenon, writes Anne Hollander, 'changes in dress *are* social changes [and] political and social changes are mirrored in dress'.[6]

In his commentary on transvestism, Peter Ackroyd suggests that in many cultures, cross-dressing has 'often been a sign of an extraordinary destiny':

In many shamanistic cultures, transvestites are regarded as sorcerers or visionaries, who, because of their double nature as men dressed as women, are sources of divine authority within the community ... It is not surprising that this double nature should be seen as a sign of the sacred, when we consider the androgynous or at least bisexual nature of the deities [that] are worshipped. If, as the Creation myths assert, Chaos—or the unity of undifferentiated sexuality—is the progenitor of all life, then the separate sexes represent a falling off from that original fecundity. Androgyny, in which the two sexes co-exist in one form and which the transvestite priest imitates in his own person, is an original state of power.[7]

Such sacred identities that link sex/gender ambiguity with spiritual prowess include the Indian *hijra,* the Kathoey of Thailand and the *Berdache* of sixteenth-century New Mexico. The gender-transcendent bissu of the *Bugis,* an ethnic group of South Sulawesi in Indonesia, are imagined to be hermaphroditic or inter sexed persons who embody female and male characteristics. Among the Bugis, four genders (rather than two) are acknowledged, plus a fifth 'paragender' identity. In addition to *oroane* (male-men) and *makunrai* (female-women), there are *calalai,* biological females who take on the roles and functions of men; *calabai,* anatomical males who take on the roles and expectations attributed to woman, and the bissu, who act as priests. The bissu dress in ways that highlight and incorporate their mixed gender and mark their role as deities—who are *dewata* (part human and part spirit). A bissu can carry a man's *badi* (knife) but wear flowers in their *hir* (hair) like a woman. In short, the role of the bissu is to bestow blessings, such as before the rice is planted and before the crops are harvested, or to consecrate marriages.

These identities link non conforming gender behaviour and spiritual potency. As Gutiérrez mentions, the Native American Berdache, known as the third sex, were biological males and females who assumed the dress styles, occupations, mannerisms and sexual comportment of the opposite gender.[8] However, as Elizabeth Wilson suggests, nowadays androgyny 'has ceased to be sacred', but has, via fashion, become a playful exchange between masculinity and femininity.[9] For Wilson, in postmodern societies, fashionable styles (ethnic, retro-chic, camp and, in this case, queer) have become an important means of recreating the 'lost self' or the 'splintered and decentred subject', thus showing that a certain identity is manifest and living.

Gender concepts and roles can only be understood in the context of specific cultures. One of the most significant cultural patterns that shapes a society's attitudes toward gender is the culturally constructed idea of the person. While the gender systems of other societies have usefully provided some alternative identification for transgendered persons in Western society, these identifications can be problematic, as the notion of the person in which they are embedded is not easily transferable. The word *gay,* for example, is used and understood in Fiji and Samoa in a different way from how it is employed and comprehended in Western cultures. In Thailand, the public expression of a person's identity is not as important as it is in the West. This significantly affects an individual's experience of gender dysphoria. Coming out as a homosexual in Thailand still brings shame or loss of face, without the compensation of the importance placed on identity considered essential in Western culture. A similar point was made by a Filipino *bakla* living in New York, in expressing a contrast between American and Filipino gay men to ethnographer Martin Manalansan:

> The Americans are different, darling. Coming out is their drama. When I was studying at [a New England college] the queens had nothing better to talk about than coming out. Maybe their families were very cruel. Back home, who cared? But the whites, my God, shedding tears, leaving the family. The stories are always so sad.[10]

Japanese Dandy Style

When in 1868, at the beginning of the Meiji period, Japan opened up its doors to the West, it also began to scrutinize what the West had to offer in an effort to compete with what was perceived as Western progress and with the intention of perhaps outdoing it. If Japan was quick to adopt Western dress, it was principally the men who did so; the women were expected to wear more traditional clothing, such as the kimono, which was a simplified version of the ancient *kosode*. One of the visions of sartorial success was the Western dandy, which soon became the benchmark for classiness and style.[11] To be dressed in a black suit and have gloves and a cane was for some the epitome to manliness, yet others in Japan saw these affectations as tipping in the opposite direction. If it was not, in our terms, queer, it was certainly not seen as impressively manly. The corollary, as Jason Karlin explains, was the macaroni in the eighteenth century, who was derided for his exaggerated adoption of continental ways.

> In their attacks on the state, they condemned foremost the vanity, fickleness, and superficiality of government leaders who followed the latest Western fashions. In this way, masculinity became one of the central modalities by which competing nationalisms were represented in Meiji Japan.[12]

The male Japanese aspirational archetype was a *shinshi,* which did not translate completely into 'gentleman', but rather also carried connotations of service to the state. Thus,

> the Japanese gentleman of the early Meiji period was typically identified by his frock coat, necktie, and white-collared shirt. On formal occasions, he wore a swallow-tailed coat and silk hat. This style became the defining emblem of Japanese gentlemen in Meiji discourse. As the leaders of modern Japan, they rationalized the adoption of Western fashion as necessary for reversing foreign perceptions of Japan as backward and uncivilized.[13]

Masculinity and conventionalization had serious intent. In complying according to these sartorial rules, one was literally showing one's commitment to the nation's push to improvement; one was serving the state. It was also a strategy that set up strong dichotomies, and to diverge from this provoked stringent criticism. This said, these new Western styles were not always worn with the greatest adeptness, which caused Japanese men to be ridiculed both outside and within; a popular caricature was of suited monkeys.[14]

The pace of Japan's Westernization created, needless to say, strict images, or facsimiles of style and gender that men and women were expected to replicate. And Japan was not about to witness the eventual coming out of gays that occurred in Europe and America in the decades after the Second World War. Indeed, homosexuality

was still not a social category and was not recognized in Japanese popular culture.[15] There exist accounts of male officers commenting on the good-looking young males that had been enlisted toward the end of the war, but, except for the occasional erotic wood block print, the degree of visibility for gays and lesbians was minimal. Merv Haddad, visiting Japan in the 1980s, noticed that 'Japan has neither a significant gay rights movement nor a very visible gay community, not even in Tokyo. Few people would identify themselves as gay, particularly women, who in Japanese culture are defined by their fathers, husbands and sons'.[16]

Immediately after the war, there began to spring up some gay bars. Understandably secretive, their main attraction was girlie boys, or *onna boi*. But it also appears that other more masculinized types were also present. One bar owner is described as 'a dominating type (*boi*); he always wears a rough, checkered and button-down shirt'.[17] On the other hand, another notable phenomenon was the *Takarazuka*, the female-to-male drag troupe, a review group combining burlesque with cathartic theatre. The women who play male parts are referred to as *otokoyaku* (literally 'male role'), and those who play female parts are called *musumeyaku* (literally 'daughter's role'). The notion of role-playing is to be especially noted here, particularly recalling our earlier invocation of Butler's concept of performing gender. As to be expected, these Japanese subcultures are highly localized and enjoy only a specialized following.

It was only in the 1990s that gays and lesbians began to have a substantial presence in Japan when they began to assert themselves as an alternative to so-called general society.[18] The gay pride and gay and lesbian Mardi Gras events or their equivalents are, in Japan and elsewhere in Asia, very recent. The Tokyo Lesbian and Gay Parade had its first manifestation in 1994. Others are even more recent: in India, the Bangaluru Pride parade began in 2008, and Shanghai Pride in China began in 2009; the Tokyo Gay and Lesbian Film Festival began comparatively early, in 1992.[19] In earlier decades, there were isolated opportunities for gays and lesbians that were tolerated so long as they remained covert. The first and largest cross-dressing club in Japan opened in 1979 in Tokyo and was known as the Elizabeth Club. Here men would not only dress up as girls, but they would also have themselves photographed in a purpose-built studio, and they staged competitions. These events were also followed and illustrated in the magazine *Queen.* Another place of interest was the red-light district in Tokyo, Kabuki-cho, which has sheltered cross-dressers since the 1960s. The expanded recognition in 1997 of gender identity disorder sanctioned many cross-dressers to take hormones to transform themselves physically. Others, however, do not do so, often on the grounds that they refuse to call their condition a disorder.[20]

Mardi Gras Boys of Singapore

The unofficial leading Asian Mardi Gras is in Singapore, despite its social regulation. But as Eng-Beng Lim shows, the repealing of the law against homosexuality in 2003

was part of a more far-reaching effort for advertising the city's broad-mindedness in an attempt to transform Singapore into a place of colour and creativity and in its bid to be the Global City of the Arts.[21] It was as if the gay and lesbian presence, as if queer style, was enlisted for the twenty-first-century globalized culture which Singapore has been working since the 1990s to harness. Lim cites Mardi Gras boys as a special phenomenon of Singapore, as those who 'perform the city-state's uncertain and superficial transformation from patriarchal father-state to "Asia's new gay capital"'.[22]

Lim understands the Mardi Gras boys in terms of a Bourdieuian cultural capital. In a sense, they are scions of the state. Their gender performance effectively advertises what Singapore wants to present to the rest of the world; namely, a place that excels at the Asian values of efficiency and order while affording its population the more liberal Euro-American rights of free choice.

Mardi Gras boys are relatively easy to spot. As Lim describes:

> Mardi Gras boys are one of several kinds of global queer boys. They are a trope of global gay worlds featuring the homoerotic cult of male youth and urban gay male practices. To name just a few sartorial and performative trademarks, queer boys are men who wear muscle tank tops with boa feathers, use skincare and cosmetic products, work out at trendy gyms, and attend pride parades and circuit dance parties. The term 'boys' is therefore not a marker of age, but a subcultural identification, and 'queer' is used rather than 'gay' to problematize any normalizing conception of sexual identity. The boys are also iconic of what social historians such as Dennis Altman have contentiously called 'global queering', a development in which queer worlds are apparently flattened out as a 'universal gay identity' is created and disseminated by Western gay culture.[23]

By around 2006, gay male culture in Singapore, precariously established, had begun exploring its vision of itself in theatre and film. As can be expected, despite the happy surface, there are still deep-seated anti-gay undercurrents in the Singapore establishment.

Albanian Sworn Virgins

The existence of women dressed as men who participate in male social roles has been an accepted cultural practice in the western Balkans since the fifteenth century. Found predominantly among the rural population, these honorary men or sworn virgins are accepted and recognized by their community and play an important part in kinship matters. According to anthropologist René Grémaux, who spent the summers of 1985 through to 1988 in the former Yugoslavia interviewing sworn virgins, the practice of dressing or passing as men is more permanent and institutionalized than cross-dressing in other social situations or cultures elsewhere. He writes, 'It concerned crossing gender identities rather than merely cross-dressing, since the individuals assumed the male social identity with the tacit approval of the family and the larger community.'[24]

In parts of Albania, especially in the northern agrarian region, people follow a code of ethics known as *Kanun* or formally the *Kanuni i Lekë Dukagjinit* (The Code of Lekë Dukagjini). This is a set of codes and laws developed by the Albanian prince Lekë Dukagjini (1410–81) and was used mostly in northern Albania, western Kosovo and southern Montenegro up until the twentieth century. The Kanun is not a religious document but rather a set of codes to ensure the continuation of Albanian identity and is followed by many groups including Roman Catholics, Russian Orthodox, Greek Orthodox, the Bosnian Church and Muslims.

The Kanun states that families must be patrilineal (meaning wealth is inherited through male lineage) and patrilocal (upon marriage, a woman moves into the household of her husband's family). Women are considered the property of the family and belong to their father until marriage, when ownership is handed to their husbands. Under the Kanun, the traditional role of women is restricted: their role is to take care of children and maintain the family home. They cannot own or buy property or vote in their local election.

The sworn virgin, *virgjinesha* or 'women-man', was born of social necessity in a region plagued by war and death, and there are several reasons why a woman would have taken this vow of celibacy. Some wanted to avoid an arranged marriage without dishonouring the groom's family, and others were forced by their fathers because there were no sons left to look after their families, or, if the family patriarch died without any male heirs, unmarried women in the family could find themselves alone and powerless because a family without a son or a father figure was often considered leaderless. By taking an oath (*besa*) of virginity, women can take on the role of men as head of the family, carry a weapon, own property and move freely among their community. Women who take on the role of men in this patriarchal society do so in order to maintain the family honour. If required, these honorary men take up arms in a blood feud to protect the family name. Breaking the vow was once punishable by death, but it is doubtful this punishment is still carried out now. Many sworn virgins today still refuse to go back on their oath, not out of fear of punishment but because the community will still reject them for breaking their vow.

While women can take the oath late in life, families in need of a male sibling to inherit the family's wealth have a girl take the vow at a very early age. The oath is usually taken in front of a town's elders—though some women take the oath privately—signalling their choice by cutting their hair and wearing traditional (or Western) men's clothes. These garments consist of tight-fitting white trousers (*potur*) and a jacket (*mitan*) with black trim braiding, a skull cap also made of white felt, and for footwear *opanke* (a type of enclosed leather sandal). Their body actions, stature and mannerisms are also very masculine. Once the vow is taken, the woman 'becomes a man', and in society she will be referred to as a 'he'. She will work like a man, dress like a man, talk like a man, and the community will treat her like a man.

In a recent *National Geographic* documentary (3 October 2008), British academic Antonia Young, whose research on Albanian sworn virgins began in 1989,

indicated that there are fewer than 100 sworn virgins in Albania (as well as Bosnia and southern Serbia) today. As women have gained more independence since the fall of communism and a stronger foothold in the workplace, fewer women are opting to take on the identity and lifestyle of the sworn virgin. In *Women Who Become Men. Albanian Sworn Virgins* (2001), Young observed that sworn virgins who lived in towns frequently wore suits, which rural sworn virgins kept for special occasions, and many wore heavy boots or shoes. With 'the gradual transition to western style clothing, most "sworn virgins" now wear western men's wear'.[25] According to Young's study, it is age that dictates what these honorary men wear in terms of recognizable male attire, rather than Western fashion, which has only recently become available. Young's study examines the way in which dress demarcates gender status in Albanian patriarchal society and how dress reflects wider cultural rules about sex, status, honour and gender in terms of socio-economic expectations.

Although there is some ambiguity in terms of sexual identity, taking an oath to become a sworn virgin should not, Young says, be equated with homosexuality. Male homosexuality was long taboo in rural Albania until 1995, when the law was amended, and female homosexuality is not mentioned in Albanian law. This lends credibility to the belief that the concept of lesbianism, or sexual relations between sworn virgins and village women, did not exist.[26]

Polynesian Gender Crossing

In the islands of Polynesia, men who dress like women and live their lives as women are known as *fa'afafine* in Samoa, *māhu* in Tahiti and Hawaii and *fakaleiti* in Tonga. The term literally means 'in the fashion of a woman' with the Tongan root *leiti* borrowed from the English 'lady'. In contemporary Polynesian cultures, women who dress and pass as men by performing masculine tasks are known in Tonga as *Fakatangata* and *fa'atama* in Samoa.

Polynesian gender crossing articulates versions of masculinity and femininity as well as cross-cultural understandings of place and identity, and so Western individualized conceptions of sexuality and gender are in opposition to Polynesian concepts of communal identity. In Fiji, queer sexuality may be spoken about covertly but not in a public space, and the term *gay* is used to mean *via via lewa* or, in the instance of reclaiming, *vaka sa lewa lewa*. These terms do not translate in the reverse direction and do not mean gay in the Western sense. Similarly, the Samoan word *fa'afafine* literally translates to 'like' or 'in the manner of' (*fa'a*) 'a woman' (*fafine*), but there is no direct English translation for the word as a whole. Not all fa'afafine dress as women and not all have sex with masculine men, even though most, but not all, take on a feminine role in sexual relationships. Therefore, they do not fit easily into the category of homosexual. Similarly, their relationships with men are not considered heterosexual. Whilst some undergo body-modifying

practices to resemble women, they are not defined as transsexual but possess a gender category of their own.

The customary role of the fa'afafine involves doing so-called women's work, such as ironing, washing, sewing, cooking, raising children and looking after the family. They are valued and respected in the community, and there is no stigma attached to being a fa'afafine in Samoan society. Fa'afafines often wear a *puletasi,* a traditional formal garment consisting of a long skirt and a matching blouse which is worn by Samoan women during formal occasions. The increasing exposure to the use of Western signifiers of femininity depicted in Western films and magazines has exposed fa'afafines to the myriad representations that fashion, make-up and appearance can have on gender identity.[27] In her study of the fa'afafine, Joanna Schmidt notes that many fa'afafine take on European feminine names and often choose a name that is associated with a famous or glamorous celebrity, such as a pop diva or a supermodel.[28] Name and clothing then become associated with a hyper-feminine, highly sexualized identity. In the Australian film, *Paradise Bent,* subtitled *Boys Will Be Girls in Samoa* (1999) and directed by Heather Croall, a division is made between cultural fa'afafines and a city kind of fa'afafines. The film introduces viewers to nightclub chorus dancer Cindy, who lives with her Australian male partner; she carries out household duties during the day and at night performs Samoan, Hawaiian and Tahitian dances, even impersonating Tina Turner on stage. Her appearance and sartorial style offstage is also feminine.

The recent popularity of beauty pageants as a visible means of claiming status and identity amongst fakaleiti in Tonga, fa'afafine in Samoa and the Kathoey of Thailand has also been well documented as sites of gender-bending performances and acts of resistance. Displays of translocality in the form of elaborate costumes, names and dances are ways of claiming a stake in local identity. These are specific gender performances that also act as a means of escaping poverty and social exclusion, which are largely a result of discrimination and lack of understanding of gender difference by mainstream society.

In *Clothing the Pacific,* Chloe Colchester comments, 'Clothing was one of the key markers of the advent of colonialism in the Pacific, and was seen by Europeans as one of the signs of the acceptance of civilisation by islanders.'[29] Polynesia was one of the last frontiers of colonial expansion and was constructed by Westerners as the embodiment of a paradise populated by 'exotic flora, fauna and peoples'. Timed with the rise of post-Enlightenment Romanticism in Europe, writes Niko Besnier, 'On the other side of the world, explorers found what they thought was humankind in its primeval state, unencumbered by the proscriptions of civilized more.'[30] Tahiti was proclaimed the New Cythera, and Louis-Antoine, Comte de Bougainville, in his 1771 book *Voyage Autour du Monde,* offered a vision of an earthly paradise where men and women lived happily in innocence, away from the corruption of civilization. His description powerfully illustrated the concept of the *bon sauvage* ('noble savage') and is clearly influenced by the utopian paradises of innocence propounded by the

likes of Jean-Jacques Rousseau. Interestingly, one of the most popular and prominent depictions of the Pacific was the way in which islanders openly approached sexuality. Bougainville documented with great enthusiasm and precision his first encounter with Tahitian women in his travels:

> In spite of all our precautions, a young girl came on board…The girl carelessly dropped a cloth, which covered her, and appeared to the eyes of all beholders, such as Venus shewed to the Phrygian shepherd, having, indeed, the celestial form of that goddess.[31]

With this description, the politics of sex, gender and colonialism would be inextricable bound and linked in the Pacific.

It was not long after that a contrary image of Polynesia, more popular amongst missionaries, began to circulate. It was one that portrayed islands of cannibals and headhunters, human sacrifices, infanticide, adultery and violent warfare. As Besnier notes, 'The island [of Polynesia] turned from the "New Cythera" (the name that Bougainville bestowed upon it) to "the filthy Sodom of the South Seas."'[32] According to Australian historian Robert Aldrich, there is an extensive body of work describing same-sex practices in Oceania. This is partly because the colonization of the Pacific by European powers 'was marked by the rationalist concerns of the enlightenment…which tried to explain, not simply judge the sexual customs of other cultures'.[33] As a project of modernity, colonialism also sought to describe indigenous customs and practices as a way of controlling bodies through taxonomies of knowledge in producing power.

Records of early Pacific encounters by Europeans describe in great detail the Tahitian mahu, the fa'afafine, fakaleiti and the *mahui* as effeminate men, dressed in traditional women's garments, that sexually service masculine men. Their increased prevalence in the postcolonial Pacific is often linked, writes Aldrich, 'to changes in traditional cross-gender sexual relations, particularly the increased control of female sexuality resulting from Christianisation'.[34] Interestingly, on the Cook Islands, the term *laelae* is used to describe men who are homosexual but presumed to be heterosexual and are considered effeminate in some way.

The Hijra: An Alternative Gender Role in India

In India, the hijra is considered to be an alternative, or third gender role, alongside the gender categories of man and woman. Multiple sexes and genders were recorded very early in Indian religion and mythology. Many of these were primarily considered to be sexually impotent males. Hijras are culturally institutionalized as an alternative, mixed-gender role, neither man nor woman, neither male nor female. Their traditional occupation is to collect payment for their performances at weddings and the birth of a male child; today they also perform for the birth of female children. They also are widely known as prostitutes, both in the past and present.

Hijras are not considered men because they do not fulfil and perform the traditional male sexual role in Indian society and do not produce offspring. They often define themselves as men who have no (sexual) desire for women, though they do frequently, perhaps universally, act as receptive sexual partners for men who are not, however, defined as homosexuals. Although the sex work of hijras is not largely known or acknowledged, hijras are perceived as quite different from other effeminate men or gay men in India.

Hijras wear women's dress with differences in styles across region. They wear traditional jewellery such as wrist bracelets, toe and nose rings and bindis, a forehead decoration in the shape of a coloured dot. They grow their hair long, imitate women's walk and gestures, voice and facial expressions and language; they take feminine names as part of their gender transformations and use female kinship terms for their relationships within the hijra community. They wear a kameez or sari, and at times Rajasthani hijras may wear a *ghagra* (long skirt), *choli* (a short, tailored, tight-fitting blouse) and *odhni* (a half-sari tucked into the waistband of a skirt and pulled over the head and shoulders). In spite of their public presentations as women, two symbolic acts unique to the hijra community immediately identify them as outside the Indian binary gender frame of reference. One is the distinctive handclap by which they announce their public presence, and the other is the actual or threatened lifting of their saris to expose their genitalia as a rebuke to an audience that insults them, either by refusing to pay in response to their demands or by questioning their authenticity as true hijras, implying they are effeminate homosexuals. Although hijras are like women, they are not perceived as women, partly because their performances as women are perceived by the wider Indian society as caricatures of the feminine and because hijras cannot give birth to children. Some hijras identify as mostly women; others, as only hijras, and their life stories, both constructed and factual, reveal multiple gender-identity changes over a lifetime, including those that result from joining and being socialized by the hijra community. Historical records from the eighteenth century note that hijras were required by government decree to distinguish themselves by wearing a man's turban with their female garments.[35]

The main legitimacy of hijra identity as an alternative gender role, for themselves and the wider community, is found within the religious context of Hinduism. Hijras are devotees of Bahuchara Mata, one of the many versions of the mother goddess worshiped throughout India. According to Hindu lore, men who are sexually impotent are called upon by Bahuchara Mata to dress and act like women and to undergo emasculation. This operation, called *nirvan,* or rebirth, involves the removal of the penis and testicles and endows hijras with the divine powers of the goddess (*shakti*). Considered to possess the Mata's divine power, hijras perform at weddings and births, receive alms as servants of the goddess at her temple, and are given alms by shopkeepers and the general public.

Hinduism, unlike the Judeo-Christian religions, embraces contradictions without the need to resolve them. Male and female are viewed as natural categories,

embodying qualities of both sex and gender, which are in complementary opposition to each other. In spite of the importance of this dichotomy, sex and gender variations, interchanges, and transformations are meaningful and positive themes in Hindu mythology, ritual and art. In Hinduism, impotence can be transformed into the power of generativity through the ideal of *tapasya,* the practice of asceticism or the renunciation of sex. *Tapas,* the power that results from ascetic practices and sexual abstinence, becomes an essential feature in the process of creation. Ascetics appear throughout Hindu mythology in procreative roles; of these, Shiva is the greatest creative ascetic. Like Shiva, whose self-emasculation became the source of his creative power, so too the hijras, as emasculated men, become vehicles for the creative power of the mother goddess, and, through her, Shiva.

Ancient Hindu texts refer to alternative sexes and genders among humans as well as deities, and the Kama Sutra, the classical Hindu manual of love, specifically refers to eunuchs and the particular sexual practices they should engage in. The ancient Hindu depiction of alternative genders among humans and deities is reinforced by the historical role of the eunuch in ancient Hindu and, more particularly, Muslim court culture, which has a 500-year history in India. This historical role has merged with those described in Hindu texts as a source of contemporary hijra identification. Hijras are viewed with ambivalence in Indian society and are treated with a combination of mockery, fear and respect. The loss of virility that the hijras represent is a major source of the fear they inspire. The hijras' power to bless a family with fertility and fortune is conjoined with their power to curse a family with infertility and misfortune. In accommodating the role of the hijra, traditional Indian mythology and history provide a context for positive meaning and self-esteem for those with variant sex and gender identities.

Ladyboys and Tomboys of Thailand

Thailand today is characterized by a complex and multiple system of gender identities, which incorporates traditional cultural meanings, a Western biomedical view and diffusion of various Western concepts of gay. Ancient Buddhist texts indicate that biological sex, culturally ascribed gender and sexuality are not clearly distinguished. Traditional Thai myths describe three original human sexes and genders— male, female, and Kathoey, or hermaphrodite, defined as a third sex, a variant of male or female, having characteristics of both sexes. Linguistic evidence suggests, however, that Kathoey, also known as ladyboys, may also have connoted a person whose gender is different from other males or a male who acts like a woman, a meaning consistent with the predominant contemporary usage.

The system of three biological sexes remained prevalent in Thailand until the mid-twentieth century. At that time, the diffusion of various Western influences resulted in a proliferating variety of alternative or variant sex and gender roles and

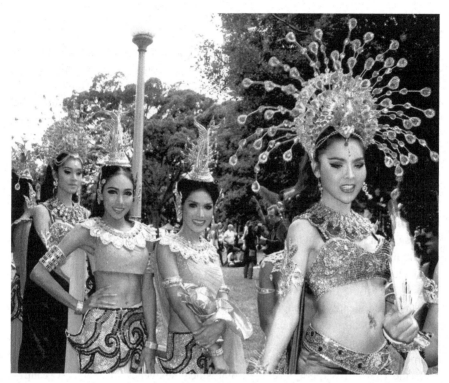

Fig. 6.1 Thai Beauties pre-parade, Hyde Park, Sydney Gay and Lesbian Mardi Gras Parade, 2011. Courtesy: C. Moore Hardy, City of Sydney Archives.

gender identities and a fluctuating attitude toward sex and gender diversity, which characterizes contemporary Thailand.

Today, the term *Kathoey* most commonly refers to a male transgender category—that is, a male who breaches biological and cultural norms of masculinity.[36] Put another way, a Kathoey is viewed as a man who appropriates female form (feminine attributes and behaviour) without becoming a woman and without ceasing to be a man. This concept variously refers to hermaphrodites, transvestites, transsexuals or effeminate homosexual men. Almost all Kathoey cross-dress and undergo hormone replacement therapy; most have breast implants, and some also undergo genital reassignment surgery, as well as other surgical procedures to feminize their appearance—for example, reducing their Adam's apple. At the same time, somewhat contradictorily, Kathoey are still sometimes viewed as halfway between men and women or a second kind of woman, a definition that contains cultural traces of the historical Buddhist position.[37] This traditional concept is also reflected in the Royal Institute Thai language dictionary which defines a Kathoey as a person who has both male and female genitals; a person whose mind (i.e., psychology) and behaviour are the opposite of their sex/gender, which (theoretically) applies to males and females.

Toms, or tomboys, typically dress in Western-style masculine clothing such as jeans and T-shirts or polo shirts, have short-cropped hair swept on the sides and swagger when they walk. Toms perform masculinities in their behaviour, attitudes, interests and desires. As masculine-acting women, Toms desire feminine-acting women, known as *Dees,* who dress as feminine women and have long hair. Although Toms and Dees enact butch-femme role-playing in their relationships, the terms *butch* and *femme* are not used in Thailand's Tom-Dee community. Toms and Dees are differentiated from Western lesbian identities, writes Peter Jackson, 'because [they] imagine lesbians to be a different type of person from themselves, a sense of disjunction and difference is created between Thai and Western female homosexualities'.[38]

Sutdida Vitoonkaewsiri, a self-identified Dee living in Bangkok, says of her tom boyfriend while sweetly caressing her palm, 'A tom? You foreigners might call her a "lesbian", but it's different here. A tom is a woman who behaves like a man. They're exactly like boys, only their bodies aren't the same.'[39]

The term *Tom* comes from the English word tomboy, and *Dee* is a derivative of the last syllable of the English word *lady.* Toms are considered by Thais to embody a transgendered identity; although biologically female, they are considered to possess a masculine soul (*cit-cay*). To be a Tom is to adopt the male gender role completely: wearing jeans and T-shirts, binding breasts to their chest and refusing, even in the bedroom, to disrobe and dispel the illusion of a masculine identity.

In the 1950s, a Western, scientific, biomedical sex/gender discourse was introduced into Thailand. This perpetuated the view within Thai academic circles that Kathoey were hermaphrodites: persons whose biological characteristics—sex glands, genitals and secondary sex characteristics—combined those of a male and a female to the extent that they could not be clearly assigned to one or the other sex/gender.[40] The role of sexual orientation and sexual practice in identifying the Kathoey has also changed. In traditional Thai culture, Kathoey sexuality was peripheral to their identity. In Thai culture, sexual orientation and sexual practices were not the basis of any personal or social identity, and the modern Western opposition of homosexual/ heterosexual as types of persons did not exist. The influence of a Western biomedical discourse, however, led to an emphasis on the feminine attributes of the Kathoey and particularly their sexuality, a view that converged with the Thai understanding of gay in the 1970s to the 1990s.

Although homoeroticism has long been recognized in Thailand, historically it was not religiously condemned as a sin or criminalized or prosecuted by the state, and no efforts were made to 'correct' or 'cure' it. Homoerotic relations between masculine-identified men (or between women), called 'playing with a friend', were distinguished, however, from sex between a man and a feminine Kathoey. These relations were viewed as less stigmatizing than sexual relations between two men because homoeroticism is not a man's fate, but it is the fate of a Kathoey. And, unlike the sexual relationships between a male and a Kathoey, relationships between

two men were considered disastrous, resulting in natural disasters, such as droughts, being struck dead by lightning, or madness.[41]

While in the late 1970s, the English term *gay* entered Thai culture as a reference mainly to a cross-dressing or effeminate homosexual male, by the 1990s, the Thai image of gay became increasingly masculinized. This new gay identity again showed cultural traces from an earlier, implicit subcategory of masculine status: a man who is gender-normative in all but his homoerotic preferences. In Thai culture, the category of man could and did accommodate homoerotic preference as simply a variation of masculine sexuality, as long as it remained private. Taking the feminine, receptive sexual role, however, was stigmatized if publicly known and defined a man as socially deficient, ranked even lower than a Kathoey.

The contemporary category of a masculinized gay identity in Thailand blurs the earlier distinction between masculine and feminine sexual practices, which are now viewed not as a defining marker of sex/gender identity but rather as mere personal preferences. Gay men in Thailand now self-identify with a strong, masculine body image and a strong preference for male heterosexual partners. This masculine gay identity, which strongly disassociates itself from an imputed feminine status, is well established among the educated and middle class, and, increasingly, among the lower and working classes. A Thai male who dresses, talks and acts in ways expected of a Thai man, who is not known to take the woman's role in sexual relations and who fulfils his social obligations by marrying and fathering a family is honoured by being considered a man, even if he has, or has had, male sexual partners.

Kathoey (sometimes known as ladyboys) are now much more thoroughly identified as feminine, with their sexuality (though not that of their sexual partners) as well as their behaviour viewed as central to their identity. While the term *Kathoey* today applies to a wide range of transgendered persons, including effeminate homosexuals, some Kathoey also self-identify as women. Culturally, they have become the Other against whom gay men construct their masculine identities. The categories of man and Kathoey are now polar opposites in the sex/gender system, as a Thai man regards himself as either a man or a Kathoey.[42]

Feminine sexual orientation, speech, behaviour and dress of the Kathoey today defines his/her social and gender identity. Ladyboys dress in very colourful traditional Thai clothing with a mix of Western design. Most Kathoey prefer to wear Western fashions such as jeans and T-shirts and opt for traditional Thai garments when performing, if they are employed as a member of a theatrical troupe or on occasions of their choice. Traditional Thai clothing is manufactured in raw, handmade silk and is considered to be of high quality amongst global fabric manufacturers and producers. Many Kathoey wear long wrap-around skirts with a floral-print blouse, or a knee-length or short skirt with a matching short-sleeve top. Other types of dresses that are popular with Kathoey are colourful batik sarongs made of cotton.

Thai academic sex and gender discourse attempts to distinguish Kathoey from homosexuals by, for example, linguistically distinguishing 'genuine Kathoey' or hermaphrodites from 'false' or 'artificial' Kathoey—that is, males who (merely) exhibit cross-gender characteristics and engage in homoerotic practices and who are sometimes defined as sexual perverts (a perspective also found frequently in India with regard to the hijra). By the 1970s and 1980s, the categories of transvestites and transsexuals were also distinguished from (biological) hermaphrodites, with only the latter considered true Kathoey. The former began to be viewed as false Kathoey, who, like homosexual men, were considered to suffer from a psychological disorder. This distinction, which retains traces of the traditional Kathoey as a distinctive intermediate sex/gender category of men born with the mind of a woman, is still sometimes used in the popular media, though it contrasts with the dominant popular view of the Kathoey as a male who makes himself up as a woman or as an alternative category of maleness.

Despite the popular Western view that Kathoey are accepted in Thailand, in fact, Kathoey and Toms are becoming increasingly constrained by the contemporary Thai state. They are prevented from changing their status legally, must take out passports in their male (or female) identities and, as a result of some recent media sensationalism, were for a time prohibited from some occupations, such as teaching, though the prohibition in regard to teaching was later rescinded. Homosexuality and male non-normative behaviour are now considered social problems by the Thai scientific community and, to some extent, by the state, somewhat negating an earlier view that the aim should be to help Kathoey and Toms to live happy and productive lives in society through sex-change operations and legal reforms that recognize the changed-gender status of post-operative transsexuals. With non-normative genders now being redefined as perversions, there has been a rise of anti-Kathoey and anti-sex-change rhetoric that now exists alongside older, more tolerant, sympathetic and non-interventionist discourses; indeed, at one time Kathoey were spirit mediums and held a powerful position in Thai culture.

What partly accounts for the Western view that Kathoey, Toms and other polymorphous gendered identities are accepted in Thailand is their high visibility. Kathoey and toms are found in all social strata and live and work openly both in rural and urban areas. Toms are particularly associated with masculine prowess and virility, and Kathoey are widely admired for their feminine grace, beauty and elegance. Kathoey are well-known performers in beauty contests and musical female impersonator revues, both critical sites of the enactment of the Kathoey, non-normative sex and gender roles. At the same time, many Kathoey and toms work in ordinary jobs and run their own businesses and identify as productive members of their communities.

If identity is inextricably intertwined with sexuality and gender, then sartorial style and appearance are central to our understanding of the ways in which bodies are inscribed by culture. As Elizabeth Wilson writes, 'Fashion is obsessed with gender

[because it] defines and redefines the gender boundary';[43] Michel Foucault argues elsewhere that, 'We are dominated by the problem of the deep truth of the reality of our sex life.'[44] Queer style then, as a form of self-expression, is as much about exploring the boundaries of masculine or feminine dress codes in the production and consumption of polymorphous identities as it is about sartorial display and power. Queer style disrupts and destabilizes cultural presumptions about sex and gender orders and creates possibilities of rearticulating and reframing meanings of gender.

Conclusion: Against Justification

The hyperdevelopment of style in, for example, Mannerist painting and Art Nouveau, is an emphatic form of experiencing the world as an aesthetic phenomenon. But only a particularly emphatic form, which arises in reaction to an oppressively dogmatic style of realism. All style—that is, all art—proclaims this. And the world is, ultimately, an aesthetic phenomenon.

That is to say, the world (all there is) cannot, ultimately, be justified. Justification is an operation of the mind which can be performed only when we consider one part of the world in relation to another—not when we consider all there is.

—Susan Sontag[1]

Change a few of the words in these lines from Sontag—heteronormative for realism, art for fashion—and you have the gist of this book. There is no strict definition for queer style, and yet it is identifiable, present and a powerful vector within our society. We might recall the Portuguese poet Fernando Pessoa, who worked under a series of pseudonyms and defended his 'unwillingness to cohere'. Although we have located the numerous stereotypes, clones and conventions that queer style has existed under, these examples compose a much wider and more mobile constellation.

A notion that we have persistently turned to is that of performance and posing. As with the case of the dandy, who looms large in this book, these qualities are not limited to queer. However, what is important to stress is the lived, temporal element in both performance and posing; they involve presence and exist as an event thus thwarting forces of atomization, of closure. This was summed up best more than two decades ago by Eve Kosofsky Sedgwick in the much-cited *The Epistemology of the Closet*:

Most moderately to well-educated Western people in this century [the twentieth] seem to share a similar understanding of sexual definition, independent of whether they themselves are gay or straight, homophobic or antihomophobic. That understanding is close to what Proust's probably was, what for that matter mine is and probably yours. That is to say, it is organized around a radical and irreducible incoherence. It holds the minoritising view that there is a distinct population of persons who 'really are' gay; at the same time, it holds the universalizing views that sexual desire is an unpredictably powerful solvent of stable identities; that apparently heterosexual persons and object choices are strongly

marled by same-sex influences and desires and vice versa for apparently homosexual ones; and that at least male heterosexual identity and modern masculinist culture may require for their maintenance the scapegoating crystallization of a same-sex male desire that is widespread and in the first place internal.[2]

Writing this book now, queer style does not have the same shock value or transgressive intent as it had in the past. As we have suggested already, we are living in a post-subcultural age in which subcultures of the past (e.g., punks) have been relatively drained of their socially explosive potential, becoming clones and being harmlessly troped (as in David Beckham's punk-style hairdo) by mainstream popular culture. This does not mean that queer style is reduced to a caricature or some shadow. There are two comments to conclude with. The first is that so long as queer is considered queer, it will always announce itself, pose, perform and reinvent itself. The second is more paradoxical and perverse: if we may generalize, queer culture is proud to be queer. There are different levels of acceptance: legal, psychological, social. Some of these are essential (such as the legal recognition of gay relationships), but others are not. To be too accepted is to lose the edge and to risk fading into an obscurity that is without delight, deprived of play, denuded of the festive spirit that is always active in the soul of queer style.

Notes

Introduction

1. Marcel Proust, *À la recherche du temps perdu* [Remembrance of Things Past], trans. C. K. Scott Moncrieff and Terence Kilmartin (Harmondsworth: Penguin, 1984), vol. 3, 948–9.
2. Heinrich von Kleist, 'Über das Marionettentheater', in *Sämtliche Werke* (Leipzig: Im Insel Verlag, 1810), 1138.
3. Steven Seidman, 'Deconstructing Queer Theory or the Under-theorization of the Social and the Ethical', in Linda Nicholson and Steven Seidman, eds., *Social Postmodernism: Beyond Identity, Politics* (Cambridge: Cambridge University Press, 1995), 117.
4. What is not acknowledged enough, however, is that while treatments continue to improve, and the lifespans of those with AIDS continue to be longer for those with access to the most up-to-date drugs, Africans, including newborn children, continue to be ravaged by the disease.
5. See also Seidman, 'Deconstructing Queer Theory', 134–5.
6. Murray Healy, 'The Queer Appropriators', in Murray Healy, ed., *Gay Skins, Class, Masculinity and Queer Appropriation* (London: Cassell, 1996), 179.
7. Ibid., 183.
8. Rob Cover, 'Bodies, Movements and Desires: Lesbian/Gay Subjectivity and the Stereotype', *Continuum* 18/1 (2004), 95.
9. Patrizia Calefato, 'Fashion and Worldliness: Language and the Imagery of the Clothed Body', *Fashion Theory* 1/1 (1997), 72.
10. Moe Meyer, 'Introduction: Reclaiming the Discourse of Camp', in Moe Meyer, ed., *The Politics and Poetics of Camp* (London: Routledge, 1994), 2.
11. Judith Butler, 'Competing Universalities', in Judith Butler, Ernesto Laclau and Slavoj Žižek, eds., *Contingency, Hegemony, Universality* (New York: Verso, 2000), 145.
12. Ibid., 148.
13. Eve Kosofsky Sedgwick, *Tendencies* (Durham, NC: Duke University Press, 1993), xii.
14. Michel Foucault, *The History of Sexuality,* trans. Robert Hurley (London: Vintage, [1977] 1990), vol. 1, 154.
15. Slavoj Žižek, *Enjoy Your Symptom!* (London: Routledge, 1992), 124.

16. Gilles Deleuze, *Proust et les signes* (Paris: Presses Universitaires de France, 1971), 150.
17. Judith Butler, 'Performative Acts and Gender Constitution', in Katie Conboy, Nadia Medina and Sarah Stanbury, eds., *Writing the Body: Female Embodiment and Feminist Theory* (New York: Columbia University Press, 1997), 410.
18. Erving Goffman, quoted by Thomas S. Weinberg, 'Sadism and Masochism: Sociological Perspectives', in Thomas S. Weinberg and G. W. Levi Kamel, eds., *S and M: Studies in Masochism* (Buffalo, NY: Prometheus Books, 1983), 67.
19. Judith Butler, *Gender Trouble and the Subversion of Identity* (London: Routledge, 1990), 29.
20. Edmund White, 'Fantasia in the Seventies', in *The Burning Library. Writings on Art, Politics and Sexuality 1969–93* (London: Random House, 1994), 39–40.
21. See, for instance, Stephen Valocchi, who stated: 'Although sociologists do recognize this alignment [toward hetero-normativity in discourse and activity] as ideological and hence as a source of power, we conspire in reproducing this alignment by treating the categories and the normative relationship among them as the starting assumptions on which our research is based and the major lens through which we interpret our data. The conflation of these variables with identities further encourages this tendency.' From Stephen Valocchi, 'Not Yet Queer Enough: The Lessons of Queer Theory for the Sociology of Gender and Sexuality', *Gender and Society* 19/6 (2005), 752.

Chapter 1: The Meaning of Style between Classic and Queer

1. Cit. Nicholas Weber, *Balthus. A Biography* (London: Weidenfeld and Nicholson, 1999), 3.
2. Alex Potts, *Flesh and Ideal. Winckelmann and the Origins of Art History* (New Haven, CT: Yale University Press, 1994), 159.
3. Ibid., 159–60.
4. These points are made throughout Hegel's *Aesthetics*. For the main examination, see G.W.F. Hegel, 'Das Ideal der Skulptur', in *Vorlesung über die Ästhetik II, Werke* (Frankfurt am Main: Suhrkamp Verlag, 1986), vol. 14, 374ff.
5. T. Davidson, trans., 'Winckelmann's Description of the Torso of the Hercules of Belvedere', *The Journal of Speculative Philosophy* 2/3 (1868), 188.
6. Ibid.
7. See, for example, Craig Williams, *Roman Homosexuality* (Oxford: Oxford University Press, 2010); and John Winkler, *The Constraints of Desire. The Anthropology of Sex and Gender in Ancient Greece* (London: Routledge, 1990).
8. Now available on YouTube; here David Walliams and Matt Lucas dress in muscle suits (quite similar to the fat suits of Mike Myers or Eddie Murphy) and communicate in mock gruff tones situations that, as the show progresses,

are increasingly homoerotic; they also display their (fake) penises which, from steroids, have atrophied into miniature Napoleonic stumps. See *Little Britain USA* (2008), HBO Network.

9. Cit. Hans Mayer, *Outsiders: A Study in Life and Letters* (Cambridge, MA: MIT Press, 1982), 168.

10. Kevin Parker, 'Winckelmann, Historical Difference, and the Problem of the Boy', *Eighteenth-Century Studies* 25/4 (1992), 544.

11. Take, for example, Bernini's *David* (1623–4), which differs from that by Verrocchio or Michelangelo for being about to throw the stone; Apollo watches on as Daphne transforms into a tree (1622–5); and his many portraits have a distracted air. In Bernini's portrait (c. 1637) of his ill-fated mistress Constanza Buonarelli she looks positively startled.

12. Moshe Barasch, *Modern Theories of Art Vol. I, From Winckelmann to Baudelaire* (New York: New York University Press, 1990), 100.

13. Friedrich Nietzsche, *The Case of Wagner,* in Walter Kaufmann, trans., *The Birth of Tragedy and the Case of Wagner* (New York: Random House, 1967), 161. See also Amelia Jones, *Postmodernism and the En-gendering of Marcel Duchamp* (Cambridge: Cambridge University Press, 1994), 19ff.

14. James Smalls, 'Making Trouble for Art History: The Queer Case of Girodet', in 'We're Here: Gay and Lesbian Presence in Art and Art History', special issue, *Art Journal* 55/4 (1996), 24.

15. Joanne Entwistle, *The Fashioned Body. Fashion, Dress and Modern Social Theory* (Cambridge: Polity, 2000), 141.

16. Dorinda Outram, *The Body and the French Revolution* (New Haven, CT: Yale University Press, 1989), 156.

17. Eve Kosofsky Sedgwick, *Between Men* (New York: Columbia University Press, 1985), 93.

18. Valerie Steele, 'Appearance and Identity', in Claudia Kidwell and Valerie Steele, eds., *Dressing the Part* (Washington, DC: Smithsonian Institution, 1989), 16.

19. Ibid., 17.

20. Patrizia Calefato, 'Style(s) between Fashion and the Grotesque', in *The Clothed Body* (Oxford: Berg, 2004), 27, 39, 38.

21. Cit. Dwight A. McBride, *Why I Hate Abercrombie and Fitch* (New York: New York University Press, 2005), 67.

22. Ibid., 60.

23. Patrizia Calefato, 'Fashion and Wordliness: Language and Imagery of the Clothed Body', *Fashion Theory: The Journal of Dress, Body and Culture* 1/1 (1997), 76.

24. Ibid., 76–77.

25. Rosemary Hennessy, 'Queer Visibility and Commodity Culture', in Linda Nicholson and Steven Seidman, eds., *Social Postmodernism: Beyond Identity, Politics* (Cambridge: Cambridge University Press, 1995), 165.

26. One strong example of queer lifestyles in recent time was the first gay TV drama, *Queer as Folk*, which helped to promote and image of what Giovanni Porfido calls 'the image of gay space'. It was a space that was narrow, limited to post-industrial Manchester, but this did not appear to trouble anyone. Manchester was painted as not only a place tolerant of gay men but one that openly welcomed them. Gay men were actively situated within the specularized space of television and the media, given a place that was hitherto denied them. See Giovanni Porfido, '*Queer as Folk* and Specularization', in Thomas Peele, ed., *Queer Popular Culture: Literature, Media, Film and Television* (New York: Palgrave, 2007), 65, 67–8.

Chapter 2: Lesbian Style: From Mannish Women to Lipstick Dykes

1. Susie Bright (Susie Sexpert, pseud.), 'College Confidential', *On Our Backs* 7/4 (1991), 11.
2. Joan Nestle, 'The Femme Question', in Joan Nestle, ed., *The Persistent Desire. A Femme-Butch Reader* (Boston: Alyson Publications, 1987), 141.
3. Ibid.
4. Elisa Glick, *Materializing Queer Desire. Oscar Wilde to Andy Warhol* (Albany: SUNY Press, 2009), 64.
5. See also Kristen Ross, 'Albertine; Or, The Limits of Representation', *NOVEL: A Forum on Fiction* 19/2 (1986), 89–97.
6. Esther Newton, 'The Mythic Mannish Lesbian: Radclyffe Hall and the New Woman', in Martin Duberman, Martha Vicinus and George Chauncery Jr, eds., *Hidden from History: Reclaiming the Gay and Lesbian Past* (New York: Plume, 1989), 281.
7. Ibid., 291.
8. Elizabeth Wilson, 'Forbidden Love', *Feminist Studies* 10/2 (1984), 214.
9. Cit. Rebecca Jennings, *Tomboys and Bachelor Girls. A Lesbian History of Post-war Britain 1945–71* (Manchester: Manchester University Press, 2007), 119.
10. Miranda Gill, *Eccentricity and the Cultural Imagination of Nineteenth-century Paris* (Oxford: Oxford University Press, 2008), 87–89.
11. Ibid., 91.
12. Elisabeth Landeson, *Proust's Lesbianism* (Ithaca, NY: Cornell University Press, 1999), 47.
13. Quentin Crisp, *The Naked Civil Servant* (Harmondsworth: Penguin, 1997), 21. See also Landeson, *Proust's Lesbianism*.
14. Landeson, *Proust's Lesbianism,* 48.
15. Marjorie Garber, *Vested Interests: Cross-dressing and Cultural Anxiety* (London: Routledge, 1992), 85.
16. Ibid., 86.

17. Laura Doan, 'Passing Fashions: Reading Female Masculinities in the 1920s', *Feminist Studies* 24/3 (1998), 670.

18. Ibid., 677–9.

19. Glick, *Materializing Queer Desire,* 76.

20. George Brassaï, *The Secret Paris of the Thirties* (London: Thames and Hudson, 1976), 147.

21. Cit. J. Leila Rupp, 'Loving Women in the Modern World', in Robert Aldrich, ed., *Gay Life and Culture: A World History* (London: Thames and Hudson, 2006), 241.

22. Ibid., 244.

23. Cit. Eric Garber, 'A Spectacle in Color: The Lesbian and Gay Subculture of Jazz Age Harlem', in Martin Duberman, Martha Vicinus and George Chauncery Jr, eds., *Hidden from History. Reclaiming the Gay and Lesbian Past* (New York: Meridien, 1990), 322.

24. Ibid., 99.

25. Elizabeth Lapovsky Kennedy and Madeline D. Davis, *Boots of Leather, Slippers of Gold. The History of a Lesbian Community* (London: Routledge, 1993), 158.

26. Ibid., 159.

27. Ibid., 164.

28. Nan Alamillah Boyd, cit. by Ken Gelder, *Subcultures: Cultural Histories and Social Practice* (London: Routledge, 2007), 15–17.

29. Ibid., 10.

30. For instance, Kennedy and Davis, *Boots of Leather, Slippers of Gold,* and Newton, 'The Mythic Mannish Lesbian'.

31. Kelly Hankin, *The Girls in the Back Room. Looking at the Lesbian Bar* (Minneapolis: University of Minnesota Press, 2002), xviii.

32. Elizabeth Lapovsky Kennedy and Madeline D. Davis, "I Could Hardly Wait to Get Back to that Bar": Lesbian Bar Culture in the 1930s and 1940s', in David Sheer and Caryn Aviv, eds., *American Queer. Now and Then* (Boulder, CO: Paradigm Publishers, 2006), 59.

33. Maxine Wolfe, 'Invisible Women in Invisible Places: The Production of Social Space in Lesbian Bars', in Gordon Brent Ingram, Anne-Marie Bouthillette and Yolanda Retter, eds., *Queers in Space. Communities, Public Places and Sites of Resistance* (Seattle: Bay Press, 1997), 307.

34. Sue-Ellen Case, 'Towards a Butch-Femme Aesthetic', in Henry Abelove, Michele Aina Barale and David Halperin, eds., *The Lesbian and Gay Studies Reader* (London: Routledge, 1993), 294–306.

35. Lillian Faderman, *Surpassing the Love of Men. Romantic Friendship and Love between Women from the Renaissance to the Present* (New York: William Morrow, 1981).

36. Arlene Stein, 'Androgyny Goes Pop: But is it Lesbian Music?', in Arlene Stein, ed., *Sisters, Sexperts, Queers: Beyond the Lesbian Nation* (Harmondsworth: Penguin, 1993), 478.

37. Barbara Creed, 'Lesbian Bodies: Tribades, Tomboys and Tarts', in Janet Price and Margrit Shildrick, eds., *Feminist Theory and the Body. A Reader* (Edinburgh: Edinburgh University Press, 1999), 123.

38. Arlene Stein, *Sex and Sensibility. Stories of a Lesbian Generation* (Berkeley: University of California Press, 1997), 478.

39. Wilson, 'Forbidden Love', 213–26.

40. Alice Solomon, 'Not Just a Passing Fancy: Notes on Butch', in Debora Bright, ed., *The Passionate Camera: Photography and Bodies of Desire* (London: Routledge, 1998), 264.

41. Sonya Andermaher, 'A Queer Love Affair? Madonna and Gay and Lesbian Culture', in Diane Hamer and Belinda Budge, eds., *The Good, the Bad, and the Gorgeous: Popular Culture's Romance with Lesbianism* (New York: HarperCollins, 1994), 32.

42. Ibid., 38.

43. Ibid., 109.

44. Judith Butler, cit. Diana Fuss, *Inside/Out. Lesbian Theories. Gay Theories* (London: Routledge, 1991), 21.

45. Andermaher, 'A Queer Love Affair?', 32.

46. Olga Vainshtein, 'Dandyism, Visual Games and the Strategies of Representation', in Peter McNeil and Vicki Karaminas, eds., *The Men's Fashion Reader* (Oxford: Berg, 2009), 93.

47. Entwistle, *The Fashioned Body,* 176.

48. Garber, *Vested Interests,* 92.

49. Butler, *Gender Trouble,* viii.

50. Richard Middleton, 'Authorship, Gender and the Construction of Meaning in the Eurythmics Hit Recording', *Cultural Studies* 9/3 (1995), 476.

51. Garber, *Vested Interests,* 97.

52. Annie Lennox cit. B. Mewborn, 'Eurythmics Unmasked', *Rolling Stone* (24 October 1985), 42.

53. Gillian Rodger, 'Drag, Camp and Gender Subversion in the Music and Videos of Annie Lennox', *Popular Music* 23/1 (2004), 19.

54. Joanne Entwistle and Elizabeth Wilson, eds., *Body Dressing* (Oxford: Berg, 2001), 218.

55. Stein, 'Androgyny Goes Pop', 107.

56. Leslie Bennetts, 'K.D. Lang Cuts it Close', *Vanity Fair* (August 1993), 50.

57. Rodger, 'Drag, Camp and Gender Subversion', 26.

58. Entwistle and Wilson, *Body Dressing,* 218.

59. Kate Nielson, 'Lesbian Chic, Part Deux', *The Advocate* (17 February 1997), 9.

60. Cit. in Kathy Akass and Janet McCabe, eds., *Reading the L Word. Outing Contemporary Television* (London: I.B. Tauris, 2006), 187.

61. Ibid.

62. Aviva Dove-Viebahn, 'Fashionably Femme: Lesbian Visibility, Style and Politics in *The L Word*', in Thomas Peele, ed., *Queer Popular Culture. Literature, Media, Film and Television* (New York: Palgrave Macmillan, 2007), 73.

63. Case, 'Towards a Butch-Femme Aesthetic', 294–306.

64. Dove-Viebahn, 'Fashionably Femme', 77.

65. Linda Dittmar, 'The Straight Goods', in Deborah Bright, ed., *The Passionate Camera. Photography and Bodies of Desire* (London: Routledge, 1998), 320.

66. Ibid., 323.

67. Anne M. Ciasullo, 'Making Her (In)Visible: Cultural Representations of Lesbianism and the Lesbian Body in the 1990s', *Feminist Studies* 27/3 (2001), 593.

68. Sherie Inness cit. Ciasullo, 'Making Her (In)Visible', 593.

69. Reina Lewis and Katrina Rolley, 'Ad(dressing) the Dyke. Lesbian Looks and Lesbian Looking', in Peter Horne and Reina Lewis, eds., *Outlooks. Lesbian and Gay Sexualities and Visual Cultures* (London: Routledge, 1996), 93.

70. Dittmar, 'The Straight Goods', 335.

71. Ibid., 335.

72. Lewis and Rolley, 'Ad(dressing) the Dyke'.

73. Ibid., 181.

74. Ibid., 182.

75. Rachel Abramowitz, 'Girl Gets Girl', *Premiere* (February 1996), 24.

Chapter 3: Gay Men's Style: From Macaroni to Metrosexual

1. *The Macaroni and Theatrical Magazine, or Monthly Register* (October 1772), 1; cit. Amelia Rauser, 'Authenticity, and the Self-made Macaroni', *Eighteenth-century Studies* 38/1 (2004), 101.

2. Ibid. The print show of Mary and Matthew Darly in London's West End was a major outlet for macaroni caricature prints. Their shop came to be known as the Macaroni Print Shop.

3. Ibid., 106.

4. Louis de Rouvroy, Duke de Saint-Simon, *Memoirs,* cit. Jeffrey Merrick and Bryant Ragan, eds., *Homosexuality in Early Modern France, a Documentary Collection* (Oxford: Oxford University Press, 2001), 126.

5. See Peter Hennen, 'Girlymen', in *Faeries, Bears and Leathermen. Men in Community Queering the Masculine* (Chicago: University of Chicago Press, 2008), 51. This said, as Hennen (52) points out, the suspicion and vilification of mollies was already present at the end of the seventeenth and early eighteenth centuries, when London authorities conducted raids on 'molly houses'.

6. Randolph Trumbach, 'The Birth of the Queen: Sodomy and the Emergence of Gender Equality in Modern Culture, 1660–1750', in Martin Duberman, Martha Vicinus and George Chauncey, eds., *Hidden from History: Reclaiming the Gay and Lesbian Past* (Harmondsworth: Penguin, 1989), passim.

7. Philip Carter, 'Men about Town: Representations of Foppery and Masculinity in Early Eighteenth-century Urban Society', in Hannah Barker and Elaine Chalus, eds., *Gender in Eighteenth-century England: Roles, Representations and Responsibilities* (New York: Longman, 1997), passim. See also Karen Harvey, 'The History of Masculinity, Circa 1650–1800', *Journal of British Studies* 44/2 (2005), 300–1.

8. 'Die Mode ist eine besondere unter jenen Lebensformen, durch die man ein Compromiss zwischen der Tendenz nach socialer Egalisierung und der nach individuellen Unterschiedsreizen herzustellen suchte.' [Fashion is particular amongst ways of life inasmuch as it seeks to find a compromise between the tendency for social equalization and impulse for self-assertion.] See Georg Simmel, 'Psychologie der Mode', in *Aufszätze und Abhandlungen 1894–1900* (Frankfurt am Main: Suhrkamp, 1992), 107. See also Georg Simmel (1998), 'Die Mode', *Philosophischer Kultur* (Berlin: Wagenbach, 1998).

9. Edward Beetham, cit. Amelia Rauser, 'Authenticity, and the Self-made Macaroni', 103.

10. Susan Sontag, 'Notes on "Camp"', in *Against Interpretation* (New York: Vintage, 1994), 279.

11. 'There are art historians, however, who apologetically and hesitatingly acknowledge the expression of the homoerotic in the art of this period. Hugh Honour and Lorenz Eitner, for example, view the homoeroticizing of masculinity in the works of Girodet and other neo-Davidians as part of a transitional interval of decay on the road to a robust period of romanticism. Walter Friedlaender chalks up Girodet's queer expression to what he derisively terms mannerist deviation in the linear construction of bodies. Both Levitine and Friedlaender belong to a pervasive line of thinking in which homosexuality and its creative expressions are begrudgingly admitted and tolerated only because of their link to classical antiquity—a connection explicitly made by the followers of David. Various other publications on the art of this period also acknowledge the intrusive presence of same-sex erotics. Most of them, however, fail to grapple satisfactorily with the meaningful uses to which these are put. A queer-wary legacy of sidestepping the issue continues today in more subtle forms, illuminated by the specific case of Girodet.' See James Smalls, 'Making Trouble for Art History: The Queer Case of Girodet', *Art Journal* 55/4 (1996), 25.

12. Margaret Powell and Joseph Roach, 'Big Hair', *Eighteenth-century Studies* 38/1 (2004), 84.

13. Dorinda Outram, *The Body and the French Revolution* (New Haven, CT: Yale University Press, 1989), 16.

14. Ibid., 88–89.

15. Cit. Gill, *Eccentricity and the Cultural Imagination of Nineteenth-century Paris*, 35.

16. Jules Barbey D'Aurevilly, *Du Dandisme et de George Brummel* (Paris: Éditions Balland, 1986), 34.

17. Dandyism 'is almost as difficult to describe as to define'. See ibid., 31.

18. Sima Godfrey, 'The Dandy as Ironic Figure', *SubStance* 11/3 (1982), 24.

19. Max Beerbohm, 'Dandies and Dandies', in *The Works of Max Beerbohm,* http://www.worldwideschool.org/library/bboks/lit/essays/TheWorksofMax Beerbohm/chap1.html.

20. Charles Baudelaire, 'Le Dandy', in Y.-G. Le Dantec, ed., *Le Peintre de la vie moderne, Œuvres complètes* (Paris: Pléiade, 1954), 906–9.

21. Ibid.

22. Brian Martin, *Napoleonic Friendship. Military Fraternity, Intimacy and Sexuality in Nineteenth-century France* (Durham: University of New Hampshire Press, 2011), 221–2.

23. Susan Shapiro, '"Yon Plumed Dandebrat": Male "Effeminacy" in English Satire and Criticism', *The Review of English Studies* 39/155 (1988), 401–2.

24. Ibid., 402.

25. Cit. ibid., 405–6.

26. Ibid., 412.

27. See also George Chauncey, *Gay New York: The Making of the Gay Male World* (London: Flamingo, 1994), 35–6: 'Sexual reticence and devotion to family became hallmarks of the middle-class gentleman in bourgeois ideology, which presumed that middle-class men conserved their sexual energy along with their other resources. The poor and the working classes, by contrast, were characterized in that ideology by their lack of such control; the apparent licentiousness of the poor, as well as their poverty, was taken as a sign of the degeneracy of the class as a whole.'

28. To Robert Ross, Wilde wrote, 'I cannot of course get rid of those revolting memories of the two years I was unlucky enough to have him with me, or of the mode by which he thrust me into the abyss of ruin and disgrace to gratify his hatred of his father and other ignoble persons.' See Letter 23 or 30 May 1896, from *Reading Gaol,* in Chris White, ed., *Nineteenth Century Writings on Homosexuality. A Sourcebook* (London: Routledge, 1999), 61.

29. Rosalind Williams, *Dream Worlds: Mass Consumption in Late 19th Century France* (Berkeley: University of California Press, 1982), 122.

30. Cit. Eva Thienpont, 'Visible Wild(e): A Re-evaluation of Oscar Wilde's Homosexual Image', *Irish Studies Review* 13/3 (2005), 292.

31. Cit. ibid.

32. Ibid.
33. Ibid., 298.
34. Ed Cohen, 'Posing the Question. Wilde, Wit and the Ways of Man', in Elin Diamond, ed., *Performance and Cultural Politics* (London: Routledge, 1996), 39.
35. Ibid.
36. Walter Pater, 'Conclusion', in *The Renaissance* (Oxford: Oxford University Press, 1986), 153.
37. See also James Eli Adams, *Dandies and Desert Saints: Styles of Victorian Masculinity* (Ithaca, NY: Cornell University Press, 1995), 154–227.
38. See Adam Geczy, *Fashion and Orientalism* (London: Bloomsbury, 2013), 85–113.
39. Alan Sinfield, *The Wilde Century* (New York: Columbia University Press, 1994), 43.
40. D. S. Neff, 'Bitches, Mollies, and Tommies: Byron, Masculinity, and the History of the Sexualities', *Journal of the History of Sexuality* 11/3 (2002), 400–1.
41. Among others, see Morris Kaplan, 'Who's Afraid of John Saul? Urban Culture and the Politics of Desire in Late Victorian London', *Journal of Lesbian and Gay Studies* 5/3 (1999), 290ff.
42. See Cohen, 'Posing the Question', 42.
43. Kaplan, 'Who's Afraid of John Saul?', 280.
44. Chauncey, *Gay New York,* 37.
45. Kaplan, 'Who's Afraid of John Saul?', 281.
46. See also Chauncey, *Gay New York,* 40ff. For a closer examination of mollies, see D. S. Neff, 'Bitches, Mollies, and Tommies', passim.
47. See also Cohen, 'Posing the Question', 46: 'In other words, by legally disposing that Wilde was guilty of sexual crimes, the court effectively determined that Wilde could no longer pose the questions which he had tried for so long to embody.'
48. Christopher Reed, *Art and Homosexuality* (Oxford: Oxford University Press, 2011), 97.
49. Oscar Wilde, 'The Picture of Dorian Gray', in *The Complete Works of Oscar Wilde* (London: Collins, 1948), 134.
50. André Fontainas, *Mes souvenirs du Symbolisme* (Paris: Nouvelle Revue Critique, 1923), 173.
51. Proust, *À la recherche du temps perdu,* vol. 3, 973.
52. For the conflation of being artistic and being gay, see Shaun Cole, *Don We Now Our Gay Apparel* (Oxford: Berg, 2000), 19.
53. See, among others, Sinfield, *The Wilde Century,* 97.
54. E. M. Forster, *Maurice* (Harmondsworth: Penguin, 1972), 136; see also Sinfield, *The Wilde Century,* 126.

55. See also Ellen Moers, *The Dandy: Brummell to Beerbohm* (Lincoln: University of Nebraska, 1978), 314.

56. A common thread in primary and secondary sources on the dandy is not only dandyism's elusive definition but also aloofness from society, which could easily be read as contempt. Writing about Baudelaire, Bernard Howells comments, 'The dandy reacts to universal misunderstanding by refusing to communicate or to participate at all and builds his self-esteem on his refusal. In this sense, dandyism is a self-induced state of mind to which Baudelaire resorts intermittently in an attempt to man himself against the threat of intellectual and moral disintegration, and it exists side by side with other forms of "gymnastique proper à fortifier la volonté at à discipliner l'âme."' See Bernard Howells, *Baudelaire: Individualism, Dandyism and the Philosophy of History* (Oxford: Legenda, 1996), 76–7.

57. Adams, *Dandies and Desert Saints,* 24.

58. Matt Cook, *London and the Culture of Homosexuality, 1885–1914* (Cambridge: Cambridge University Press, 2003), 31–2.

59. 'The men had become dandified and bohemian and their class origins obscured. They also followed the fashion for shaving, which, though certainly not a definitive indication of sexual deviance, was a commonly noted feature of defendants in cases of gross indecency between men.' See Cook, *London and the Culture of Homosexuality,* 35.

60. Cook, *London and the Culture of Homosexuality,* 41.

61. Alexander Waugh, *The House of Wittgenstein: A Family at War* (New York: Anchor Books, 2008), 41.

62. Cook, *London and the Culture of Homosexuality,* 39.

63. See Cole, *Don We Now Our Gay Apparel,* 17: 'At Cambridge University, Cecil Beaton drew a similar crowd of aesthetes, including Stephen Tennant. Beaton, who described himself as "really a terrible, terrible homosexualist and [I] try so hard not to be", was often to be seen on the streets of Cambridge wearing an "evening jacket, red shoes, black-and-white trousers, and a huge blue cravat"; and as the weather got colder "he brightened the Cambridge scene with an outfit comprising fur gauntlet gloves, a cloth-of-gold tie, a scarlet jersey and Oxford bags."'

64. Cook, *London and the Culture of Homosexuality,* 40.

65. See Winkler, *The Constraints of Desire,* 55ff.

66. Judith Butler, *Bodies that Matter* (London: Routledge, 1993), 125ff.

67. Jessica Feldman, *Gender on the Divide: The Dandy in Modernist Literature* (Ithaca, NY: Cornell University Press, 1993), 270.

68. George Painter, *Proust* (Harmondsworth: Penguin, 1989), vol. 1, 127. The quotations are from Proust but unreferenced, based on a visit he made to Montesquiou at his residence on the rue Franklin at Passy, 7 July 1891.

69. Ibid.

70. Ibid.

71. Ibid.

72. Cit. Patrick Chaleyssin, *Robert de Montesquiou: Mécène et Dandy* (Paris: Édi- tions d'art Somogy, 1992), 81.

73. Painter, *Proust,* 102.

74. Ibid. The passage goes on: '"How I despise these little flunkeys of Des Es- seintes," he would scream, perfidiously alluding to Montesquiou, who was re- puted to be the original of the aesthete Des Esseintes in Huysmans's *A Rebours.* His perpetual, factitiously hostile talk about homosexuality was particularly embarrassing in public.'

75. Proust, *À la recherche du temps perdu,* vol. 1, 818.

76. Ibid.

77. Cole, *Don We Now Our Gay Apparel,* 19; Sinfield, *The Wilde Century.*

78. John Clarke, 'The Skinheads and the Magical Recovery of Working Class Community', in Stuart Hall and Tony Jefferson, eds., *Resistance through Ritu- als: Youth Subcultures in Postwar Britain* (London: Routledge, 1976); Cole, *Don We Now Our Gay Apparel,* 19, 27 n. 30.

79. See Henri de Régnier, cit. Chaleyssin, *Robert de Montesquiou,* 82.

80. Proust, *À la recherche du temps perdu,* 73.

81. Ibid., vol. 3, 1042.

82. Jerrold Siegel, *Bohemian Paris: Culture, Politics, and the Boundaries of Bour- geois Life, 1830–1930* (Baltimore: Johns Hopkins University Press, 1986), 364.

83. Ibid., 371.

84. Monica Miller, *Slaves to Fashion. Black Dandyism and the Styling of Black Diasporic Identity* (Durham, NC: Duke University Press, 2009), 5.

85. Ibid., 65.

86. Cit. ibid., 246–7.

87. Ibid.

88. Ibid., 256.

89. Cole, *Don We Now Our Gay Apparel,* 1; Valerie Steele, *Fashion and Erotism* (Oxford: Oxford University Press, 1985), 246; and Richard Dyer, *The Culture of Queer* (London: Routledge, 2002), 63–4.

90. Barbey D'Aurevilly, *Du Dandisme,* 21ff. In the words of Jessica Feldman, 'Barbey likens Brummell to coquettes, courtesans, and muses. Women never forgive him for being as graceful as they. His vocation is to please: the Prince of Wales's courtship of Brummell is as simple as the conquest of woman. Even the dandy's characteristic aggressive coldness, his defining aloofness from women, it itself a female characteristic.' See Feldman, *Gender on the Divide,* 87–8.

91. Butler, *Gender Trouble,* 151 n.6.

92. Chauncey, *Gay New York,* 210ff.

93. Albert Camus, *L'homme revolté* (Paris: Gallimard, 1951), 75.

94. Elizabeth Wilson, *Bohemians: Glamorous Outcasts* (London: I.B. Tauris, 2000). See also Sandra Barwick, 'Bohemia, True and Blue', in *A Century of Style* (London: Allen and Unwin, 1984); and Geczy, *Fashion and Orientalism,* chapter 3.

95. Calvin Tomkins, *Duchamp: A Biography* (London: Chatto and Windus, 1996).

96. Jones, *Postmodernism and the En-gendering of Marcel Duchamp*, 150.

97. Ibid., 153–5.

98. Ibid., 169.

99. Ibid., 170. Christopher Reed takes exception with such a reading, however. From the 1940s onward, 'his art's play with androgyny transformed into patterns of heterosexual misogyny characteristic of surrealist fantasies of eroticized violence against women's bodies'. See Reed, *Art and Homosexuality,* 142.

100. The portrait is by Chris Makos and entitled *Altered Ego (Andy Warhol in Tribute to Rrose Sélavy)*. Unlike Duchamp, who dressed himself in woman's clothing, Warhol's tribute has him wear a blond wig, make-up and preppy boy's clothes, his hands clasped demurely over one raised thigh. Warhol is not the only queer male to pastiche Duchamp in drag; in 1988, the Japanese artist Yasumasa Morimura did his own version: there are two hats and two sets of arms, one apparently a white woman's, thus blurring not only gender but also race. See also Reed, *Art and Homosexuality,* 236.

101. J. C. Flügel, *The Psychology of Clothes* (London: Hogarth Press, 1930), 108–21, 211–15. See also Steele, *Fashion and Eroticism,* 28–30.

102. Chauncey, *Gay New York,* 230.

103. Ibid., 248–9.

104. Christopher Isherwood, *Christopher and His Kind* (London: Methuen, 1977), 29. With respect to Berlin's reputation, Reed comments: 'Having lost the war, Germany was particularly hard-hit by the emotionally and economic upheavals of the 1920s. Berlin emerged as a center of sexual experimentation with a variegated sex industry that attracted many foreigners.' See Reed, *Art and Homosexuality,* 110.

105. Isherwood, *Christopher and His Kind,* 29.

106. Ibid., 30.

107. Dyer, *The Culture of Queer,* 65–66.

108. Isherwood, *Christopher and His Kind,* 32.

109. Ibid., 31.

110. Cit. Harry Oosterhuis, 'Homosexual Emancipation in Germany Before 1933: Two Traditions', in Harry Oosterhuis and Hubert Kennedy. eds., *Homosexuality and Male Bonding in Pre-Nazi Germany* (New York: Harrington Park Press, 1991), 3.

111. Cit. ibid., 4.

112. Cook, *London and the Culture of Homosexuality,* 33–5.

113. Heinrich Pudor, 'Nudity in Art and Life', in Harry Oosterhuis and Hubert Kennedy, eds., *Homosexuality and Male Bonding in Pre-Nazi Germany* (New York: Harrington Park Press, 1991), 109–13.

114. Cole, *Don We Now Our Gay Apparel*, 31.

115. Ibid., 33. Cole also states (45): 'In the first half of the twentieth century gay men could project an overtly visible presence by adopting an effeminate appearance. Those who could not or did not want to adopt such an image in public restricted their gay identity to small signifiers or overt behavior only in "safe" gay spaces.'

116. Dyer, *The Culture of Queer*, 66.

117. *Brooklyn Daily Eagle*, 28 February 1925; Frank Sullivan, *New York World*, 28 February 1925; *Daily News Record*, 23 March 1925; cit. Erté, *Things I Remember: An Autobiography* (London: Peter Owen, 1975), 78.

118. See Cole, *Don We Now Our Gay Apparel*, 59–69; and Shaun Cole, 'Invisible Men: Gay Men's Dress in Britain, 1950–70', in Amy de la Haye and Elizabeth Wilson, eds., *Defining Dress: Dress as Object, Meaning and Identity* (Manchester: Manchester University Press, 2000), 143–54.

119. Cole, *Don We Now Our Gay Apparel*, 23.

120. Christopher Breward, 'Style and Subversion: Postwar Poses and the Neo-Edwardian Suit in Mid-twentieth-century Britain', *Gender and History* 14/3 (2002), 562. See also Cole, 'Invisible Men', 144–5; and Sinfield, *The Wilde Century*, 130–56.

121. Williams, *Dream Worlds*, 107–55.

122. See Geczy, *Fashion and Orientalism*, chapter 4.

123. Cole, *Don We Now Our Gay Apparel*, 72–4.

124. Ibid., 74.

125. Cit. Cole, 'Invisible Men', 149.

126. Elizabeth Wilson, *Adorned in Dreams: Fashion and Modernity* (London: I. B. Tauris, 2007), 183, and Amelia Jones, '"Clothes Make the Man": The Male Artist as Performative Function', *Oxford Art Journal* 18/2 (1995), 21ff.

127. Stephen Gundle, *Glamour: A History* (Oxford: Oxford University Press, 2008), 2.

128. Andy Warhol, *The Philosophy of Andy Warhol (From A to B and Back Again)* (New York: Harcourt, 1977), 77.

129. Brigitte Weingart, '"That Screen Magnetism": Warhol's Glamour', *October 132* (2010).

130. Victor Bockris, *Warhol: The Biography* (Cambridge: Da Capo Press, 2003), 456.

131. Glick, *Materializing Queer Desire*, 154.

132. See Cole, *Don We Now Our Gay Apparel*, 142.

133. Glick, *Materializing Queer Desire*, 107–32.

134. Paul Trynka, *Starman: David Bowie, the Definitive Biography* (London: Sphere, 2012). See also Thomas Jones, 'So Ordinary, So Glamorous', *London Review of Books* 34/7 (2012), 17–20.

135. Stan Hawkins, *The British Pop Dandy: Masculinity, Popular Music and Culture* (Burlington: Ashgate, 2009), 10ff.

136. Ibid.

137. Margaret Drewal, 'The Camp Trace in Corporate America. Liberace and the Rockettes at Radio City Music Hall', in Moe Meyer, ed., *The Politics and Poetics of Camp,* 161.

138. Ibid., 177.

139. Ibid., 192.

140. Lee Mentley, cit. Lillian Faderman and Stuart Timmons, *Gay L.A.: A History of Sexual Outlaws, Power Politics and Lipstick Lesbians* (New York: Basic Books, 2006), 142. Cole supplied an exhaustive matrix of the covert communication of hankie-wearing in *Don We Now Our Gay Apparel,* 114.

141. Joseph H. Hancock II, 'Chelsea on 5th Avenue: Hypermasculinity and Gay Clone Culture in the Retail Brand Practices of Abercrombie and Fitch', *Fashion Practice* 1/1 (2009), 75.

142. Ibid., 78.

143. Guy Snaith, 'Tom's Men: The Masculinization of Homosexuality and the Homosexualization of Masculinity at the End of the Twentieth Century', *Paragraph* 26 (2003), 77.

144. Ibid., 78.

145. Ibid., 77.

146. Vito Russo, *The Celluloid Closet,* rev. ed. (New York: Harper and Row, 1987), 32ff.

147. See Reed, *Art and Homosexuality,* 167–9.

148. For the best analysis of gay male fashion clones, see Shaun Cole, '"Macho Man": Clones and the Development of a Masculine Stereotype', *Fashion Theory* 4/2 (2000), 112–40.

149. Parker Tyler, *Screening the Sexes: Homosexuality in the Movies* (San Francisco: Holt, Reinhart and Winston, 1972), v–vii.

150. Sally Gray, '"I'm Here Girlfriend What's New?" Art, Dress and the Queer Performative Subject: The Case of David McDiarmid', *Fashion Theory* 12/3 (2008), 294.

151. Ibid., 304.

152. Ibid., 309.

153. David Colman, 'Gay or Straight? Hard to Tell', *New York Times* (19 June 2005), http://www.nytimes.com/2005/06/19/fashion/sundaystyles/19GAYDAR.html, accessed 5 August 2011.

154. Ibid.

155. Ibid.

156. Julien Macdonald, 'The Usual Suspects', *Attitude* (2001), 81, cit. Snaith, 'Tom's Men', 86.

157. 'There is, of course, a notable and marked shift from the stereotype of the camp and the effeminate homosexual epitomized in 1970s [*sic*] representations as

Mr Humphries in *Are You Being Served* to a more chic, groomed, and market-able figure was see represented in, say, models for Calvin Klein or Abercrombie and Fitch.' See Rob Cover, 'Bodies, Movements and Desires', 81.

158. See Kate Schofield and Ruth Schmidt, 'Fashion and Clothing: The Construction and Communication of Gay Identities', *International Journal of Retail and Distribution Management* 33/4 (2005), 311ff.

159. Jeffrey Weeks, *Sexuality and its Discontents* (London: Routledge, 1985), 189.

160. Cover, 'Bodies, Movements and Desires', 81.

161. See, for example, Schofield and Schmidt, 'Fashion and Clothing: The Construction and Communication of Gay Identities', 321.

162. T. Burnett, *The Rise and Fall of the Regency Dandy. The Life and Times of Scrope Berdmore Davies* (London: John Murray, 1981), 51.

163. Rob Latham, *Consuming Youth. Vampires, Cyborgs and the Culture of Consumption* (Chicago: University of Chicago Press, 2002), 94.

164. Burnett, *The Rise and Fall of the Regency Dandy,* 94.

165. Frank Mort, 'New Men and New Markets', in Peter McNeil and Vicki Karaminas, eds., *The Men's Fashion Reader* (Oxford: Berg, 2009), 454.

166. Jon Savage, 'What's So New about the New Man?' *Arena* 8 (Spring 1988), 33–5.

167. Ibid., 34.

168. Jay Clarkson, 'Contesting Masculinity's Makeover: *Queer Eye,* Consumer Masculinity, and "Straight-acting" Gays', *Journal of Communication Inquiry* 29/3 (2005), 252–3.

169. Ibid., 253.

170. For camp, kitsch and parody, see Chuck Kleinhaus, 'Taking out the Trash: Camp and the Politics of Parody', in Moe Meyer, ed., *The Politics and Poetics of Camp* (London: Routledge, 1994), 182–201.

Chapter 4: Kiss of the Whip: Bondage, Discipline and Sadomasochism, or BDSM Style

1. Leopold von Sacher-Masoch, *Venus in Furs* (New York: Zone Books, 1991), 145.

2. Robin R. Linden, Darlene R. Pagano, Diana E. H. Russell and Susan Star, eds., *Against Sadomasochism: A Radical Feminist Analysis* (East Palo Alto, CA: Frog in the Well, 1982), 2–3.

3. Michel Foucault, *Madness and Civilization: A History of Insanity in the Age of Reason* (London: Tavistock, 1965), 97.

4. Erving Goffman, quoted in Thomas S. Weinberg, 'Sadism and Masochism: Sociological Perspectives', in Thomas S. Weinberg and G. W. Levi Kamel, eds., *S and M: Studies in Masochism* (Buffalo, NY: Prometheus Books, 1983), 106.

5. Gilles Deleuze, *La Présentation de Sacher-Masoch* (Paris: Minuit, 1967), passim.

6. Chantal Nadeau, 'Girls on a Wired Screen. Cavani's Cinema and Lesbian S/M', in Elizabeth Grosz and Elspeth Probyn, eds., *Sexy Bodies. The Strange Carnalities of Feminism* (London: Routledge, 1995), 216.

7. Ibid., 223.

8. Deleuze, *La Présentation de Sacher-Masoch,* 80.

9. Ibid.

10. Ibid., passim.

11. Edmund White and David Bergman (1994), 'Sado Machismo', in *The Burning Library* (London: Random House, 1994), 57–9. See also ibid., 61: 'Sadism is, presumably, a way for uptight men to release their thunderbolts under the guise of passion. The masochist has indicated his readiness to be punished, and to abuse him seems to be simple compliance, almost charity. Still better, the anger can always be disavowed and laughed off later as just part of the game.'

12. Ibid., 59.

13. Ibid., 61.

14. Scott Lively and Kevin Abrams, *The Pink Swastika: Homosexuality and the Nazi Party* (Salem, OR: Lively Communications, 1995), 119–21.

15. Valerie Steele, *Fetish. Fashion, Sex and Power* (Oxford: Oxford University Press, 1996), 182.

16. Jennifer Craik, *Uniforms Exposed. From Conformity to Transgression* (Oxford: Berg, 2005), 6.

17. Ibid., 227.

18. Ibid., 228.

19. Steele, *Fetish,* 182.

20. Edmund White, *Genet* (London: Chatto and Windus, 1993), 325–6.

21. Daniel Harris, *The Rise and Fall of Gay Culture* (New York: Hyperion, 1997), 181.

22. Ibid., 200.

23. Hennen, *Faeries, Bears and Leathermen,* 137.

24. Steele, *Fetish,* 105.

Chapter 5: Drag: Of Kings and Queens

1. Harris, *The Rise and Fall of Gay Culture*, 204.

2. Andy Medhurst, 'Camp', in Andy Medhurst and Sally Munt, eds., *Lesbian and Gay Studies: A Critical Introduction* (London: Cassell, 1997), 282.

3. Esther Newton, *Mother Camp: Female Impersonators in America* (Chicago: University of Chicago Press, 1979), 109–11.

4. Judith Halberstam, *Female Masculinity* (Durham, NC: Duke University Press, 1998), 231, 232.

5. Medhurst, 'Camp', 285.

6. Ibid., 286.
7. Halberstam, *Female Masculinity,* 238.
8. Peter Ackroyd, *Dressing Up. Transvestism and Drag. The History of an Obsession* (London: Simon and Schuster, 1979), 104.
9. Vern Bullough and Bonnie Bullough, *Cross Dressing Sex and Gender* (Philadelphia: University of Pennsylvania Press, 1979), 234.
10. Langston Hughes, *The Big Sea. An Autobiography* (New York: Hill and Wang, 1993), 273.
11. Ibid., 227–8.
12. Michael Cunningham, 'The Slap of Love', *Open City* 6 (2010), 175–96.
13. Barbara Vinken, *Fashion Zeitgeist. Trends and Cycles in the Fashion System* (Oxford: Berg, 2005), 52.
14. Ibid., 50.
15. James Reed, 'They're Puttin' on the Vogue', *Time* (22 May 1989), 55.
16. Garber, *Vested Interests,* 159.
17. Vinken, *Fashion Zeitgeist,* 51.
18. Ibid., 50.
19. Butler, *Bodies that Matter,* 130.
20. Elizabeth Howe, *The First English Actresses: Women and Drama 1660–1700* (Cambridge: Cambridge University Press, 1992).
21. Elizabeth Drorbaugh, 'Sliding Scales. Notes on Stormé DeLarverié and the Jewel Box Revue, the Cross-dressed Woman on the Contemporary Stage, and the Invert', in Lesley Ferris, ed., *Crossing the Stage. Controversies on Cross-dressing* (London: Routledge, 1993), 121.
22. Halberstam, *Female Masculinity,* 232.
23. Ibid., 232.
24. Ibid.
25. Judith Halberstam, 'Techno-homo: On Bathrooms, Butches, and Sex with Furniture', in J. Terry and M. Calvert, eds., *Processed Lives: Gender and Technologies in Everyday Life* (London: Routledge, 1997), 187.
26. Halberstam, *Female Masculinity,* 261.
27. Jennifer Lyn Patterson, 'Capital Drag', *Journal of Homosexuality* 43/3 (2003), 99–123; and Tara Pauliny, 'Erotic Arguments and Persuasive Acts', *Journal of Homosexuality* 43/3 (2003), 100.

Chapter 6: Crossing Genders, Crossing Cultures

1. Virginia Woolf, *Orlando* (London: Wordsworth Series, 2003), 155.
2. Linda B. Arthur, *Religion Dress and the Body* (Oxford: Berg, 1999).
3. Garber, *Vested Interests,* 17.
4. Ibid., 24.

5. Ibid.
6. Anne Hollander, *Sex and Suits. The Evolution of Modern Dress* (New York: Kodansha, 1995), 4.
7. Cit. in Elizabeth Wilson, *Adorned in Dreams. Fashion and Modernity* (London: I. B. Tauris, 2007), 122.
8. Ramón Gutiérrez, 'Deracinating Indians in Search of Gay Roots: A Response to Will Roscoe's "The Zuni Man-Woman"', *Out/Look* 1/4 (1989), 61–7.
9. Wilson, *Adorned in Dreams*, 122.
10. Martin F. Manalansan IV, *Global Diva's Filipino Gay Men in the Diaspora* (Durham, NC: Duke University Press, 2003), 27.
11. Jason Karlin, 'The Gender of Nationalism: Competing Masculinities in Meiji Japan', *Journal of Japanese Studies* 28/1 (2002), 41.
12. Ibid., 43.
13. Ibid., 44.
14. Ibid., 52–4.
15. Mark McLelland, Katsuhiko Sugunama and James Welker, 'Introduction: Re(Claiming) Japan's Queer Past', in Mark McLelland, Katsuhiko Sugunama and James Welker, eds., *Queer Voices From Japan* (Plymouth: Lexington Books, 2007), 11.
16. Merv Haddad, 'The Discreet Charm of Gay Life in Japan in the Early 1980s', in Stephen Murray, ed., *Oceanic Homosexualities* (New York: Garland, 1992), 371. See also John Treat, *Great Mirrors Shattered. Homosexuality, Orientalism, and Japan* (Oxford: Oxford University Press, 1999), 213.
17. Kabiya Kazuhiko, 'Lifestyles in the Gay Bars', in Mark McLelland, Katsuhiko Sugunama and James Welker, eds., *Queer Voices From Japan* (Plymouth: Lexington Books, 2007), 107.
18. Sunagawa Hideki, 'Reflections on the Tokyo Lesbian and Gay Parade 2000', in Mark McLelland, Katsuhiko Sugunama and James Welker, eds., *Queer Voices From Japan,* (Plymouth: Lexington Books, 2007), 281–2.
19. http://en.wikipedia.org/wiki/List_of_LGBT_events
20. Mitsuhashi Junko, 'My Life as a "Woman"', in Mark McLelland, Katsuhiko Sugunama and James Welker, eds., *Queer Voices From Japan* (Plymouth: Lexington Books, 2007), 295–311.
21. Eng-Beng Lim, 'The Mardi Gras Boys of Singapore's English-language Theatre', *Asian Theatre Journal* 22/2 (2005), 294.
22. Ibid.
23. Lim, 'The Mardi Gras Boys', 296.
24. René Grémaux, 'Mannish Women of the Balkan Mountains: Preliminary Notes on the "Sworn Virgins" in Male Disguise, with Special Reference to Their Sexuality and Gender-identity', in Jan Bremmer, ed., *From Sappho to de Sade. Moments in the History of Sexuality* (London: Routledge, 1989), 242.

25. Antonia Young, *Women Who Become Men. Albanian Sworn Virgins* (Oxford: Berg, 2001), 108.
26. Ibid., 58.
27. Joanna Schmidt, 'Paradise Lost? Social Change and *Fa'afafine* in Samoa', *Current Sociology* 51/3–4 (2003), 417–32.
28. Ibid.
29. Chloe Colchester, ed., *Clothing the Pacific* (Oxford: Berg, 2003), xi.
30. Niko Besnier, 'Polynesian Gender Liminality through Time and Space', in Gilbert Herdt, ed., *Third Sex, Third Gender: Beyond Sexual Dimorphism in Culture and History* (New York: Zone, 1996), 289.
31. Ibid., 290.
32. Ibid.
33. Robert Aldrich, *Colonialism and Homosexuality* (London: Routledge, 2003), 265.
34. Ibid., 265.
35. Serena Nanda, *Neither Man nor Woman. The Hijras of India* (Belmont, CA: Wadsworth, 1999), 547.
36. Peter Jackson, 'Thai Research on Male Homosexuality and Transgenderism and the Cultural Limits of Foucaultian Analysis', *Journal of the History of Sexuality* 8/1 (1997), 60.
37. Peter Jackson, 'Kathoey-gay-man: The Historical Emergence of Gay Male Identity in Thailand', in Lenore Manderson and Margaret Jolly, eds., *Sites of Desire, Economies of Pleasure: Sexualities in Asia and the Pacific* (Chicago: University of Chicago Press, 1997), 166–90.
38. Jackson, 'Thai Research on Male Homosexuality'.
39. http://www.cnngo.com/bangkok/none/dont-call-me-lesbian-tomdee-culture-thailand-176517#ixzz0wB7toGHj
40. Jackson, 'Thai Research on Male Homosexuality', 61.
41. Ibid., 63, 64.
42. Jackson, 'Kathoey-gay-man', 172.
43. Wilson, *Adorned in Dreams*, 117.
44. Michel Foucault, 'An Ethics of Pleasure', in Silvere Lotringer, ed., *Foucault Live (Interviews, 1966–84)* (New York: Semiotext(e), 1989), 378.

Conclusion: Against Justification

1. Susan Sontag, 'On Style', in *Against Interpretation* (New York: Vintage, 1994), 28.
2. Eve Kosofsky Sedgwick, *The Epistemology of the Closet* (Berkeley: California University Press, 1990), 85.

Bibliography

Abelove, Henry, Barale, Michele Aina and Halperin, David, eds. (1993), *The Lesbian and Gay Studies Reader,* London: Routledge.

Abramowitz, Rachel (1996), 'Girl Gets Girl', *Premiere* (February), 24–8.

Ackroyd, Peter (1979), *Dressing Up. Transvestism and Drag. The History of an Obsession,* London: Simon and Schuster.

Adams, James Eli (1995), *Dandies and Desert Saints: Styles of Victorian Masculinity,* Ithaca, NY: Cornell University Press.

Akass, Kathy and McCabe, Janet, eds. (2006), *Reading the L Word. Outing Contemporary Television,* London: I. B. Tauris.

Aldrich, Robert (2003), *Colonialism and Homosexuality,* London: Routledge.

Aldrich, Robert, ed. (2006), *Gay Life and Culture: A World History,* London: Thames and Hudson.

Alexeyeff, Kalissa (2008), 'Globalising Drag in the Cook Islands: Fiction, Repulsion, Abjection', *The Contemporary Pacific* 20/1, 143–61.

Andaya, Leonard (2000), 'The Bissu: A Study of a Third Gender in Indonesia', in Barbara Andaya, ed., *Other Posts: Women, Gender and History in Early Modern Southeast Asia,* Honolulu: University of Hawaii Press.

Andermaher, Sonya (1994), 'A Queer Love Affair? Madonna and Gay and Lesbian Culture', in Diane Hamer and Belinda Budge, eds., *The Good, the Bad, and the Gorgeous: Popular Culture's Romance with Lesbianism,* London: HarperCollins, 28–40.

Arnold, Rebecca (2001), *Fashion, Desire and Anxiety. Image and Morality in the Twentieth Century,* New Brunswick, NJ: Rutgers University Press.

Arthur, Linda B. (1999), *Religion Dress and the Body,* Oxford: Berg.

Ayoup, Colleen and Podmore, Julie (2003), 'Making Kings', *Journal of Homosexuality,* 43/3, 51–74.

Ayres, Tony, ed. (1996), *String of Pearls. Stories about Cross-dressing,* London: Allen and Unwin.

Barasch, Moshe (1990), *Modern Theories of Art Vol. I, From Winckelmann to Baudelaire,* New York: New York University Press.

Barbey D'Aurevilly, Jules (1986), *Du Dandisme et de George Brummel,* Paris: Éditions Balland.

Barwick, Sandra (1984), *A Century of Style,* London: Allen and Unwin.

Baudelaire, Charles (1954), 'Le Dandy', in Y.-G. Le Dantec, ed., *Le Peintre de la vie moderne, Œuvres complètes,* Paris: Pléiade.

Bech, Henning (1997), *When Men Meet: Homosexuality and Modernity,* Oxford: Polity.

Beerbohm, Max (1896), 'Dandies and Dandies', in *The Works of Max Beerbohm,* http://www.worldwideschool.org/library/books/lit/essays/TheWorksofMax Beerbohm/chap1.html, 2, accessed 3 January 2012.

Bennetts, Leslie (1993), 'k.d. lang Cuts it Close', *Vanity Fair* (August), 89–95.

Benstock, Shari (1990), 'Paris Lesbianism and the Politics of Reaction, 1900–1940', in Martin Duberman, Martha Vicinus and George Chauncery Jr, eds., *Hidden from History. Reclaiming the Gay and Lesbian Past,* New York: Meridien.

Besnier, Niko (1996), 'Polynesian Gender Liminality through Time and Space', in Gilbert Herdt, ed., *Third Sex, Third Gender: Beyond Sexual Dimorphism in Culture and History,* New York: Zone.

Besnier, Niko (2002), 'Trangenderism, Locality, and the Miss Galexy Beauty Pagent in Tonga', *American Ethnologist* 29/3, 534–66.

Besnier, Niko (2004), 'The Social Production of Abjection. Desire and Silencing among Transgender Tongans', *Social Anthropology* 12/3, 301–23.

Blackwood, Evelyn (1998), 'Tombois in Western Sumatra: Constructing Masculinity and Erotic Desire', *Cultural Anthropology* 13/4, 491–521.

Blackwood, Evelyn and Wieringa, Saskia (1999), *Female Desires: Same-Sex Relations and Transgender Practices Across Cultures,* New York: Columbia University Press.

Bockris, Victor (2003), *Warhol: The Biography,* Cambridge: Da Capo Press.

Boellstroff, Tom (2005), *The Gay Archipelago: Sexuality and Nation in Indonesia,* Princeton, NJ: Princeton University Press.

Brassaï, George (1976), *The Secret Paris of the Thirties,* London: Thames and Hudson.

Breward, Christopher (2002), 'Style and Subversion: Postwar Poses and the Neo-Edwardian Suit in Mid-twentieth-century Britain', *Gender and History* 14/3, 75–88.

Brewer, Carolyn (1999), 'Baylan, Asog, Transvestism and Sodomy: Gender, Sexuality and the Sacred in Early Colonial Philippines', *Intersections: Gender, History and Culture in the Asian Context* 2, 116–24.

Bright, Susie (Susie Sexpert, pseud.) (1991), 'College Confidential', *On Our Backs* 7/4, 11–12.

Bullough, Vern L. and Bullough, Bonnie (1979), *Cross Dressing Sex and Gender,* Philadelphia: University of Pennsylvania Press.

Burnett, T. (1981), *The Rise and Fall of the Regency Dandy. The Life and Times of Scrope Berdmore Davies,* London: John Murray.

Butler, Judith (1990), *Gender Trouble and the Subversion of Identity,* London: Routledge.

Butler, Judith (1993), *Bodies that Matter,* London: Routledge.

Butler, Judith (1997), 'Performative Acts and Gender Constitution', in Katie Conboy et al., eds., *Writing the Body: Female Embodiment and Feminist Theory,* New York: Columbia University Press, 134–42.

Butler, Judith, Laclau, Ernesto and Žižek, Slavoj, eds. (2000), *Contingency, Hegemony, Universality,* New York: Verso.

Calefato, Patrizia (1997), 'Fashion and Worldliness: Language and the Imagery of the Clothed Body', *Fashion Theory. The Journal of Dress, Body and Culture,* 1/1, 69–90.

Calefato, Patrizia (2004), *The Clothed Body,* Oxford: Berg.

Camus, Albert (1951), *L'homme revolté,* Paris: Gallimard.

Carassus, Emilien (1971), *Le mythe du dandy,* Paris: Librairie Arman Colin.

Carter, Philip (1997), 'Men about Town: Representations of Foppery and Masculinity in Early Eighteenth-century Urban Society', in Hannah Barker and Elaine Chalus, eds., *Gender in Eighteenth-century England: Roles, Representations and Responsibilities,* New York: Longman.

Case, Sue-Ellen (1993), 'Towards a Butch-femme Aesthetic', in Henry Abelove, Michele Aina Berale and David Halperin, eds., *The Lesbian and Gay Studies Reader,* London: Routledge, 294–306.

Chaleyssin, Patrick (1992), *Robert de Montesquiou: Mécène et Dandy,* Paris: Éditions d'art Somogy.

Chauncey, George (1994), *Gay New York: The Making of the Gay Male World,* London: Flamingo.

Ciasullo, Anne M. (2001), 'Making Her (In)Visible: Cultural Representations of Lesbianism and the Lesbian Body in the 1990s', *Feminist Studies* 27/3, 577–608.

Clark, Danae (1995), 'Lesbianism', in Corey K. Creekmur and Alexander Doty, eds., *Out in Culture: Gay, Lesbian and Queer Essays on Popular Culture,* Durham, NC: Duke University Press.

Clarke, John (1976), 'The Skinheads and the Magical Recovery of Working Class Community', in Stuart Hall and Tony Jefferson, eds., *Resistance through Rituals: Youth Subcultures in Postwar Britain,* London: Routledge.

Clarkson, Jay (2005), 'Contesting Masculinity's Makeover: *Queer Eye,* Consumer Masculinity, and "Straight-acting" Gays', *Journal of Communication Inquiry* 29/3, 285–311.

Cohen, Ed (1996), 'Posing the Question. Wilde, Wit and the Ways of Man', in Elin Diamond, ed., *Performance and Cultural Politics,* London: Routledge.

Colchester, Chloe, ed. (2003), *Clothing the Pacific,* Oxford: Berg.

Cole, Shaun (2000), *Don We Now Our Gay Apparel,* Oxford: Berg.

Cole, Shaun (2000), 'Invisible Men: Gay Men's Dress in Britain, 1950–70', in Amy de la Haye and Elizabeth Wilson, eds., *Defining Dress: Dress as Object, Meaning and Identity,* Manchester: Manchester University Press.

Cole, Shaun (2000), '"Macho Man": Clones and the Development of a Masculine Stereotype', *Fashion Theory* 4/2, 125–40.

Colman, David (2005), 'Gay or Straight? Hard to Tell', *New York Times* (19 June), http://www.nytimes.com/2005/06/19/fashion/sundaystyles/19GAYDAR.html, accessed 5 August 2011.

Cook, Matt (2003), *London and the Culture of Homosexuality, 1885–1914,* Cambridge: Cambridge University Press.

Costa, Lee Ray and Matzner, Andrew (2007), *Male Bodies. Women's Souls. Personal Narratives of Thailand's Transgendered Youth,* New York: Haworth Press.

Cottingham, Laura (1996), *Lesbians Are So Chic... That We're Not Really Lesbians At All,* London: Cassell.

Cover, Rob (2004), 'Bodies, Movements and Desires: Lesbian/Gay Subjectivity and the Stereotype', *Continuum* 18/1, 122–35.

Craik, Jennifer (2005), *Uniforms Exposed. From Conformity to Transgression,* Oxford: Berg.

Creed, Barbara (1999), 'Lesbian Bodies: Tribades, Tomboys and Tarts', in Janet Price and Margrit Shildrick, eds., *Feminist Theory and the Body. A Reader,* Edinburgh: Edinburgh University Press.

Crisp, Quentin (1997), *The Naked Civil Servant,* Harmondsworth: Penguin.

Cunningham, Michael (n.d.), 'The Slap of Love', *Open City* 6, 175–96, http://opencity.org/archive/issue-6/the-slap-of-love, accessed 17 August 2011.

Cvetkovich, Anne (1998), 'Untouchability and Vulnerability: Stone Butchness as Emotional Style', in Sally R. Munt, ed., *Butch/Femme: Inside Lesbian Gender,* London: Cassell.

Dahl, Ulrika (2009), '(Re)figuring Femme Fashion', *Lamda Nordica* 14/3–4, 43–77.

Davidson, T., trans. (1868), 'Winckelmann's Description of the Torso of the Hercules of Belvedere', *The Journal of Speculative Philosophy* 2/3, 188.

De la Haye, Amy and Wilson, Elizabeth, eds. (2000), *Defining Dress: Dress as Object, Meaning and Identity,* Manchester: Manchester University Press.

Deleuze, Gilles (1967), *La Présentation de Sacher-Masoch,* Paris: Minuit.

Deleuze, Gilles (1971), *Proust et les signes,* Paris: Presses Universitaires de France.

Devereux, George (1937), 'Homosexuality among the Mohave Indians', *Human Biology* 9, 498–527.

Dittmar, Linda (1998), 'The Straight Goods', in Deborah Bright, ed., *The Passionate Camera. Photography and Bodies of Desire,* London: Routledge.

Doan, Laura (1998), 'Passing Fashions: Reading Female Masculinities in the 1920s', *Feminist Studies* 24/3, 663–700.

Doan, Laura (2001), *Fashioning Sapphism. The Origins of Modern English Lesbian Culture,* New York: Columbia University Press.

Doty, Alexander (1993), *Making Things Perfectly Queer: Interpreting Mass Culture,* Minneapolis: Minnesota University Press.

Dove-Viebahn, Aviva (2007), 'Fashionably Femme: Lesbian Visibility, Style and Politics in *The L Word*', in Thomas Peele, ed., *Queer Popular Culture,* New York: Palgrave Macmillan.

Drewel, Margaret (1994), 'The Camp Trace in Corporate America. Liberace and the Rockettes at Radio City Music Hall', in Moe Meyer, ed., *The Politics and Poetics of Camp,* London: Routledge.

Drorbaugh, Elizabeth (1993), 'Sliding Scales. Notes on Stormé DeLarverié and the Jewel Box Revue, the Cross-dressed Woman on the Contemporary Stage, and the Invert', in Lesley Ferris, ed., *Crossing the Stage. Controversies on Cross-dressing,* London: Routledge.

Dyer, Richard (2002), *The Culture of Queer,* London: Routledge.

Entwistle, Joanne (2000), *The Fashioned Body. Fashion, Dress and Modern Social Theory,* Cambridge: Polity.

Entwistle, Joanne and Wilson, Elizabeth E., eds. (2001), *Body Dressing,* Oxford: Berg.

Erté (1975), *Things I Remember: An Autobiography,* London: Peter Owen.

Faderman, Lillian (1981), *Surpassing the Love of Men. Romantic Friendship and Love between Women from the Renaissance to the Present,* New York: William Morrow.

Faderman, Lillian (1991), *Odd Girls and Twilight Lovers: A History of Lesbian Life in Twentieth Century America,* Harmondsworth: Penguin.

Faderman, Lillian and Timmons, Stuart (2006), *Gay L.A.: A History of Sexual Outlaws, Power Politics and Lipstick Lesbians,* New York: Basic Books.

Feinberg, Leslie (1993), *Stone Butch Blues: A Novel,* Milford, CT: Firebrand.

Feldman, Jessica (1993), *Gender on the Divide: The Dandy in Modernist Literature,* Ithaca, NY: Cornell University Press.

Fillin-Yeh, Susan (2001), *Dandies. Fashion and Finesse in Art and Culture,* New York: NYU Press.

Flügel, J. C. (1930), *The Psychology of Clothes,* London: Hogarth Press.

Fontainas, André (1923), *Mes souvenirs du Symbolisme,* Paris: Nouvelle Revue Critique.

Forster, E. M. (1972), *Maurice,* Harmondsworth: Penguin.

Foucault, Michel (1965), *Madness and Civilization: A History of Insanity in the Age of Reason,* London: Tavistock.

Foucault, Michel (1989), 'An Ethics of Pleasure', in Silvere Lotringer, ed., *Foucault Live (Interviews, 1966–84),* New York: Semiotext(e), 371–81.

Foucault, Michel (1990), *The History of Sexuality: Volume I: An Introduction,* trans. Robert Hurley, London: Vintage.

Fuss, Diana (1991), *Inside/Out. Lesbian Theories. Gay Theories,* Routledge: London.

Garber, Eric (1990), 'A Spectacle in Color: The Lesbian and Gay Subculture of Jazz Age Harlem', in Martin Duberman, Martha Vicinus and George Chauncery Jr, eds., *Hidden from History. Reclaiming the Gay and Lesbian Past,* New York: Meridien.

Garber, Marjorie (1992), *Vested Interests. Cross-dressing and Cultural Anxiety,* London: Routledge.

Geczy, Adam (2013), *Fashion and Orientalism,* London: Bloomsbury.

Geertz, Clifford (1975), *The Interpretations of Cultures,* New York: Hutchinson.

Gelder, Ken (2007), *Subcultures: Cultural Histories and Social Practice,* London: Routledge.

Gill, Miranda (2008), *Eccentricity and the Cultural Imagination of Nineteenth-century Paris,* Oxford: Oxford University Press.

Glick, Elisa (2009), *Materializing Queer Desire. Oscar Wilde to Andy Warhol,* Albany: SUNY Press.

Godfrey, Sima (1982), 'The Dandy as Ironic Figure', *SubStance* 11/3, 21–33.

Gosselin, Chris and Wilson, Glenn (1980), *Sexual Variations: Fetishism, Sado-masochism and Transvestism,* London: Faber.

Gray, Sally (2008), '"I'm Here Girlfriend What's New?" Art, Dress and the Queer Performative Subject: The Case of David McDiarmid', *Fashion Theory* 12/3, 293–312.

Greed, Barbara (1999), 'Lesbian Bodies: Tribades, Tomboys and Tarts', in Janet Price and Margrit Shildrick, eds., *Feminist Theory and the Body. A Reader,* Edinburgh: Edinburgh University Press.

Grémaux, René (1989), 'Mannish Women of the Balkan Mountains: Preliminary Notes on the "Sworn Virgins" in Male Disguise, with Special Reference to Their Sexuality and Gender-identity', in Jan Bremmer, ed., *From Sappho to de Sade. Moments in the History of Sexuality,* London: Routledge.

Grémaux, René (1996), 'Woman Becomes Man in the Balkans', in Gilbert Herdt, ed., *Third Sex, Third Gender. Beyond Sexual Dimorphism in Culture and History,* New York: Zone Books.

Grosz, Elizabeth and Probyn, Elspeth, eds. (1995), *Sexy Bodies: The Strange Carnalities of Feminism,* London: Routledge.

Gundle, Stephen (2008), *Glamour: A History,* Oxford: Oxford University Press.

Gutiérrez, Ramon (1989), 'Deracinating Indians in Search of Gay Roots: A Response to Will Roscoe's "The Zuni Man-Woman"', *Out/Look* 1/4, 61–7.

Haddad, Merv (1992), 'The Discreet Charm of Gay Life in Japan in the Early 1980s', in Stephen Murray, ed., *Oceanic Homosexualities,* New York: Garland.

Halberstam, Judith (1997), 'Techno-homo: on Bathrooms, Butches, and Sex with Furniture', in J. Terry and M. Calvert, eds., *Processed Lives: Gender and Technologies in Everyday Life,* London: Routledge.

Halberstam, Judith (1998), *Female Masculinity,* Durham, NC: Duke University Press.

Halberstam, Judith (2005), *In a Queer Time and Place, Transgender Bodies, Subcultural Lives,* New York: New York University Press.

Hamer, Diane and Budge, Belinda, eds. (1994), *The Good, the Bad, and the Gorgeous: Popular Culture's Romance with Lesbianism,* London: HarperCollins.

Hancock, Joseph, H. II (2009), 'Chelsea on 5th Avenue: Hypermasculinity and Gay Clone Culture in the Retail Brand Practices of Abercrombie and Fitch', *Fashion Practice* 1/1, 63–86.

Hankin, Kelly (2002), *The Girls in the Back Room. Looking at the Lesbian Bar,* Minneapolis: University of Minnesota Press.

Harris, Daniel (1995), *The Rise and Fall of Gay Culture,* New York: Hyperion.

Harvey, Karen (2005), 'The History of Masculinity, Circa 1650–1800', *Journal of British Studies* 44/2, 296–311.

Hawkins, Stan (2009), *The British Pop Dandy: Masculinity, Popular Music and Culture,* Burlington: Ashgate.

Healy, Murray, ed. (1996), *Gay Skins Class, Masculinity and Queer Appropriation,* London: Cassell.

Hegel, G.W.F. (1986), *Vorlesung über die Ästhetik II, Werke,* vol. 14, Frankfurt am Main: Suhrkamp Verlag.

Hennen, Peter (2008), *Faeries, Bears and Leathermen. Men in Community Queering the Masculine,* Chicago: University of Chicago.

Hennessy, Rosemary (1995), 'Queer Visibility and Commodity Culture', in Linda Nicholson and Steven Seidman, eds., *Social Postmodernism: Beyond Identity, Politics,* Cambridge: Cambridge University Press.

Hideki, Sunagawa (2007), 'Reflections on the Tokyo Lesbian and Gay Parade 2000', in Mark McLelland, Katushiko Sugunama and James Welker, eds., *Queer Voices from Japan,* Plymouth: Lexington Books.

Hollander, Anne (1995), *Sex and Suits. The Evolution of Modern Dress,* New York: Kodansha.

Horne, Peter and Lewis, Reina, eds. (1997), *Outlooks: Lesbian and Gay Sexualities and Visual Cultures,* London: Routledge.

Howe, Elizabeth (1992), *The First English Actresses: Women and Drama 1660–1700,* Cambridge: Cambridge University Press.

Howells, Bernard (1996), *Baudelaire: Individualism, Dandyism and the Philosophy of History,* Oxford: Legenda.

Hughes, Langston (1993), *The Big Sea. An Autobiography,* New York: Hill and Wang.

Isherwood, Christopher (1977), *Christopher and His Kind,* London: Methuen.

Jackson, Peter (1997), 'Kathoey-gay-man: The Historical Emergence of Gay Male Identity in Thailand', in Lenore Manderson and Margaret Jolly, eds., *Sites of Desire, Economies of Pleasure: Sexualities in Asia and the Pacific*, Chicago: University of Chicago Press, 166–90.

Jackson, Peter (1997), 'Thai Research on Male Homosexuality and Transgenderism and the Cultural Limits of Foucaultian Analysis', *Journal of the History of Sexuality* 8/1, 52–85.

Jackson, Peter (2004), 'Gay Adaptation: Tom-dee Resistance, and Kathoey Indifference: Thailand's Gender/Sex Minorities and the Episodic Allure of Queer English', in William L. Leap and Tom Boellstorff, eds., *Speaking in Queer Tongues. Globalisation and Gay Language,* Champaign: University of Illinois.

Jackson, Peter A. and Sullivan, Gerard, eds. (1999), *Lady Boys, Tom Boys, Rent Boys. Male and Female Homosexuality in Contemporary Thailand,* New York: Harrington Park Press.

Jennings, Rebecca (2007), *Tomboys and Bachelor Girls. A Lesbian History of Postwar Britain 1945–71,* Manchester: Manchester University Press.

Jennings, Rebecca (2008), *A Lesbian History of Britain. Love and Sex between Women Since 1500,* Westport, CT: Greenwood World Publishing.

Johnson, Mark (1997), *Beauty and Power: Transgendering and Cultural Transformation in the Southern Philippines,* Oxford: Berg.

Jones, Amelia (1994), *Postmodernism and the En-gendering of Marcel Duchamp,* Cambridge: Cambridge University Press.

Jones, Amelia (1995), '"Clothes Make the Man": The Male Artist as Performative Function', *Oxford Art Journal* 18/2, 18–32.

Jones, Thomas (2012), 'So Ordinary, So Glamorous', *London Review of Books* 34/7, 17–20.

Junko, Mitsuhashi (2007), 'My Life as a Woman', in Mark McLelland, Katushiko Sugunama and James Welker, eds., *Queer Voices from Japan,* Plymouth: Lexington Books.

Kaplan, Morris (1999), 'Who's Afraid of John Saul? Urban Culture and the Politics of Desire in Late Victorian London', *Journal of Lesbian and Gay Studies* 7/3, 267–314.

Karlin, Jason (2002), 'The Gender of Nationalism: Competing Masculinities in Meiji Japan', *Journal of Japanese Studies* 28/1, 41–77.

Kazuhiko, Kabiya (2007), 'Lifestyles in the Gay Bars', in Mark McLelland, Katushiko Sugunama and James Welker, eds., *Queer Voices from Japan,* Plymouth: Lexington Books.

Kennedy, Elizabeth Lapovsky and Davis, Madeline D. (1993), *Boots of Leather, Slippers of Gold. The History of a Lesbian Community,* London: Routledge.

Kennedy, Elizabeth Lapovsky and Davis, Madeline D. (2006), '"I Could Hardly Wait to Get Back to that Bar": Lesbian Bar Culture in the 1930s and 1940s', in David Sheer and Caryn Aviv, eds., *American Queer. Now and Then,* Boulder, CO: Paradigm Publishers.

Kleinhaus, Chuck (1994), 'Taking Out the Trash: Camp and the Politics of Parody', in Moe Meyer, ed., *The Politics and Poetics of Camp,* London: Routledge.

Kleist, Heinrich von (1810), 'Über das Marionettentheater', in *Sämtliche Werke,* Leipzig: Im Insel Verlag.

Landeson, Elisabeth (1999), *Proust's Lesbianism,* Ithaca, NY: Cornell University Press.

Latham, Rob (2002), *Consuming Youth. Vampires, Cyborgs and the Culture of Consumption,* Chicago: University of Chicago Press.

Levillain, Henriette, ed. (1991), *L'Esprit dandy: de Brummel à Baudelaire,* Paris: Corti.

Lewis, Reina (1997), 'Looking Good: The Lesbian Gaze and Fashion Imagery', *Feminist Review* 55 (Spring), 92–109.

Lewis, Reina and Rolley, Katrina (1996), 'Ad(dressing) the Dyke. Lesbian Looks and Lesbian Looking', in Peter Horne and Reina Lewis, eds., *Outlooks. Lesbian and Gay Sexualities and Visual Cultures,* London: Routledge.

Lim, Eng-Beng (2005), 'The Mardi Gras Boys of Singapore's English-language Theatre', *Asian Theatre Journal* 22/2, 293–309.

Linden, Robin R., Pagano, Darlene R., Russell, Diana E. H. and Star, Susan, eds. (1982), *Against Sadomasochism: A Radical Feminist Analysis,* East Palo Alto, CA: Frog in the Well Publishing.

Lively, Scott and Abrams, Kevin (1995), *The Pink Swastika: Homosexuality and the Nazi Party,* Salem, OR: Lively Communications.

Lorde, Audre (1982), *Zami. A New Spelling of My Name,* New York: Crossing Press.

Lothstein, Leslie Martin (1983), *Female-to-male Transsexualism: Historical, Clinical and Theoretical Issues,* London: Routledge.

MacDowell, Colin (1992), *Dressed to Kill: Sex, Power and Clothes,* London: Hutchinson.

Mageo, Janette-Marie (1996), 'Samoa on the Wilde Side: Male Transvestism, Oscar Wilde, and Liminality in Making Gender', *Ethos* 24/4, 588–627.

Manalansan, Martin F. IV (2003), *Global Diva's Filipino Gay Men in the Diaspora,* Durham, NC: Duke University Press.

Martin, Brian (2011), *Napoleonic Friendship. Military Fraternity, Intimacy and Sexuality in Nineteenth-century France,* Durham: University of New Hampshire Press.

Martin, Fran, Jackson, Peter A., McLelland, Mark and Yue, Audrey, eds. (2008), *Asia Pacific Queer. Rethinking Genders and Sexualities,* Urbana: University of Illinois Press.

Matzner, Andrew (2001), *O Au No Keia: Voices from Hawai'is Mahu and Transgender Communities,* Chicago: Xlibris.

Mayer, Hans (1982), *Outsiders: A Study in Life and Letters,* Cambridge, MA: MIT Press.

McBride, Dwight A. (2005), *Why I Hate Abercrombie and Fitch,* New York: New York University Press.

McClintock, Anne (1995), *Imperial Leather. Race, Gender and Sexuality in the Colonial Context,* London: Routledge.

McLelland, Mark, Sugunama, Katsuhiko and Welker, James (2007), 'Introduction: Re(Claiming) Japan's Queer Past', in *Queer Voices From Japan,* Plymouth: Lexington Books.

Medhurst, Andy (1997), 'Camp', in Andy Medhurst and Sally Munt, eds., *Lesbian and Gay Studies: A Critical Introduction,* London: Cassell, 274–93.

Merrick, Jeffrey and Ragan, Bryant, eds. (2001), *Homosexuality in Early Modern France, a Documentary Collection,* Oxford: Oxford University Press.

Mewborn, B. (1985), 'Eurythmics Unmasked', *Rolling Stone* (24 October), 85.

Meyer, Moe, ed. (1994), *The Politics and Poetics of Camp,* London: Routledge.

Middleton, Richard (1995), 'Authorship, Gender and the Construction of Meaning in the Eurythmics Hit Recording', *Cultural Studies* 9/3, 465–85.

Miller, Monica (2009), *Slaves to Fashion. Black Dandyism and the Styling of Black Diasporic Identity,* Durham, NC: Duke University Press.

Moers, Ellen (1978), *The Dandy: Brummell to Beerbohm,* Lincoln: University of Nebraska Press.

Mort, Frank (2009), 'New Men and New Markets', in Peter McNeil and Vicki Karaminas, eds., *The Men's Fashion Reader,* Oxford: Berg.

Murray, Stephen, ed. (1992), *Oceanic Homosexualities,* New York: Garland.

Nadeau, Chantal (1995), 'Girls on a Wired Screen. Cavani's Cinema and Lesbian S/M', in Elizabeth Grosz and Elspeth Probyn, eds., *Sexy Bodies. The Strange Carnalities of Feminism,* London: Routledge.

Nanda, Serena (1999), *Neither Man nor Woman. The Hijras of India,* Belmont, CA: Wadsworth.

Neff, D. S. (2002), 'Bitches, Mollies, and Tommies: Byron, Masculinity, and the History of the Sexualities', *Journal of the History of Sexuality* 11/3, 395–438.

Nestle, Joan, ed. (1987), *The Persistent Desire. A Femme-Butch Reader,* Boston: Alyson Publications.

Newton, Esther (1979), *Mother Camp: Female Impersonators in America,* Chicago: University of Chicago Press.

Newton, Esther (1989), 'The Mythic Mannish Lesbian: Radclyffe Hall and the New Woman', in Martin Duberman, Martha Vicinus and George Chauncery Jr, eds., *Hidden from History: Reclaiming the Gay and Lesbian Past,* New York: Plume.

Newton, Esther (1993), *Cherry Grove, Fire Island: Sixty Years in America's First Gay and Lesbian Town,* New York: Beacon Press.

Nicholson, Linda and Seidman, Steven, eds. (1995), *Social Postmodernism: Beyond Identity, Politics,* Cambridge: Cambridge University Press.

Nielson, Kate (2004), 'Lesbian Chic, Part Deux', *The Advocate* (17 February), 9.

Nietzsche, Friedrich (1967), 'The Case of Wagner', in Walter Kaufmann, trans., *The Birth of Tragedy and the Case of Wagner,* New York: Random House.

Oosterhuis, Harry and Kennedy, Hubert, eds. (1991), *Homosexuality and Male Bonding in Pre-Nazi Germany,* New York: Harrington Park Press.

Outram, Dorinda (1989), *The Body and the French Revolution,* New Haven, CT: Yale University Press.

Painter, George (1989), *Proust,* Harmondsworth: Penguin.

Parker, Kevin (1992), 'Winckelmann, Historical Difference, and the Problem of the Boy', *Eighteenth-century Studies* 25/4, 544.

Pater, Walter (1986), *The Renaissance,* Oxford: Oxford University Press.

Patterson, Jennifer Lyn (2003), 'Capital Drag', *Journal of Homosexuality* 43/3, 99–123.

Pauliny, Tara (2003), 'Erotic Arguments and Persuasive Acts', *Journal of Homosexuality* 43/3, 221–49.

Podmore, Julie A. (2006), '"Gone Underground"? Lesbian Visibility and the Consolidation of Queer Space in Montréal', *Social And Cultural Geography* 7/4, 595–625.

Porfido, Giovanni (2007), '*Queer as Folk* and Specularization', in Thomas Peele, ed., *Queer Popular Culture: Literature, Media, Film and Television,* New York: Palgrave.

Pottie, Lisa (1996), 'Hierarchies of Otherness: The Politics of Lesbian Styles in the 1990s, or, What to Wear?', *Canadian Women's Studies/Les Cahiers de la Femme* 16/2, 49–52.

Potts, Alex (1994), *Flesh and Ideal. Winckelmann and the Origins of Art History,* New Haven, CT: Yale University Press.

Powell, Margaret and Roach, Joseph (2004), 'Big Hair', *Eighteenth-century Studies* 38/1, 79–99.

Proust, Marcel (1984), *À la recherche du temps perdu* [Remembrance of Things Past], trans. C. K. Scott Moncrieff and Terence Kilmartin, 3 vols., Harmondsworth: Penguin.

Pudor, Heinrich (1991), 'Nudity in Art and Life', in Harry Oosterhuis and Hubert Kennedy, eds., *Homosexuality and Male Bonding in Pre-Nazi Germany,* New York: Harrington Park Press.

Pulotu-Endemann, Karl F. and Peteru, Carmel L. (2001), 'Beyond the Paradise Myth, Sexuality and Identity', in Cluny Macpherson, Paul Spoonley and Anae Melani, eds., *Tangata o te moana nui: the evolving identities of Pacific peoples in Aotearoa /New Zealand,* Palmerston North: Dunmore Press.

Rauser, Amelia (2004), 'Authenticity, and the Self-made Macaroni', *Eighteenth-century Studies* 38/1, 101–17.

Reed, Christopher (2011), *Art and Homosexuality,* Oxford: Oxford University Press.

Reed, James D. (1989), 'They're Puttin' on the Vogue', *Time* (22 May), 27.

Rodger, Gillian (2004), 'Drag, Camp and Gender Subversion in the Music and Videos of Annie Lennox', *Popular Music,* 23/1.

Rosenbloom, Stephanie (2008), 'For Housewives, She's the Hot Ticket', *New York Times* (13 April), http://www.nytimes.com/2008/04/13/fashion/13trainer.html, accessed 27 September 2011.

Ross, Kristen (1986), 'Albertine; Or, The Limits of Representation', *NOVEL: A Forum on Fiction* 19/2, 135–49.

Rupp, J. Leila (2006), 'Loving Women in the Modern World', in Robert Aldrich, ed., *Gay Life and Culture: A World History,* London: Thames and Hudson,.

Russo, Vito (1987), *The Celluloid Closet,* rev. ed., New York: Harper and Row.

Ryzick, Melena (2007), 'Daughters of the Dinah, Unbound', *New York Times* (1 April), http://www.nytimes.com/2007/04/01/fashion/01golf.html, accessed 16 March 2011.

Savage, Jon (1998), 'What's So New about the New Man?' *Arena* 8 (Spring), 33–5.

Schmidt, Joanna (2001), 'Redefining Fa'afafine: Western Discourses and the Construction of Trangenderism in Samoa', *Intersexions: Gender, History and Culture in the Asian Context* 6 (August), 125–37.

Schmidt, Joanna (2003), 'Paradise Lost? Social Change and Fa'afafine in Samoa', *Current Sociology* 51/3–4, 417–32.

Schofield, Kate and Schmidt, Ruth (2005), 'Fashion and Clothing: The Construction and Communication of Gay Identities', *International Journal of Retail and Distribution Management* 33/4, 310–23.

Scott, Linda (2005), *Fresh Lipstick. Redressing Fashion and Feminism,* London: Palgrave.

Sedgwick, Eve Kosofsky (1985), *Between Men,* New York: Columbia University Press.

Sedgwick, Eve Kosofsky (1990), *The Epistemology of the Closet,* Berkeley: University of California Press.

Sedgwick, Eve Kosofsky (1993), *Tendencies,* Durham, NC: Duke University Press.

Sedgwick, Eve Kosofsky (2004), '*The L Word:* Novelty in Normalcy', *The Chronicle of Higher Education* 50/19, 10–11.

Shapiro, Susan (1988), '"Yon Plumed Dandebrat": Male "Effeminacy" in English Satire and Criticism', *The Review of English Studies* 39/155, 400–12.

Siegel, Jerrold (1986), *Bohemian Paris: Culture, Politics, and the Boundaries of Bourgeois Life, 1830–1930,* Baltimore: Johns Hopkins University Press.

Simmel, Georg (1992), 'Psychologie der Mode', in *Aufszätze und Abhandlungen 1894–1900,* Frankfurt am Main: Suhrkamp.

Simmel, Georg (1998), 'Die Mode', in *Philosophischer Kultur,* Berlin: Wagenbach.

Sinfield, Alan (1994), *The Wilde Century,* New York: Columbia University Press.

Sinnott, Megan (2004), *Toms and Dees. Transgender Identity and Female Same-sex Relationships in Thailand,* Honolulu: University of Hawaii Press.

Sinnott, Megan (2008), 'The Romance of the Queer. The Sexual and Gender Norms of Tom and Dee in Thailand', in Fran Martin, Peter A. Jackson, Mark McLelland and Audrey Yue, eds., *Asia Pacific Queer. Rethinking Genders and Sexualities,* Urbana: University of Illinois Press.

Smalls, James (1996), 'Making Trouble for Art History: The Queer Case of Girodet', *Art Journal* 55/4, 35–9.

Snaith, Guy (2003), 'Tom's Men: The Masculinization of Homosexuality and the Homosexualization of Masculinity at the End of the Twentieth Century', *Paragraph* 26, 77–88.

Solomon, Alice (1998), 'Not Just a Passing Fancy: Notes on Butch', in Debora Bright, ed., *The Passionate Camera: Photography and Bodies of Desire,* London: Routledge, 263–75.

Sontag, Susan (1994), *Against Interpretation,* New York: Vintage.

Souhami, Diana (1988), *Gluck,* London: Phoenix Press.

Spring, Justin (2011), *Secret Historian: The Life and Times of Samuel Steward, Professor, Tattoo Artist and Sexual Renegade,* New York: Farrar, Strauss and Giroux.

Steele, Valerie (1985), *Fashion and Erotism,* Oxford: Oxford University Press.

Steele, Valerie (1985), 'The Social and Political Significance of Macaroni Fashion', *Costume* 19, 94–109.

Steele, Valerie (1989), 'Appearance and Identity', in Claudia Kidwell and Valerie Steele, eds., *Dressing the Part,* Washington, DC: Smithsonian Institution.

Steele, Valerie (1996), *Fetish. Fashion, Sex and Power,* Oxford: Oxford University Press.

Stein, Arlene (1993), 'Androgyny Goes Pop: But is it Lesbian Music?', in Arlene Stein, ed., *Sisters, Sexperts, Queers: Beyond the Lesbian Nation,* Harmondsworth: Penguin.

Stein, Arlene (1997), *Sex and Sensibility. Stories of a Lesbian Generation,* Berkeley: University of California Press.

Stoler, Ann L. and Cooper, Frederick (1997), 'Between Metropole and Colony: Rethinking a Research Agenda', in Frederick Cooper and Ann L. Stoler, eds., *Tensions of Empire: Colonial Cultures in a Bourgeois World,* Berkeley: University of California Press, 1–58.

Suárez, Juan (2008), 'The Puerto Rican East Side and the Queer Underground', *Grey Room* 32, 78–90.

Suthrell, Charlotte (2004), *Unzipping Gender. Sex, Cross-dressing and Culture,* Oxford: Berg.

Thienpont, Eva (2005), 'Visible Wild(e): A Re-evaluation of Oscar Wilde's Homosexual Image', *Irish Studies Review* 13/3, 6–37.

Thorpe, Rochella (1996), 'A House Where Queers Go: African-American Lesbian Nightlife in Detroit', in Ellen Lewin, ed., *Inventing Lesbian Cultures in America,* Boston: Beacon Press.

Tomkins, Calvin (1996), *Duchamp: A Biography,* London: Chatto and Windus.

Totman, Richard (2003), *The Third Sex: Kathoey: Thailand's Ladyboys,* London: Souvenir Press.

Treat, John (1999), *Great Mirrors Shattered. Homosexuality, Orientalism, and Japan,* Oxford: Oxford University Press.

Trebay, Guy (2001), 'Boys Don't Cry: Fashion Falls for a Tough Looker', *New York Times* (3 April), http://www.nytimes.com/2001/04/03/living/03DRES.html, accessed 6 November 2012.

Trebay, Guy (2004), 'The Secret Power of Lesbian Style', *New York Times* (27 June), http://www.nytimes.com/2004/06/27/fashion/27LESB.html, accessed 4 February 2011.

Trumbach, Randolph (1989), 'The Birth of the Queen: Sodomy and the Emergence of Gender Equality in Modern Culture, 1660–1750', in Martin Duberman, Martha Vicinus and George Chauncey, eds., *Hidden from History: Reclaiming the Gay and Lesbian Past,* Harmondsworth: Penguin.

Trynka, Paul (2012), *Starman: David Bowie, the Definitive Biography,* London: Sphere.

Tyler, Parker (1972), *Screening the Sexes: Homosexuality in the Movies,* San Francisco: Holt, Rinehart and Wilson.

Vainshtein, Olga (2009), 'Dandyism, Visual Games and the Strategies of Representation', in Peter McNeil and Vicki Karaminas, eds., *The Men's Fashion Reader,* Oxford: Berg.

Valocchi, Stephen (2005), 'Not Yet Queer Enough: The Lessons of Queer Theory for the Sociology of Gender and Sexuality', *Gender and Society* 19/6, 750–70.

Vinkin, Barbara (2005), *Fashion Zeitgeist. Trends and Cycles in the Fashion System,* Oxford: Berg.

Volcano, Del LaGrace and Halberstam, Judith 'Jack' (1999), *The Drag King Book,* London: Serpents Tail.

von Sacher-Masoch, Leopold (1991), *Venus in Furs,* New York: Zone Books.

Walker, Lisa (1998) 'Embodying Desire: Piercing and the Fashioning of "Neo Butch/ Femme" Identities', in Sally R. Munt, ed., *Butch/Femme. Inside Lesbian Gender,* London: Cassell.

Warhol, Andy (1977), *The Philosophy of Andy Warhol (From A to B and Back Again),* New York: Harcourt.

Waugh, Alexander (2008), *The House of Wittgenstein: A Family at War,* New York: Anchor Books.

Weber, Nicholas (1999), *Balthus. A Biography,* London: Weidenfeld and Nicholson.

Weeks, Jeffrey (1976), '"Sins and Diseases": Some Notes on Homosexuality in the Nineteenth Century', *History Workshop* 1, 211–19.

Weeks, Jeffrey (1985), *Sexuality and its Discontents,* London: Routledge.

Weinberg, Thomas (1983), 'Sadism and Masochism: Sociological Perspectives', in Thomas S. Weinberg and G. W. Levi Kamel, eds., *S and M: Studies in Masochism,* Buffalo, NY: Prometheus Books.

Weingart, Brigitte (2010), '"That Screen Magnetism": Warhol's Glamour', *October* 132, 43–70.

Wherrett, Richard, ed. (1999), *Mardi Gras True Stories from Lock Up to Frock Up,* Victoria: Viking.

White, Chris, ed. (1999), *Nineteenth Century Writings on Homosexuality. A Sourcebook,* London: Routledge.

White, Edmund (1993), *Genet,* London: Chatto and Windus.

White, Edmund (1994), *The Burning Library. Writings on Art, Politics and Sexuality 1969–93,* London: Random House.

Wilde, Oscar (1948), *The Complete Works of Oscar Wilde,* London: Collins.

Williams, Craig (2010), *Roman Homosexuality,* Oxford: Oxford University Press.

Williams, Rosalind (1982), *Dream Worlds: Mass Consumption in Late 19th Century France,* Berkeley: University of California Press.

Wilson, Elizabeth (1984), 'Forbidden Love', *Feminist Studies* 10/2, 213–26.

Wilson, Elizabeth (2000), *Bohemians: Glamorous Outcasts,* London: I. B. Tauris.

Wilson, Elizabeth (2007), *Adorned in Dreams: Fashion and Modernity,* London: I. B. Tauris.

Winkler, John (1990), *The Constraints of Desire. The Anthropology of Sex and Gender in Ancient Greece,* London: Routledge.

Winter, Sam (2006), 'What Made Me this Way? Contrasting Reflections by Thai and Filipina Transwomen', *Intersections: Gender, History and Culture in the Asian Context* 14 (November), http://intersections.anu.edu.au/issue14/winter.htm, accessed 27 September 2011.

Winter, S. and Udomsak, N. (2002), 'Male, Female and Transgender: Stereotypes and Self in Thailand', *International Journal of Transgenderism* 6/1, 55–72.

Wolfe, Maxine (1997), 'Invisible Women in Invisible Places: The Production of Social Space in Lesbian Bars', in Gordon Brett Ingram, Anne-Marie Bouthillette and Yolanda Retter, eds., *Queers in Space. Communities, Public Places and Sites of Resistance,* Seattle: Bay Press.

Woolf, Virginia (2003), *Orlando,* London: Wordsworth Series.

Young, Antonia (2001), *Women Who Become Men. Albanian Sworn Virgins,* Oxford: Berg.

Young, Antonia (2007), 'Once Were Women', *The Good Weekend, The Sydney Morning Herald* (20 October), 47–51.

Žižek, Slavoj (1992), *Enjoy Your Symptom!* London: Routledge.

Zwilling, Leonard and Sweet, Michael (1996), 'Like a City Ablaze: The Third Sex and the Creation of Sexuality in Jain Religious Literature', *Journal of the History of Sexuality* 6/3, 359–84.

Index

Note: The terms 'queer', 'gay' and 'lesbian' do not feature as they are on almost every page. Italics indicate images.

Made in the USA
Columbia, SC
15 December 2017